Praise for *Maya for Games*

"In the constantly changing world of 3D game development, this is the best book yet for anyone looking to get into 3D modeling for the gaming industry. *Maya for Games* is like having a game artist sitting right next to you!"

—Sky Kensok, Partner and Founder WXP, Inc.

"Whether you are a novice or veteran artist in the industry, *Maya for Games* comprises tricks and techniques that are certain to improve your workflow."

—Duane Molitor, Microsoft Games Studio

"This is a great '3D Artist Bible' and an awesome reference for learning and retaining the intricacies of Maya's robust tools!"

—Tim Toulouse, QA Lead, Microsoft Game Studios

Maya for
Games

Maya for Games

Modeling and Texturing Techniques with Maya and Mudbox

Michael Ingrassia

AMSTERDAM • BOSTON • HEIDELBERG • LONDON • NEW YORK • OXFORD
PARIS • SAN DIEGO • SAN FRANCISCO • SINGAPORE • SYDNEY • TOKYO

Focal Press is an imprint of Elsevier

Focal Press is an imprint of Elsevier
30 Corporate Drive, Suite 400, Burlington, MA 01803, USA
Linacre House, Jordan Hill, Oxford OX2 8DP, UK

Library of Congress Cataloging-in-Publication Data
Ingrassia, Michael.
 Maya for games : modeling and texturing techniques with Maya and Mudbox/Michael Ingrassia.
 p. cm.
 Includes index.
 ISBN 978-0-240-81064-5 (pbk. : alk. paper) 1. Computer animation. 2. Maya (Computer file)
3. Three-dimensional display systems. 4. Video games—Design.
5. Computer games—Design. I. Title.
TR897.7.I525 2009
006.6'96—dc22

 2008030771

British Library Cataloguing-in-Publication Data
A catalogue record for this book is available from the British Library.

ISBN: 978-0-240-81064-5

For information on all Focal Press publications
visit our website at www.books.elsevier.com

08 09 10 11 5 4 3 2 1

Typeset by Charon Tec Ltd., A Macmillan Company. (www.macmillansolutions.com)

Printed in Canada.

Contents

Contents

Contents

Contents

Contents

Contents

Acknowledgments

I would like to take a moment to thank the Focal Press staff, in particular Laura Lewin, Chris Simpson, and Georgia Kennedy, for their assistance and for providing me the opportunity to create this book.

Thanks to my good friend Alan, whose Maya expertise and professionalism is unsurpassed.

Finally to my Uncle Robert, who nurtured my artist skills from an early age, taught me to never be satisfied with my work, and encouraged me to always strive to do better on the next project. His mentoring has helped make me the artist I am today.

Introduction: Why I Decided to Write This Book

Welcome

Thank you for choosing, in my opinion, one of the best books available for next-generation modeling and 3D game art techniques. I would like to take a moment to say a few words regarding the purpose of this book (or, as I would call it, training courseware) and what you can expect to learn from it. Many years ago when I was new to 3D and learning Studio Max, I came across a book I found incredibly enlightening as each chapter took me deeper into an original underwater scene. I came away having learned a great deal from that book and to date have not found another like it. As a veteran 3D artist and professional Maya instructor, I have been longing for a well-structured book on Maya modeling to use as a training aid for my students. Additionally, for some time now, other instructors have echoed the same desire. So when the opportunity came before me to write this book, I was excited for the chance to create something special for educating 3D artists.

Why I Prefer Working in Maya

Maya, as is true of any 3D application, is simply a tool—a powerful tool, but nonetheless just a tool. Put a paintbrush in the hands of Michelangelo and he'll paint the ceiling of the Sistine Chapel. Put the same paintbrush in the hands of someone less skilled, and he'll paint his house. It's the user's skill, not the tool, that makes great 3D art.

I bring this up because regardless of the 3D program you prefer, the knowledge and skills you gain from this book will make you a better 3D artist. But what makes Maya so desirable for many 3D artists is its ease of use, customization capabilities, and therefore speed. Custom tool shelf, MEL or Maya Extended Language scripting, and keyboard shortcuts are the heart of Maya's power.

Once you become comfortable using Maya, you will build on a series of customized tools on a daily basis. These tools and customization capabilities are what make Maya so comfortable and attractive to use. It is a powerful program that will become a pleasure to use more and more as you become familiar with how it works and gain a better understanding of its potential.

So moving forward , keep in mind that the goal of this title is to train a wide range of people with varying skills and 3D desires. At the end of the book, I can assure you that all users will have a stronger understanding of the many 3D processes used in the game and film industries, processes I have used for the past decade on a daily basis.

Go Ahead and Jump Right In

So roll up your sleeves and jump right in! Don't be afraid to make mistakes, because you will. We all do. Even with my years of experience as a professional 3D artist, I am constantly learning and understanding how I can "make it better" the next time around. That's why 3D modeling is so much fun, because it is consistently challenging. Give it your best shot, and don't be afraid to scrap your model and start over. Remember, you are here to learn. What you might enjoy knowing is that I had many friends, both experienced 3D artists and others who were new to 3D and Maya software, work through these projects. They provided me with valuable feedback on areas that needed more explanation or additional screenshots. I truly feel this book is one of the best available on 3D modeling and will become a favorite you'll want to keep on your work desk.

And if you get in a jam, feel free to send me an e-mail and ask any questions you might have. I would be glad to help you through your problem-solving process.

Happy modeling!

Michael Ingrassia
3D Industry Veteran
www.MayaInstructor.com

How to Use This Book Effectively

The following comments are worth reading, especially if you are just flipping through this book at the bookstore. This page will give you a great understanding of my teaching philosophies and methods to my madness.

What This Book *Is Not* About

First, what this book *is not* about. This book was *not* designed to be a complete bible of all the tools and abilities within Maya. It isn't intended to be about all modeling tools or techniques available either. Maya is a deep and diverse application. Many tools and abilities lie in its power, but to discuss them all here would take up half, if not more, of the pages in this book and be completely boring to the user outside of serving as a reference to what each tool is capable of doing. Therefore, it would be a great disservice to include too much information on tools that won't be necessary on the projects within this book and, quite honestly, on tools I have not been required to use in my professional career as a 3D game artist.

Progressive Modeling and Lessons

As we progress through the book, my explanations will slowly allow you to think and work on your own. In the beginning you will find my instruction to be detailed and meticulous, but to avoid redundancy I will mention tools but not describe where they are located because you will already know where they are by this point. This is why it is so important that you work through this book from beginning to end in a linear fashion. Don't think of this book as a random guide but as an in-classroom course where you are following my instruction on a daily basis. In the end, those who follow my direction will come away with a strong understanding of Maya, modeling, and 3D technique.

Working in Different Versions of Maya?

Three words: custom tool shelf. At the time of this writing, users of this book will find that all of the tools and techniques I will show apply to any version of Maya up to 2008. Because we will be making a custom tool shelf, all of the necessary tools we require will be at our disposal regardless of where they are within the Maya menus. Some features have been changed or moved in the updated versions, but not so much as to cause confusion or to outdate this book anytime soon. My goal was to create a well thought out training course within this book, and I feel I have successfully done so.

Working in Another 3D Application?

If your 3D application happens to be other than Maya, no worries either. Many of the tools I use in Maya are similar to tools available in other applications such as Max. The tools may have different names, but most perform the same or similar functions. Give the book a try. I know you will find if helpful and a great resource for many techniques related to 3D in general.

Simplifying Redundancy

Another reason to work from the beginning to the end with this book is to avoid repeating the same tools and techniques. With each new lesson I add more tools and methodology, but I also deliberately avoid the same "click here and do that" directions. By the end of this book you will notice the lessons become less about telling you what to do every step of the way and focus instead on showing you where to go with the new skills you are acquiring. More experienced 3D users will find in these lessons a refreshing opportunity and change of pace.

So Who Is This Book For?

If you are a beginner, then you're in luck! This is one book that will be on your desk for quite some time, as the techniques presented here will help you grow as an efficient modeler.

But if you are an intermediate to advanced 3D artist, rejoice! I have been asked repeatedly why all of the books in today's market keep mulling over the same boring basics. I couldn't agree more. That's why when I set out to write this book, I knew I had many great techniques to draw from that I have learned and honed over the past decade working at various major studios. Think of this book as a treasure trove of unique and aspiring approaches for making your life as a modeler go much smoother and maybe even more fun too.

I promise you, this will be one book you guard like a watchdog. Coworkers or fellow students who stop by your desk and pick it up to check it out will get a vicious snarl—well, that's my dream anyway!

So enjoy and please feel free to check out my personal website where I will have much information about myself, my work, and, soon, many free tutorials and models for those of you who have purchased this book.

Why the World War I Theme?

Why Did I Chose World War I for the Subject Matter?

I could have chosen just about any subject or style in writing this book. Many ideas crossed my mind, from cyber-stealth warfare like Crysis to cartoonish style Jak and Daxter, but I wanted to give the users of this book some unique challenges. First, most games today involve some form of warfare or gun battles—something I'm not entirely happy about, but we'll keep politics out of the equation. The truth is, when you begin your career as a 3D artist, chances are the game you will be working on will involve some form of character shooting a weapon. From a design standpoint, there is a beautiful, simple aesthetic quality about WWI. The shape of the "doughboy" soldier helmet has always intrigued me, and I felt the fashion style of this era would be a fresh and creative direction for modeling. Also, the thought of teaching how to create a Sopwith Camel biplane, made infamous when WWI ace pilot Arthur Roy Brown successfully shot down Baron Manfred von Richthofen, also known as "The Red Barron," was simply too good to pass up. Besides, World War II has been covered enough in many games, but WWI hasn't.

What to Expect by the End

The second reason I chose to focus on WWI was to provide users the opportunity to create and display some unique game model assets on their show reels. As an instructor, I have seen my share of 3D books demonstrating all too often an alien spacecraft, a poorly executed game character, or, worse, how to model a hammer or a wine glass. These are boring, overdone, and useless when trying to impress a game studio that you have what it takes to enter the gaming industry. By the end of this book, you will have created many of the assets required to assemble a WWI scene or game level. You will also learn how to show off your models to prospective employers in Bonus Chapter 13, when I show you how to create impressive 3D model turntables for a killer show reel. I hope you find this book as much fun to read as it was to write.

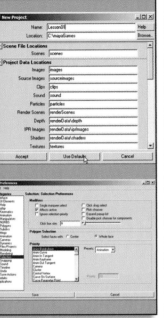
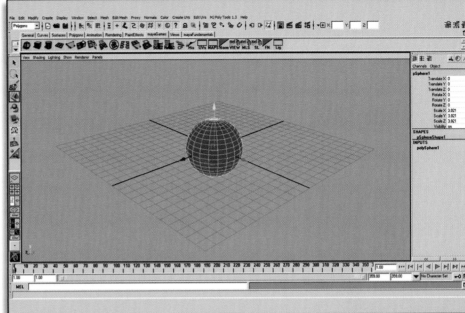

Maya Fundamentals: User Interface

Maya's user interface can be a bit intimidating at first glance. A lot of information is displayed at one time! But once you understand the basic components and how they relate to one another, you'll see it's a rather easy application to learn. Although I will not be investing time to explain all of the tools, menus, and selections available, everything you wish to know is provided within the **Maya Help** documentation (**f1 hot key**).

Let's start by taking a look at the entire interface in color-coded form:

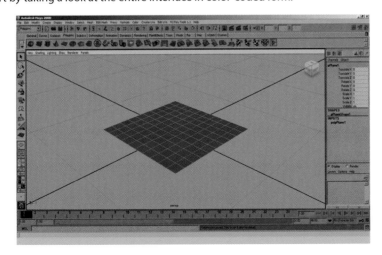

TOP MENU BAR

The Top Menu bar displays the many drop-down menus available within a section of Maya such as Polygons, Animation, Rendering, and so on. The menu will always remain the same from file to window. These are universal tools that you will use throughout production.

STATUS LINE

The status display allows you to make certain changes to a wide variety of selections. For modeling, I personally do not use this section frequently aside from the rendering buttons. Maya's documentation will explain all the buttons and their purpose.

SHELF

The shelf will become our lifeline as we work through this book. More important will be the custom shelf we will create with specific tools we will use frequently.

TOOL BOX

The toolbox again is something I rarely use, as many of the options are available on hot keys once you become more familiar with them.

VIEWPORT

The viewport is where your production work will be displayed. You have many options from the viewport menus to make changes to your display. For example, you can change the viewport from a single panel to a quad panel and to anything in between. You can show wireframes on your mesh, remove the grid, and so forth. Reading the Maya documentation on viewports is highly recommended.

CHANNEL/LAYER BOX

The channel panels display pertinent information regarding a selected object. A subsection called Inputs provides even further important and often-used information. The Layer panel allows users to isolate, hide, and organize objects and items throughout production. For example, you can keep all of the lights in a scene on one layer, all items in one section layered from another, and so on.

ANIMATION TIME SLIDER

This slider allows users to toggle through and set keyframes during animation. We will discuss it briefly in the bonus chapter, a lesson on creating an animated turntable for models.

COMMAND LINE

Command line is very useful for entering MEL script commands and activating scripts.

HELP LINE

The Help line displays comments regarding issues as they are completed or if there was a conflict.

Maya Fundamentals: Preferences Settings

Setting Custom Preferences

Many of Maya's preferences can be changed. One modification I find useful in my daily workflow is to change faces from Center to Whole Face. I also prefer my attributes windows to be on separate popup rather than embedded into the channel area, which I find annoying. I also highly recommend changing the level of Undos to Infinite, so you can back up as far as you wish on a project. Finally, we'll turn on the Border Edges highlight to make viewing our mesh edges a bit easier throughout the work in this book.

Center to Whole Face Selection

You will find this feature helpful. Basically we will remove the small pixel that your cursor needs to select a mesh face and replace it with Whole Face, so now you can select a face anywhere on its live area:

- Select Window/Setting Preferences.
- Select Preferences.
- Click on Selection.
- Under Polygon Selection, select Whole Face.

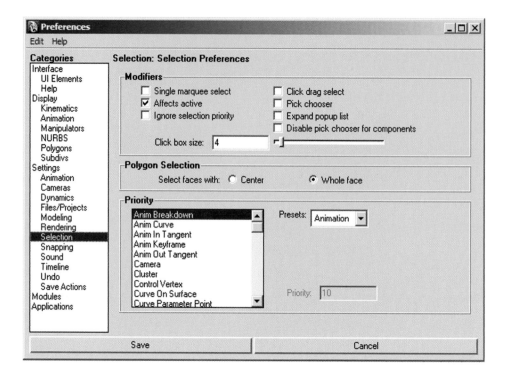

Attribute Windows

Currently, anytime you wish to view an objects attributes (containing all information regarding that asset), the window defaults to embed in the channel controls on the right panel. It can become frustrating to keep changing while working. Therefore, having the Attribute Editor on a separate window allows me to minimize, so I can continue working yet view it anytime I wish:

- Categories, select Interface.
- Open Attribute Editor, select In Separate Window.
- Do the same for the Open Tool Settings and Layer Editor.

Unlimited Undos

This self-explanatory option enables you to undo mistakes as far back as you wish into a project:

- Select Undo.
- At Queue, select Infinite.

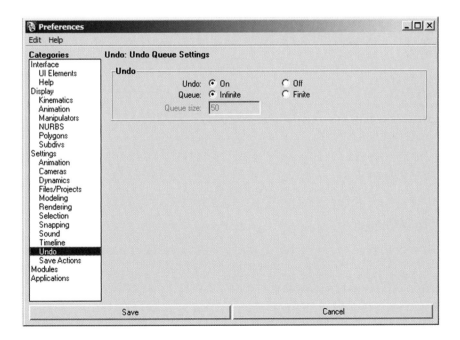

Turn on Border Edges Highlight

At times in your modeling it becomes difficult to see edges or open edges clearly. If you turn on the Highlighting feature, you will spot these edges faster:

- Select Polygons under Polygon Display.
- Check Border edges.

You can increase the edge thickness by doing the following:

- Select Polygon Display/Edge Width.

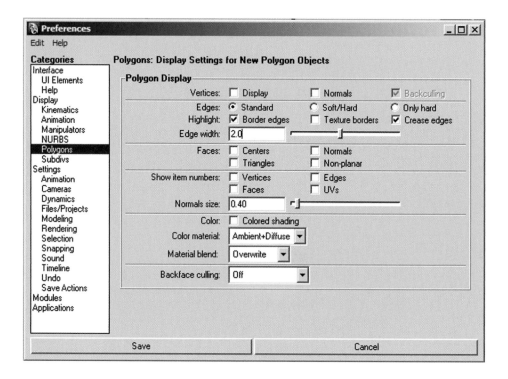

IMPORTANT: *After you complete these changes, make sure to select Save at the bottom of the Preferences window.*

Plug-In Manager

Because we are setting up preferences, let's make sure of a few things with the Plug-In Manager too. We need to make sure we are able to export/import .OBJ files:

- Select Window/Setting/Preferences.
- Choose Plug-In Manager.
- At ObjExport.mll, check both Loaded and Auto Load.

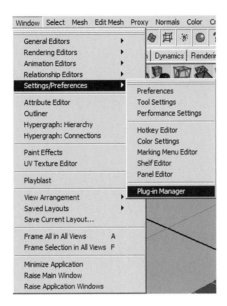

Maya Fundamentals: Hot Keys

Maya's hot keys allow users to work quickly. Several of the keys I use frequently are listed next. I find these keys helpful in my daily modeling production workflow.

Hot Keys

Manipulators

Q: Hide Manipulator tool

W: Translate

E: Rotate

R: Scale

Object Views

4: Wireframe mode

5: Shaded mode

6: Textured mode

7: Lit mode

Maya Help

f1: Maya Help/Search

Working Modes

f2: Animation

f3: Modeling

f4: Dynamics

f5: Rendering

Selection Mode

f8: Switches to/from Edit and Object modes

alt/Arrow: Moves selection 1 pixel at a time

Arrow: Pick walking through vertices

Z or ctrl/Z: Undo

shift/Z: Redo

X: Snap to Grid

C: Snap to Line/Edge

V: Snap to Vertice

F: Frame camera to selection in viewport

A: Frame camera to all objects in viewport

G: Redo last command

Y: End tool but remain selected

B: Adjust brush size

P: Parent

ctrl/D: Duplicate

ctrl/G: Group

ctrl/N: New Scene

ctrl/S: Save Scene

Maya Fundamentals: Creating a Custom Tool Shelf

Brief Description of Each Tool's Function

Create Poly Sphere. Creates default sphere.

Create Poly Cube. Creates default cube.

Create Poly Cylinder. Creates default cylinder.

 Create Poly Plane. Creates default plane.

 Create Polygon Tool. Masks out overall shape.

 Extrude. Extrudes faces or edges to add depth/thickness.

 Split Poly. Divides mesh.

 Merge Vertices. Cleans up open mesh.

 Combine. Joins two or more meshes into one object.

 Insert Edge Loop. Adds new edge split across object.

 Append to Poly. Mends open faces.

 Fill Hole. Fills open faces quickly.

 Soften Edge. Softens edging for smooth curves.

 Harden Edge. Hardens sharp edges and corners.

 UV Tex Ed. Views and cleans up UVs for texturing.

 Center Pivot. Centers the objects pivot automatically.

 Delete History. Removes old processes to reduce memory.

 Hypershade. Builds shaders and applies materials to mesh.

Creating a Custom Tool Shelf

To make modeling easier in our workflow and to also make the projects in this book easy for Maya users, we are going to create a custom tool shelf with the most common tools we will be using throughout this book. You can add more tools that you prefer using later.

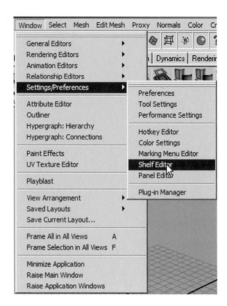

- Go to Window/Settings/Preferences/Shelf Editor.
- Select New Shelf and rename it: mayaGames.
- Select Save All Shelves.

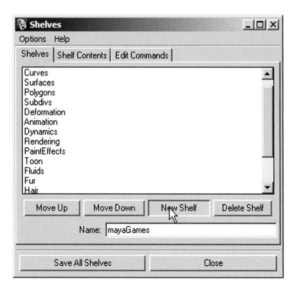

We now have a new blank shelf on which to add our favorite tools. To add a tool to the shelf, you simply need to locate it within its appropriate menu listing, but before selecting it do the following:

- Hold down the ctrl + shift keys.
- Select your tool. The icon representing that tool will be displayed on the new shelf.

How Your Shelf Should Look after You Add the New Tools

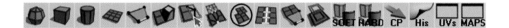

NOTE: *Should you add an unwanted tool or put it in the wrong position, that's fine. At the end of this lesson I will show you how to remove or switch positions of tool icons.*

Here Is Where Each Tool Is Located in Maya 2008

Create Primitive Shapes
Create/Polygon Primitives/Cube, Sphere, and so on

Create Polygon Tool
Mesh/Create Polygon Tool

Extrude
Edit Mesh/Extrude

Split Polygon Tool
Edit Mesh/Split Polygon

Merge Vertices Tool
Edit Mesh/Merge

Combine
Mesh/Combine

Insert Edge Loop Tool
Edit Mesh/Insert Edge Loop

Append to Polygon Tool
Edit Mesh/Append To Polygon

Fill Hole
Mesh/Fill Hole

Soften/Harden Edge
Normals/Soften or Harden Edge

Center Pivot
Modify/Center Pivot

Delete History
Edit/Delete All by Type/History

UV Texture Editor
Window/UV Texture Editor

Hypershade
Window/Rendering Editors/Hypershade

Changing Tool Names

Now that we have completed our shelf, we need to go back and change a few icon names to make them easier to understand (i.e., we'll change UTE < UV Texture Editor> to just UVs):

- Go To Window/Settings/Preferences/Shelf Editor.

Under Shelf Contents, you will see all of the new tools we created. Scroll down and do the following:

- Soften Edge change Icon Name to SOFT.
- Harden Edge change Icon Name to HARD.
- UV Texture Editor change Icon Name to UVs.
- Hypershade change Icon Name to MAPS.
- Select Save All Shelves.

Now you're ready to begin the lessons in this book. Remember, you can add, remove, or change positions of icons at any time.

To remove a tool icon, simply middle mouse drag **(MMD)** the icon over to the trash can on the right side. To change an icon's position, MMD to the left side of the new position then release.

Maya Fundamentals: Setting up a New Project

It's best to start good habits early. One of the most important is the creation of a **New Project** folder. This step is important because all folders corresponding to textures, mesh, and other data related to that specific model will be organized correctly and transferable to other users or computers without breaking any paths.

Step 1

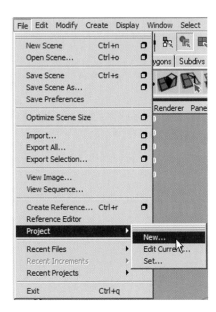

- Create a folder on your hard drive called mayaGames.
- Open Maya.

- Go to File menu (top left).
- Go to Project/New.

Step 2

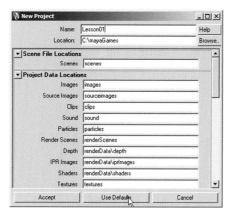

- In the New Projects attribute window, create a new name: Ch02_StoneArchway.
- In Locations, hit Browse and locate the mayaGames folder you just created.
- Select Use Defaults (you can rename these folder if you wish).
- Select Accept.

Step 3

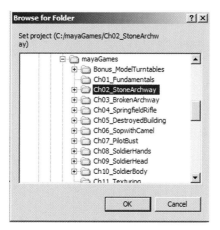

- Go to the File menu.
- Go to Project/Set.
- Click on the folder called mayaGames.
- Select OK.

DONE!: *This step will save you grief and trouble later. It's good housekeeping, and game studios will expect you to have well-organized and clean work folders.*

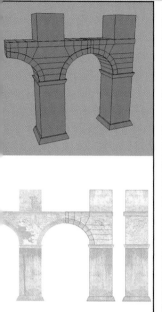

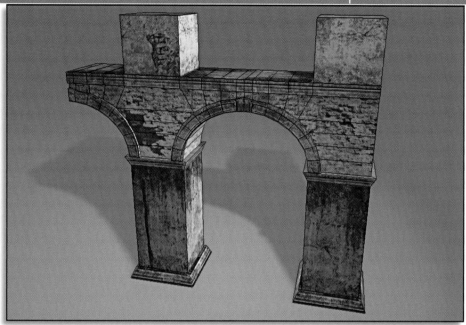

The Stone Archway

What We'll Learn

This lesson introduces you to a variety of tools within Maya that you can use for modeling and texturing. Utilizing the most basic and popular form of modeling, known as "box" modeling, we will begin our process with a standard cube and build from there. It's a rather simple lesson, but it has many interesting aspects that you will find helpful as you continue learning.

Before Beginning

You should have created your customized tool shelf before beginning any lesson in this book. If you are unsure of how to create a new project folder, please refer back to Setting up a New Project in Chapter 1. All projects in this book will reside in the **mayaGames** folder you created earlier.

Step 1: Getting Started

- Open Maya and create a new project called stoneArchway.
- Remember to set the project to the correct folder, stoneArchway.
- Save your scene, and name it stoneArchway01.ma.

Open the DVD that accompanies this book, and locate the folder Lesson_Templates.

- Copy (ctrl + C) the image maps called **stoneArch_Grid.tif** and **stoneArch_Map.tif.**
- Paste (ctrl + V) them into the sourceimages folder located within the **stoneArchway** project folder.

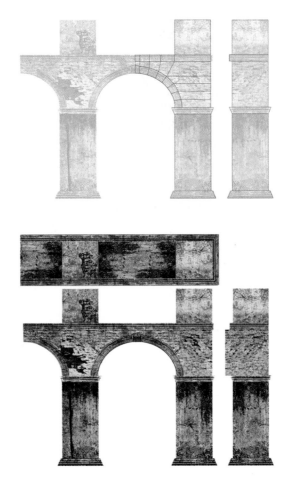

Why Are We Copying and Pasting?

Why we are copying and pasting instead of simply opening a project folder from the book's DVD? Because in the real world, you will not have the convenience of simply opening a file and having everything you need waiting for you. The purpose here is to develop a good understanding of workflow and housekeeping.

Step 2: Preparing the Modeling Template

Creating a New Template

- Create a new polygon plane.
- Change the scale under INPUTS from 1 to 24 in width/height.
- Change divisions from 0 to 1 in subdivision width/height.
- Rename **Plane1** to **templateFront** and press Enter.

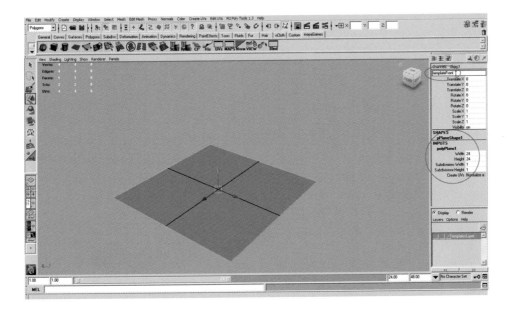

Creating a New Layer

- One the right panel below the channels is the layer editor.
- Click on the yellow asterisk icon to create a new layer.
- Double-click on **layer1** and rename **templateLayer.**
- Press Save.

With both templates selected, do the following:

- Right-click on the new layer, and choose Add Selected Objects.
- On the new layer, click twice on the **middle box** next to "V" (visible) to activate "R" (render mode)

This will display the templates but prevent them from becoming selectable.

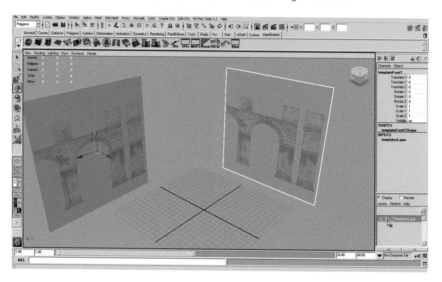

Creating a New Shader

- Open the Hypershade (Maps) editor.
- Double-click on the default Lambert1 shader.
- Turn the transparency slider up approximately 50%.
- Close its Attribute Editor, but keep the Hypershade Editor open.

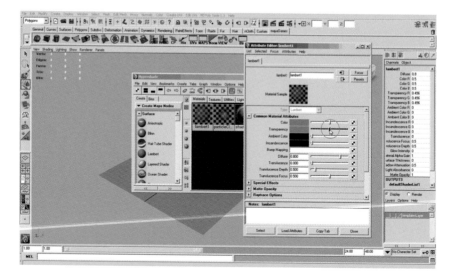

Creating a Template Map Shader

- Now create another Lambert shader.
- Double-click the shader to pen its Attribute window.
- Rename lambert2 to Templates.
- Press Enter and click on the checker icon for the color channel.
- Select File in the Create Render Node panel.
- Make sure **Normal** is selected under the 2D Textures drop-down list.
- Select the folder icon for Image Name.

If you set up your project correctly you should see both maps you pasted in earlier.

- Select stoneArch_Grid.tif, and press Open.
- Click back onto your image plane templateFront, and apply the map to it.

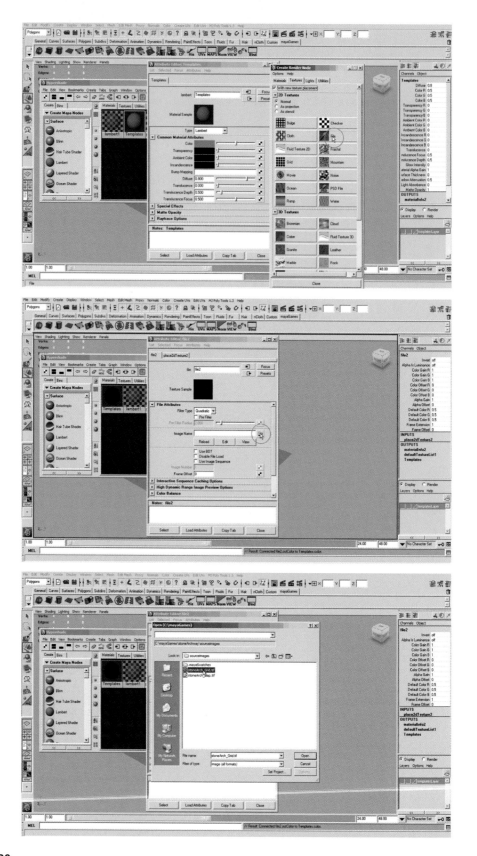

Applying the Shader to Template Mesh

- Select your mesh
- Open the Hypershade "Maps" window
- Right click on the Template shader you just made
- Drag up to Apply Materials to Selection
- Release right mouse button

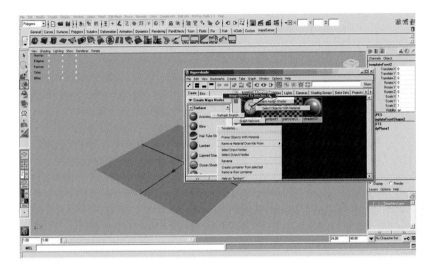

- Close the Hypershade.
- Press 6 on your keyboard to activate texture mode.
- Select the template, and rotate it (E key) 90 degrees in the Rotate X channel.

You can type in exact measurements rather than rotating visually.

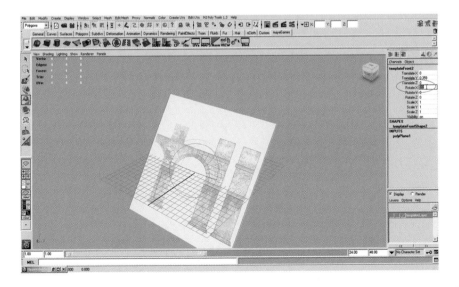

- Now let's move to our front camera by clicking on the viewcube Front
- Translate (W key) the template up (Y axis) so the bottom of the archway lines up with the horizontal grid line. Approximately 9 in the Translate Y should work.
- You also need to line up the center of the archway with the center of your scene by translating in X; a setting of 1 works well.

Finally, we want to push our template back so it doesn't interfere with our mesh.

- Translate in Z to −20.
- Now let's Modify/Freeze Transformations to zero out our template.
- Click the Center Pivot on your shelf.
- Click Delete History on your shelf and let's save the scene.

Duplicating the Template

- Duplicate the selected template by pressing ctrl + D.
- Rotate the new template, RotateY 90 degrees.
- TranslateZ to 19.35.
- TranslateX to −20.
- Rename the new template to templateSide.
- Select both templates and Modify/Freeze Transformations.
- Again delete history and save your scene.

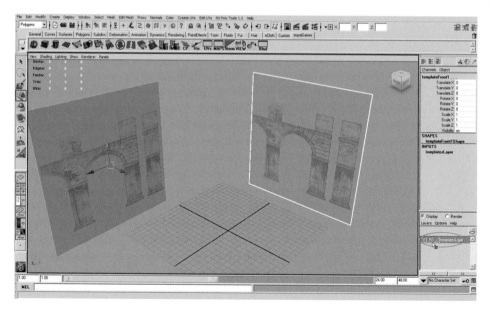

Personally I find the **Grid** to be distracting when modeling. Follow these steps to turn off the grid:

- Go to Show on the top edge of your viewport.
- Scroll down to the bottom and uncheck Grid.
- Make sure you are in the correct view mode and direction by selecting Panels/ Orthographic/Side.

Begin Modeling

Our goal is to create a simple box model of the column. This object is a simple shape that will be mirrored once the initial column is created, saving us a great amount of work time.

- Create a poly cube.

Translate the X and Y over to the right column, and move it into position just above the bottom ledge. My measurements are as follows:

- TranslateX 4.128
- TranslateY 6.991

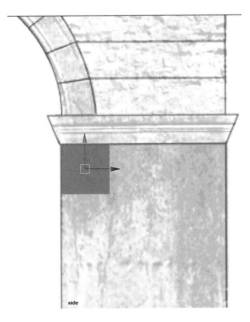

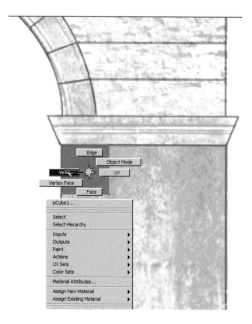

We're starting here so we can scale the cube more accurately than if we started from the bottom.

- Right-click/drag on the cube to activate the edit menu.
- Select Vertex, and drag over the vertices on the right side of the cube.
- Drag the red arrow (from the arrowhead) to the right edge of the column.
- Then do the same to the vertices on the bottom of the cube, bringing them down to the column ledge.
- Change your viewport to the side view
- Scale the entire cube to match the column width on the grid image.
- Once complete, change the viewport back to the front view.

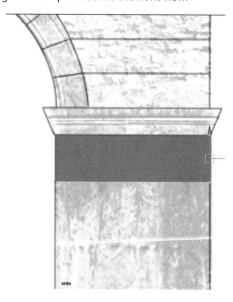

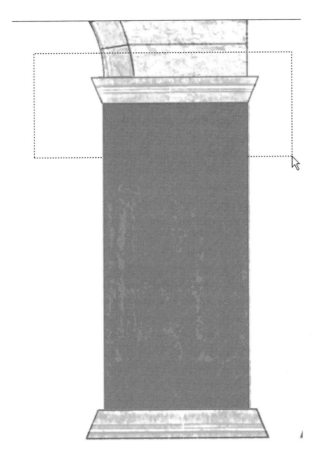

Next we are going to extrude faces to build out the model using the box modeling technique. A great way to select a face without moving the camera is to drag-select over the top of the cube, then, holding the ctrl key, drag again over the center of the cube leaving just the top face active.

Extruding Faces

- Select the Extrude icon from the tool shelf and drag upward from the blue **arrowhead** to the next grid line on the column.
- Click on any color square above the arrowhead to activate the light blue center square, which allows you to scale proportionately.
- Scale the face to match the angle of the column. It may not be exact as the grid was drawn by hand and not perfectly symmetrical. But get as close as you can.

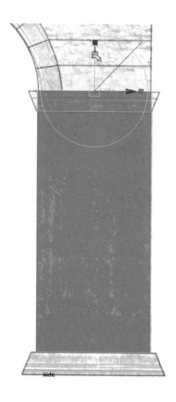

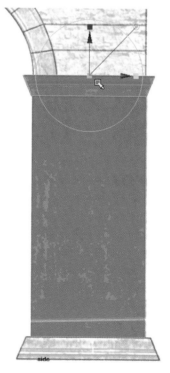

- With the top face still selected, pressing the G key will redo the same tool, so a new face can be extruded.
- Pull the blue arrow up before scaling it; this will make it easier to see the width.
- Then move the blue arrow back even with the edge below it and press G again.

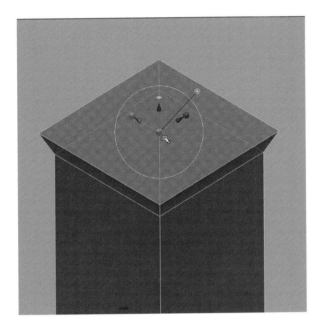

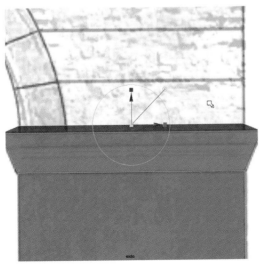

- This time bring the arrow up to the top of the edge trim.
- Drag the face up to the top of the arch.
- Select the left face inside the arch, and extrude it to the middle of the arch.

You have basically created three new cubes atop the middle column ledge.

Step 3: Creating the Arch

Splitting Vertices

This next part of our lesson includes splitting vertices—basically creating two faces from one. It is an essential part of modeling, and there are many tools and methods for splitting vertices. Let me quickly discuss the three basic tools.

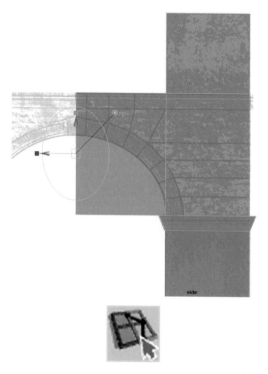

First there is a **Split Vertices Tool** in Maya that allows you to create one split at a time. This tool can be modified to snap or be free floating, allowing you many options to work with. We will discuss and use this tool later on in the book.

The second tool and the one we will begin using now is Maya's version of the MJPolyTool and is called **Insert Edge Loop Tool**. It allows you to quickly split new edge loops (a continuous row of edges around an object).

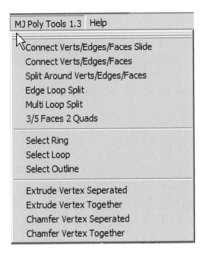

The third tool is actually a free third- party script and a favorite among most of us "old dogs." It is called **MJPolyTools** and is a simple yet effective splitting tool. I have used it for many years, and it has been of immense help in improving my speed and workflow. This script is recommended, and more information on downloading and installing it is available at the back of this book.

Let's create the ledge face split now.

- Select the Insert Edge Loop tool on your shelf, and click on any of the three vertical edges of the column. A dotted line will show and follow your cursor.
- Release when you have the split where you would like.
- If you make a mistake, either press the Z key to undo or right-click select vertices and move the entire row into the correct position.

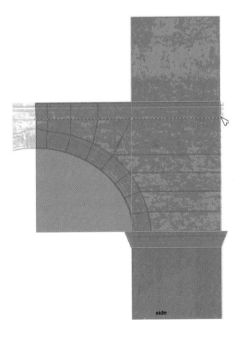

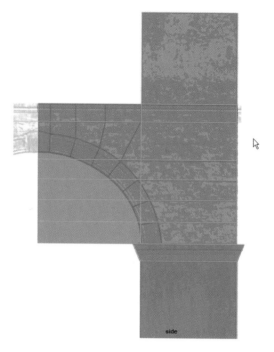

- Continue to add splits now for the remainder of the horizontal rows shown on the grid.
- Once complete, begin selecting the vertices in the center of the cube and moving them into the position to create the arch.

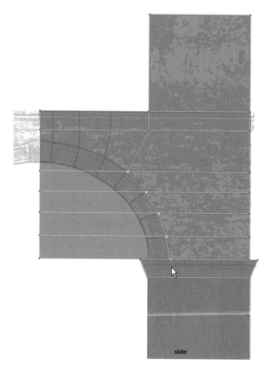

Be sure to drag over the vertices so you are selecting both the front and back vertices simultaneously!

- Next, do the same with the vertices on the left of the cube. Bring them into place with the arch. You may need to move them visually to line up with the diagonal rows in the arch curve.

You'll notice we have a slight issue. We need another edge to complete the middle of the wall. There are many ways to solve this problem but the easiest is going to be using the Split Polygon tool and adding three edges around the wall.

- Select the Split Polygon tool from your shelf. Start from the inner arch and work your way around the wall.
- Move the edge down to line up with the lower part of the center section, and be sure the vertices you snapped across the wall line up.

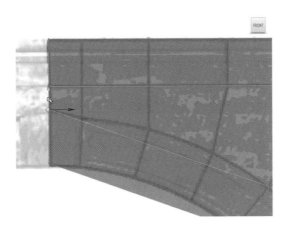

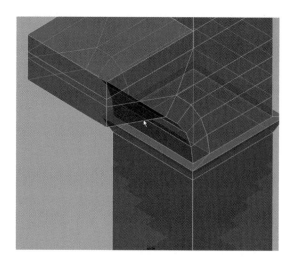

You can ensure vertices lining up correctly by V snapping the vertice using the "arm" of the arrow and not the arrowhead. This will snap in a vertical plane but not cross horizontally.

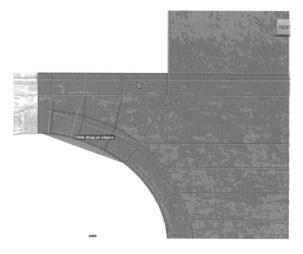

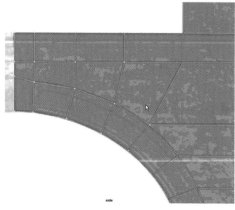

The last step in this part of our lesson is to now use the Insert Edge Loop tool to add a few vertical edges to complete the arch. Once you have completed this stage, go to the bottom face of your column and extrude two more faces to complete the lower trim of the column as shown.

Delete History and save your file as **stoneArchway02.ma**.

Step 4: Mirroring the Geometry

We now have a clean box-modeled column. The remainder of this lesson will entail using a mirror tool to create a duplicate column facing the opposite direction. We could simply create a duplicate and rotate it 180 degrees in this situation, but when you are modeling unique objects such as a character head, that won't be an option. So we will mirror and keep our process continuous throughout all lessons in this book.

Completing the Model

- Set the viewport to the Orthographic Front view and look at the mesh and template together.

To complete this model, you need two duplicates. You will use the first duplicate for the half archway. The second duplicate will be a mirror copy of the column.

- Press ctrl + D and make a duplicate copy.
- Move this far off to the left side for now.
- On the main column, we need to delete the three faces in the middle of the arch.

If we don't delete these faces, they will remain inside the geometry causing an unusual hard edge that will display poor lighting and shadows in game. Removing these faces ensures a clean and hollow model.

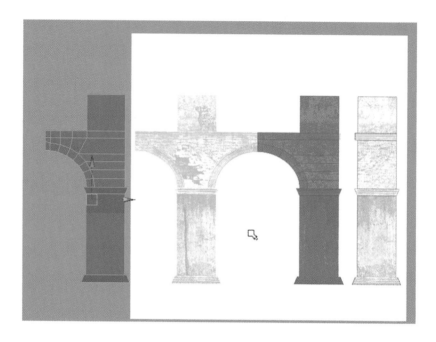

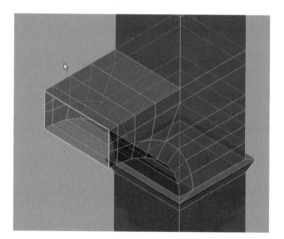

Mirror Geometry

- To mirror a shape, go to the Mesh/Mirror Geometry-Options box.
- Within the option, disable the check box Merge with Originals.

You do this because you never want to rely on Maya merging for you. Many times you may have a vertice at a slight distance from zero, and this will not seal correctly, meaning that your mesh will not be "waterproof." It's always best to merge vertices manually at all times. To make merging vertices easier, however, we can use a few tricks.

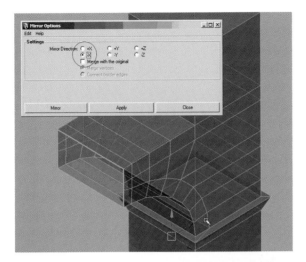

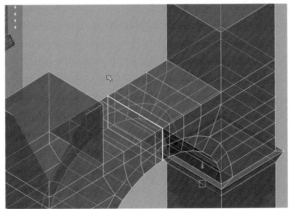

Merging Vertices

- Go to Display/Heads Up Display, and check Poly Count.
- This will now bring up a display on your viewport's upper left corner (if you did not have it open already). Let's set up our Merge Vertice tool correctly now.
- Double-click the Merge Vertice icon on your shelf to open its Options Box.
- Set the Threshold to .0100.
- Press Enter.

This setting will merge vertices that are on top of or extremely close to one another. Notice that the Verts Display reads 16. There are two sets of 8-vertice geometry here.

Click on your Merge Vertice icon again, and keep an eye on this number. It should always read half the value it was before to ensure a clean merge.

In this case, if you see 8, then you did it right!

- Now is a good time to delete History.
- Save out your file as **stoneArchway03.ma**.

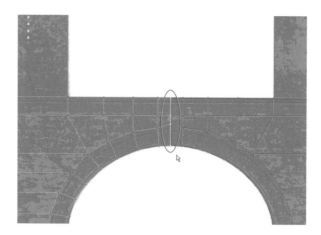

WARNING!: *You should notice that the archway lines up perfectly with the template image. If not, then somewhere you went wrong and may need to backtrack your steps.*

We're almost finished modeling. There are just a few more things to do. This part may get somewhat confusing, so follow the instructions carefully. We now want to add the remaining archway mesh to complete the model. Rather than build it from extruding faces—which we could do, but it wouldn't be as perfect and would also take much more time—we are going to cut apart the previously duplicated column and salvage just the part we need. We again also have to delete a few faces from the existing archway to hollow out a clean connection.

- Go to Perspective view.
- Select the face of the main archway as shown, and delete it.
- Select the unwanted parts of the duplicate column.
- Delete them so your remaining geometry looks like the image shown.

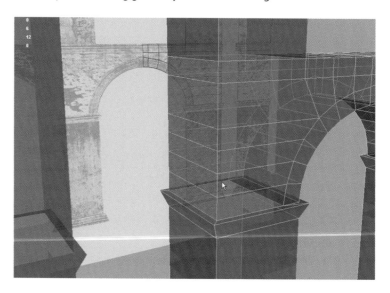

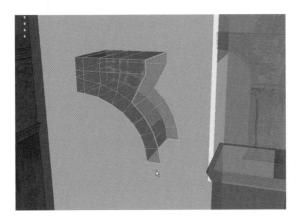

Snapping Points

Now let's snap the new section into the main section. To do this, we will move the object's pivot point to a necessary corner.

- Press the insert key,
- Hold down the V key and snap the pivot to the top edge vertice.
- Press the insert key once more to close the active pivot.
- Now press the V key once more, and snap the mesh to the column wall as shown.

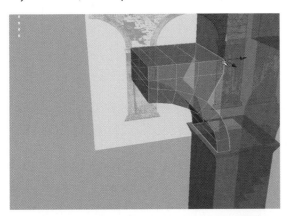

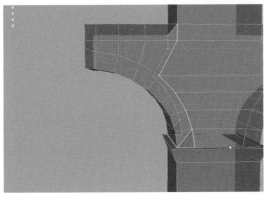

Combining Meshes

We are now going to use a new tool that will combine both meshes into one so we can merge the vertices properly.

- Select both objects, and click the **Combine** icon on the shelf.
- Now that you've learned how to V snap vertices, do the same for the rows on the column except the bottom row; leave this one where it is for now.

Your model should match the image if done correctly. Don't merge as yet.

You'll notice we have one small problem. At the bottom of the arch the edges have crossed over. There are many ways to fix this problem. For this lesson, let's remove the interfering faces and we'll rebuild them afterward.

- Select the two bottom faces as shown and delete them.

Now we have two holes that need repairing.

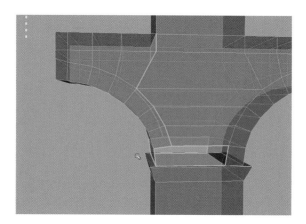

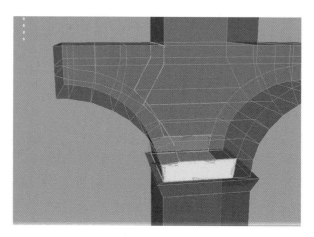

Before we can repair the hole, we have to merge the mesh together to seam all edges clean.

- Right-click on the mesh, and select Vertices.
- Select over the region of vertices in the area. You don't have to be precise this time because we snapped our vertices earlier ensuring the low Threshold of the Merge Vertices tool will work properly.
- Use the Split Vertices tool to restore the bricks on the bottom arch.

Using the Append to Polygon Tool

Once again, there are several ways to fix these holes, but we will use a tool called Append to Polygon. It displays an arrow (counterclockwise) on which edge to select next. The hole will repair itself quickly.

- Right-click and select Edges.
- Select one edge on the first hole.
- Go to the Edit Mesh/Append to Polygon tool.

Finishing Up

We have just about completed our model. The last step is an easy one. We want to extrude the faces of the top ledge and the arch to give them both some dimension.

- Select the faces (just on the front side) as in the image, and extrude.
- Inspect the mesh on all sides to make sure there are no problems such as open faces.
- Select the wall and rename it in the upper right panel as **stoneArchway**.
- Delete History and save as file as **stoneArchway04.ma**.

Use your visual judgment to determine how far to pull out the extruded wall—I would recommend about half the distance from the wall to the outer ledges.

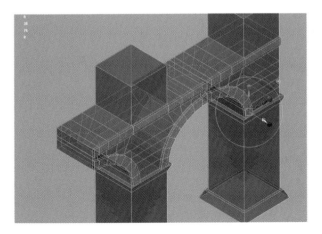

Step 5: Applying Planar UV Projection

Applying UVs to the Finished Archway

With the model now completed, we can apply UV coordinates that will allow us to texture our model. Think of UVs as an outer skin that is wrapped around the mesh, similar to gift-wrapping a box. Applying UVs can be one of the most tedious and frustrating parts of the 3D process. But through the lessons in this book, we are going to explore many unique and creative ways to get great UVs and apply them to our models.

The Stone Archway is perfect for a simple **planar** style UV map, planar being a flat map from one camera direction. And because we will use our template map as our final texture map, we can use a trick in this instance.

Applying the UV Coordinates

- Select the stoneArchway mesh.
- Turn the Template layer from R back to nothing (selectable).
- Shift + select the Front Template plane.
- Go to Create UVs/Planar Mapping/Options box.
- Check on the Z axis (front view).
- Press Project and close the panel.

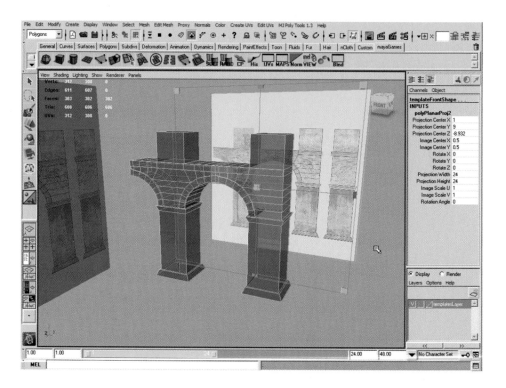

You'll notice a bounding box displays, showing the region that has become UV mapped. Now we will create a new shader with the template texture that doesn't have the grid.

Duplicating a New Shader

Sometimes you want a new shader that has many of the same settings as another shader but perhaps one small difference such as base color or image map. Rather than redoing the shader from scratch, we can duplicate an existing shader and, in this case, simply replace the texture.

- Click on Maps (hypershade editor).
- Click on the Template shader.
- Go to Edit/Duplicate/Shading Network and click.

Creating a New Shader

- Double-click to open the Att Editor.
- Change the name to archwayTexture.
- Click on the color bar, and find the map called stoneArch_Map.tif.
- Close the Att Editor window.

Applying the Shader Map

- Select the wall model.
- Right-click on the new shader map.
- Drag up to Apply Material To Selection.

You should see the mesh update with the new texture map.

Not Perfect but…

Well, this is a great technique but not entirely perfect. You will notice the sides of our wall now have stretch marks. This is because the current UV coordinates are from just the Z axis on all sides. To remedy this situation, we will now select just the faces of the wall sides and do the same technique as we did earlier.

- Switch views to Side Ortho view.
- Right-click and select Faces.
- Drag-select over the side faces of the wall and the two end caps of the top ledge.
- Shift + Left Select the side template.
- Shift + Right Select the face of the side template.
- Go to Create UVs/Planar Mapping/Options Box.
- Check on the X axis (side view).
- Press Project and close the panel.

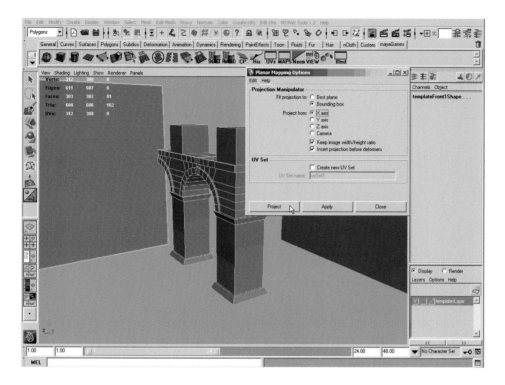

You'll notice the wall updates with the side template map.

Now we just have the top faces to select carefully and apply one more projection, this time from the Y axis (top view). Repeat the same steps you followed previously, but this time select the top faces.

Oh yes, you will need to make a new duplicated template for the top view. You should understand enough at this point to give it a go. Don't worry if you can't figure this one out. I promise you, by the time you work through a few more tutorials, you'll know exactly how to solve this problem.

Why We Are Now Finished

Our first lesson will be considered finished, even with the texturing stage because the concept art department created pretty realistic template art. We do have an issue with multiple UVs currently lying on top of each other, and for next generation of games, that's not a good thing. But I will show you how we fix that problem and add even more detail and realism in Chapter 3, The Broken Archway.

Here is a quick render of this projesct's model with a simple three-point lighting setup.

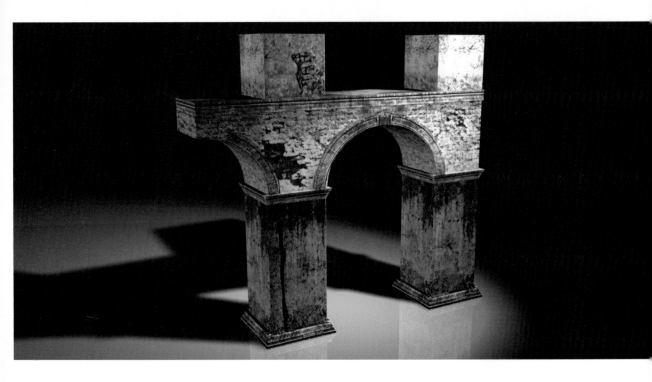

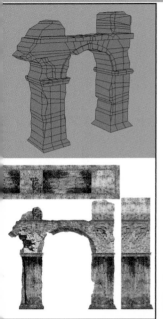

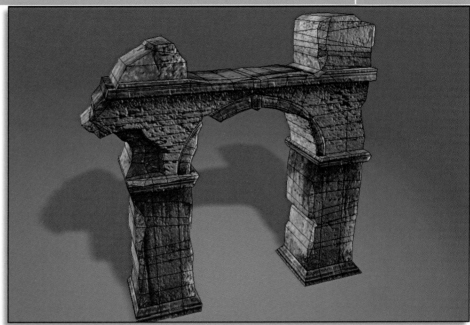

The Broken Archway

This next lesson is a great introduction to working with the Create Polygons tool. It will be the basis of the image-based modeling (IBM) technique we'll use on a few lessons in this book. You will find it may take a little longer to set up this technique, but in the end it goes rather quickly and delivers excellent results in the final model. You will also see the benefits of using Maya's Transfer Maps option, which is a huge time-saver for generating quality texture maps.

Preparing the Template Image

I took the original Stone Archway concept art and painted white over the sharp edges to break up and distress the wall. Then I used Photoshop to draw green lines where I felt edges would work best. Notice how I focused on the extreme outer and extreme inner edges in an attempt to minimize the number of polygons required to achieve a good enough representation of the overall shape. In the Templates folder on the DVD, I saved two versions of the template maps: **brokenArch_Grid,** which will be our template map, and **brokenArchMap,** which will be our final texture placeholder.

45

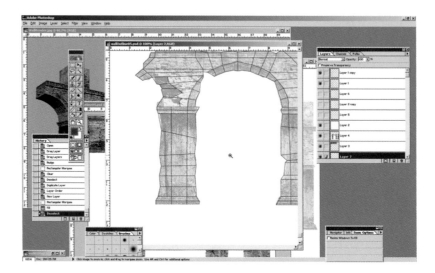

Setting up the Project and Template

- Set up a new project within the same mayaGames folder.
- Name it Ch03_BrokenArchway.
- Be sure to "set" the project to the correct folder.
- Create two templates using the same technique you used for the first lesson, and name them templateSide and templateFront.
- Remember to scale the planes to 24 units.
- Rotate and translate the templates roughly into position.

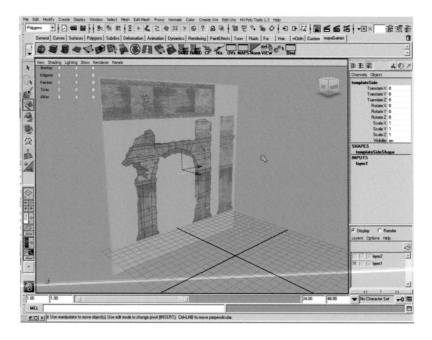

Preparing Shaders for Modeling

- Open Maps (hypershade editor), and add 50% transparency to the default shader1.
- Create a second Lambert shader, and rename it Template.
- Insert the texture map brokenArch_Grid.tif.
- Select both template panels, and apply the shader to them.
- Finally, create a new layer in the layers channel.
- Rename it Templates, and "lock" the layer by choosing R.

Should you need clarity on these steps, refer to Chapter 2.

Step 1: Begin Modeling

We are going to create the outer shape of the wall. We can model in sections, then we can combine them into one wall shape.

Using the Create Polygons Tool

- Switch to the side orthographic view.
- Select the Create Polygon tool.
- Begin to create the polygon shape by following the edges around the wall. This technique is similar to connecting the dots.

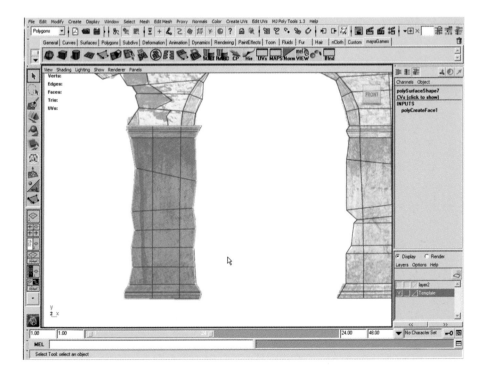

Continue to create all necessary shapes. Don't be too concerned if they are not perfect. You can adjust them by adding and subtracting vertices later.

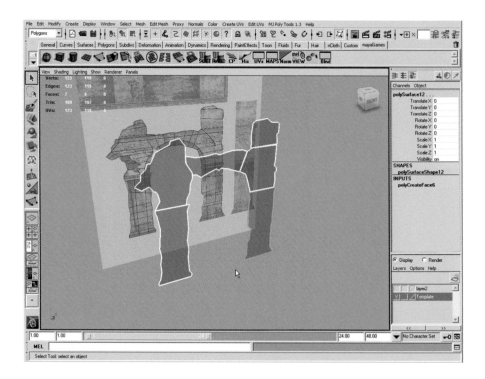

 TIP: *Shift + select allows you to select multiple objects, faces, and other elements. But sometimes this method will also deselect them. Holding shift + ctrl + select forces Maya to select only. Holding ctrl + select forces Maya to deselect only.*

Combining the Shapes

- Select all the polygonal shapes.
- Click on Combine to make all shapes into one object.
- Click off the mesh to deselect it.
- Double-click on the Merge Vertices tool to open its Options box.
- Change the Threshold setting to 5.0.

This step allows us to merge vertices that are not so close to each other. Now go around the wall and begin merging vertices that are close to one another. If one is missing in an area, pass it for now. We'll fix it later.

You may notice edges that you are sure were merged correctly, yet the thick border remains. This indicates that the facing normals are reversed.

To fix a reversed facing normal, follow these steps:

- Select the mesh in object mode (green outline).
- Go to Display/Polygons/Face Normals.
- Select faces with normals that are pointing backward.
- Go to Normals/Reverse.

Now all normals are reading properly, and you will notice the thick border edges went away on the connecting seams. The only annoying issue is that the normals display needs to be turned off through the menu again. I recommend creating a shelf button for future use (ctrl + shift + click on the tool in the menu).

Now is a good time to delete History and save your file as a new iteration (i.e., brokenArchway02.ma).

Step 2: Finalizing the Wall Face

Now you will use the Split Vertices tool to match the edge splits as shown on the template image. Basically you are connecting the dots again.

 TIP: *If you would like your Split tool to snap to the exact middle of an edge automatically, complete the following steps:*

- Open up the Split Vertices Tool/Option box.
- Change the Snapping Tolerance to 33.

This will ensure the Split Vertice Tool snaps to cut a face edge at exactly 50% halves, but remain flexible enough to allow other percentages of snapping too.

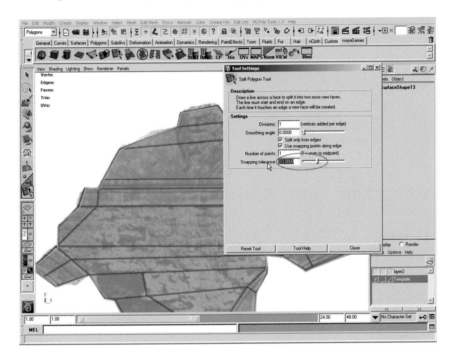

TECHNIQUE: *There is a trick to getting the Split Vertices tool to work correctly. To make it snap to a vertice and not create a new one, you should click the arrow on an edge and drag it toward the desired vertice until you see it snap in place. Just clicking on an edge will create a new vertice, defeat the purpose, and make a big mess.*

Splitting Vertices

- Choose the Split Vertices tool.
- Begin connecting edges to match template art.
- Selects vertices, and move them to clean up.

TRICK

Aligning Vertices: *One way to ensure alignment on horizontal or vertical vertices is to use the scale manipulator. Select the vertices you want in a straight edge, and scale in the appropriate direction.*

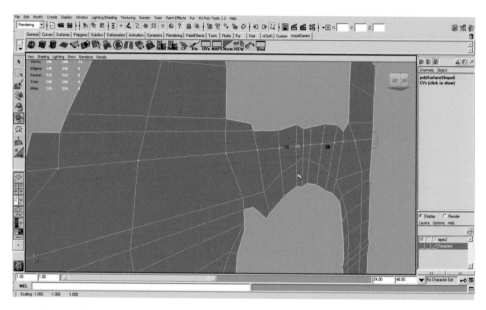

Finishing the Base Wall

The process for completing the base wall is straightforward. Continue splitting vertices until you match all of the template outlines. You will notice in the example that there is one small area of a blown-out section where the vertices don't connect. These are sometimes referred to as "n-gons," polygons that dead end. I could work these into quads, but I prefer to wait until I have extruded my wall and added other details as these problems always find a way of working themselves out into quads later in the modeling process.

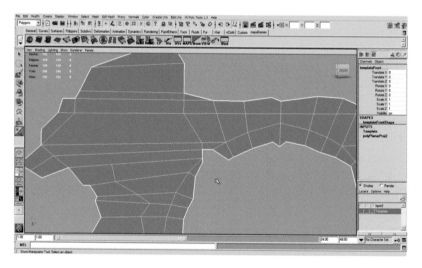

3's, 4's, 5's...Oh My

So what is the deal with triangles, quads, and n-gons? Well, the ideal situation is to maintain your mesh so that it is made up of all quads when possible. Game engines will automatically

triangulate. Faces of five sides or more should be addressed when possible, but these do in fact occur in the real production world, especially when deadlines are ticking to ship product. So will it hurt to leave faces less or more than quads? Well, yes and no. You don't want to be sloppy, so do your absolute best to ensure that you are using all quads when you can. But don't lose sleep if you have a stray triangle or five-sided face. At best, try to bury these in an area that won't be seen, such as at the top of a ledge or window trim.

If you are working on a character model or definitely using Mudbox, then this becomes a more serious issue. But for broken up environment assets, this occurs all of the time in real game productions.

TRICK

Progressive UV Layout: *UVs don't need to wait until the end of modeling in every situation. There are times when it makes sense to lay out a base UV coordinate just to get faces in an organized manner. Let's use a tree model as an example. Imagine the headache involved with laying out the mesh of a twisting truck, multiple branches, and roots. If you apply a cylindrical map to the base cylinder before modeling, you have established an organized layout that becomes easier to select and adjust later in the UV process.*

This is what we will do for our wall. We will lay out a base planar UV before we extrude the wall thickness.

Applying the UV Coordinate

- Select the base mesh.
- Shift-select the Template plane.
- Go to Create/Planar Mapping options box.
- Set Projection Manipulator on Z Axis (front view).
- Click Project.

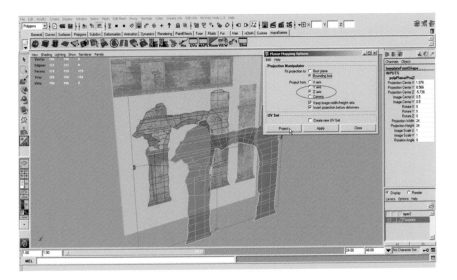

Checking Your Progress
- Select the wall.
- Open Maps, and apply the Template shader.
- Delete History, and save.

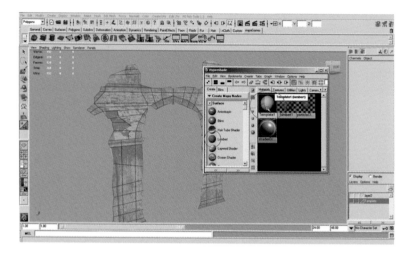

We can now begin to extrude the wall depth and add more details such as ledges, trim, and broken bricks. This will take our wall into the next-generation category.

Extruding the Wall

- Reapply the original default (part transparent) shader.
- Select the wall mesh.
- Click on Extrude, and pull out (or push back) the blue arrow to the required depth shown on the on the Side template.

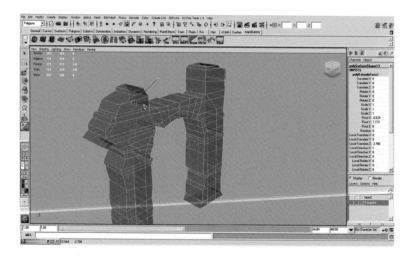

Adding Basic Details

- Continue selecting and extruding the ledges and trim to match the template.
- View the brokenArchway05.ma file to get an idea of what the mesh should look like.

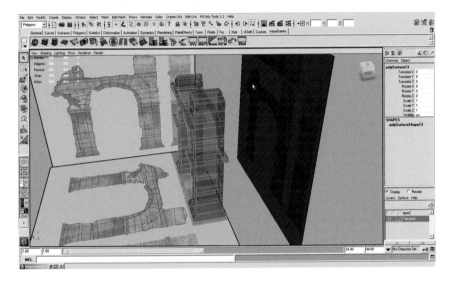

Creating the Texture Map Shader

- Open Maps (hypershade) again.
- Select the Template shader.
- Select Edit/Duplicate/Shading Network.
- Double-click shader to open Attribute editor.
- Assign the name brokenArch_Map.tif to the color file.
- Apply texture to the wall.

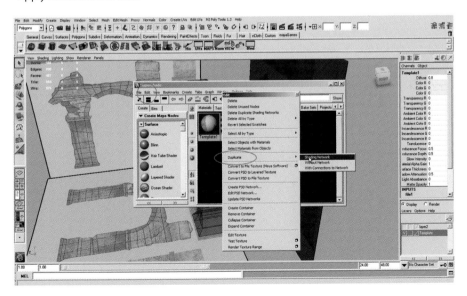

Continuing with Finer Details

This part can take some time because polishing, massaging, and finessing (terms we like to use) the model is a labor of love at this stage. Sometimes in production we import the model before this stage and do the polishing as a final pass before level lockdown.

There isn't much to add here because you can do as much or as little as you would like. If you're new to 3D, then I would suggest learning more of the other lessons in this book then coming back to detail this model at a later time.

Step 3: Preparing the UVs

Earlier in Chapter 2, we placed planar maps onto the faces from various X, Y, and Z directions. To lay out UVs properly for today's game design, we need to take it a step further by breaking out all of the sides and placing them into one area to allow texture and normal maps to work efficiently.

We'll explore techniques such as Transfer Maps as shown in Chapter 11 (Technique 9: Transfer Maps).

Explaining the Following Process

1. First we will lay out the UV on the wall as before, using planar maps from various angles.
2. Any trouble spots can be "automatic mapped" or from "camera angle" and sewn together.
3. When we are finished, we'll make a duplicate mesh. One will become the **Source** mesh, the other our **Target** mesh.
4. We'll lay out the UVs on the Target mesh more efficiently and maximize the UV space as best as possible.
5. We'll then use a technique called "transfer maps" that will "bake" a new color map onto our Target mesh.
6. We can then us Photoshop to touch up and improve the new map. We will generate normal and ambient occlusion maps from our color map too.

Completing Our UV Layouts

As in Chapter 2, select the faces and template from each axis and apply the UV map coordinates. Be sure to change the UV Manipulator direction for each new axis. Once completed, inspect the model for any missed or incorrectly textured faces.

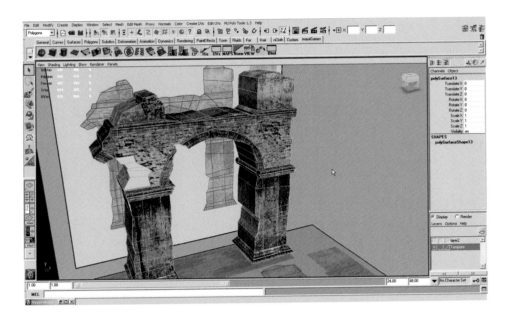

Fixing Incorrect Faces

Here is an example of faces that were mapped incorrectly. I forgot to select the underside of the arch to become mapped with the top Y mapping. So rather than reselect all of the top faces, I will select just these few and apply the Y planar map to them.

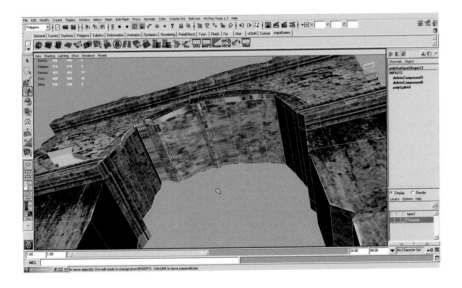

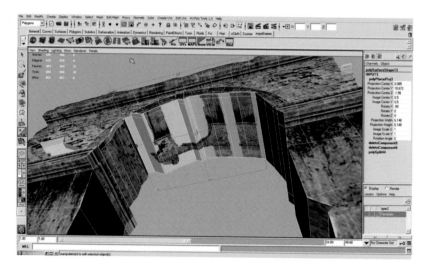

Isolating the New UVs

- Open the UV editor.
- Zoom out so you can see the full upper right square (also called 0,1).
- Right-click, and select UVs from menu.
- Drag over all UVs that are showing.

You will notice now that all UVs for all of the model have become visible, but that's okay; the UVs we need are already selected.

- Move them off to one side, and scale them down. This doesn't need to be exact right now. The idea is to fit them back into the image at the approximate scale. To do this we will move them over the top UVs and scale closer.
- Hit the F key to frame the camera view.

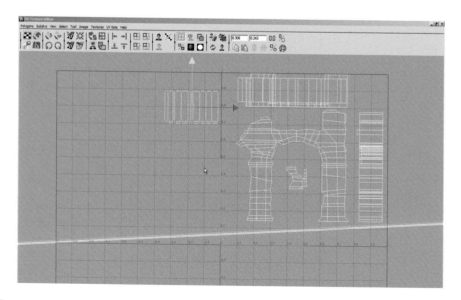

As you can see here, I scaled the UV to match the top view (the edges are selected only to make them more visible).

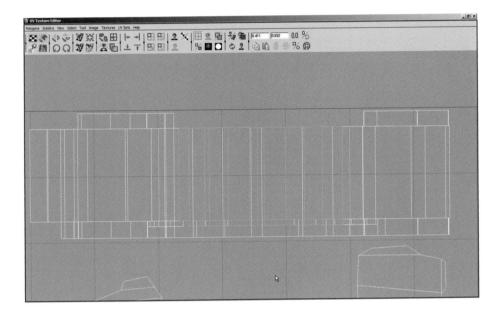

Let's pretend you accidentally deselected the edges. How can you reselect without having to go back and select all the faces again as before? It's simple.

- Select one UV that you know is part of the new panel.
- Go to Select/Select Shell.

This will allow you to select the entire panel UV set as before.

Finished, or Are You Hungry for More?

We can finish here and move on to the duplicate mesh UV layout, or we can add more detail. If you felt getting to this point was challenging, then skip ahead to Finishing the UV Layout. Those of you who are hungry for more, let's move on!

Step 4: Adding More Details

It's never too late to add more details, especially at this stage. I created a simple bump map, which I then converted into a normal map using the NVidia filter in Photoshop. We are going to take a look at this process in Chapter 11, Texture Mapping Techniques.

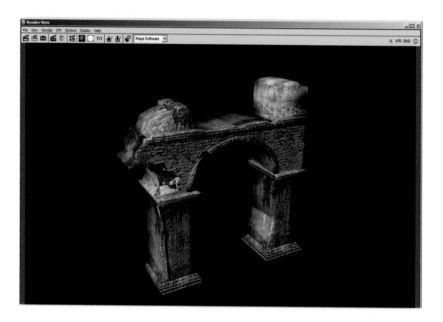

This allows me to review what changes or additions I can make to further enhance the final model. I know that I want to add more complexity to the broken-out chunks, so I will begin doing that now.

What about the UVs?

The UVs for the new faces will need mapping coordinates, but the rest of the model will be fine. We may need to redo a few planar maps if we move the vertices around or simply massage the UVs to relax some stretching. But because we are working with broken rock and rubble, much of any stretching won't be visibly noticeable.

Breaking up the Mesh

The process is simple. I call it "rubbleizing." I make out a list of what I would like to change:

1. Chip away some edges.
2. Add a few loose bricks.
3. Carve into some broken spots so that the image looks more realistic.

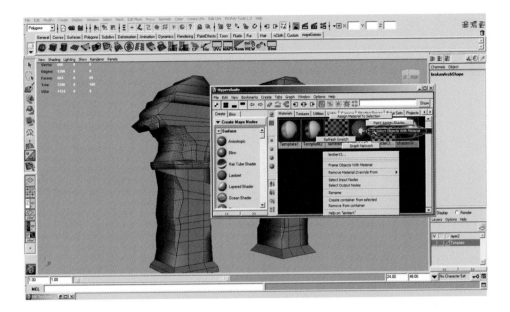

Because I am creating new faces, I will create a new shader for now as a placeholder. This allows me to quickly color the new areas that require texture coordinates.

- Open Maps, and create new Lambert shader. Name it Rubble.
- Open the Split Polygon Tool options.
 - Uncheck Split only from edges and Use snapping points along edges.
 - Change Snapping tolerance to 0.0.

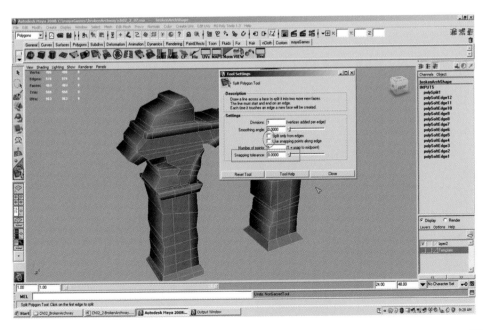

This will allow us to split faces anywhere along the surface.

- Select the edges inside the split faces, and delete them so we have a clean surface.

We'll come back and split those edges better later on.

- Continue rubbleizing a few more areas that look good to you.
- Select the faces of the modified areas, and apply the new shader (I colored mine red)
- Reset your Split Polygon tool (remember to set Snapping to 33).
- Clean up the mesh by splitting edges throughout the mesh.

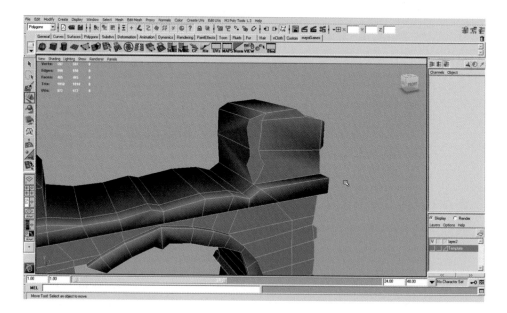

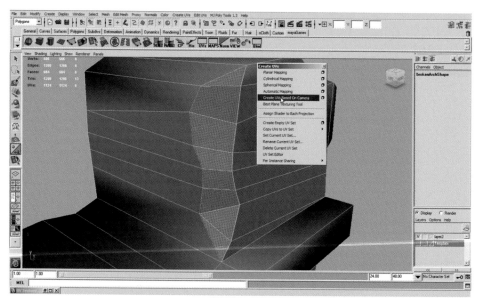

Moving Forward: Repairing the UV Shells

Happy, Happy, Joy, Joy

I'm satisfied at this stage to move on to the final texturing phase. After analyzing the changes I made, I decided it would be easier to redo the planar mapping throughout the mesh rather than playing "tweak-fest" for an hour or so. I used the same technique we learned earlier for selecting faces, then I selected the template face and applied the coordinate in the appropriate direction.

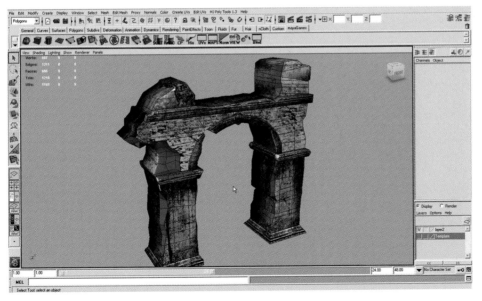

Quick Selecting Faces

Because the new faces require UVs, they are now all over the UV editor. But there is a trick we can do to clean them from our workplace.

- Open Maps, and right-select on the red rubbleized shader.
- To the right you will find Select Objects with Material.

Now all the red shaded chunks will be highlighted.

- In the UV editor, right-select UVs, and drag over and move to the left panel.

Wait! Notice the UVs seem to be connected to the wall faces? That's true, and the usual Cut and Move technique is grueling and time consuming. Fortunately, I have a secret in my bag of tricks that will save oodles of time.

 TRICK: *By selecting a face and using the Flip selection in the UV editor, you can quickly cut and isolate a face instead of using the more tedious method of selecting the UV edges, cutting the UVs, and selecting the shell. Just be sure to hit Flip again to return the UV back to its correct direction.*

With the faces selected, do the following:

- Go to Polygons/Flip (doesn't matter if it's horizontal or vertical).
- Flip the faces.
- Then select Flip again to flip them back to their original direction.
- Now right-select UVs, and slide to the right panel.

Does this method work better? That's because Maya did the cutting for you automatically when it flipped the faces. Now you can concentrate on redoing the wall face UV coordinates.

Using Camera Projected UV Mapping

Another favorite of mine is the camera projection. It allows me to quickly get just the right angle for a map that will have the least amount of distortion. Because the rubble is basic rock, you will never notice any stretching as long as your angle is within reason.

- Select the faces of one crack, and hit the F key.
- Move the camera to a position that can "see" all of the faces clearly.
- Select Create UVs/Create UVs based on Camera.
- Open the UV editor.
- See the cleanly mapped crack; now select its UVs and move to the right (don't scale it).

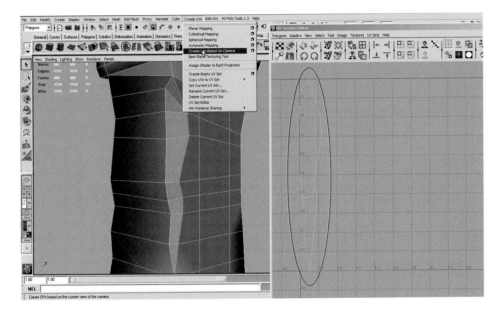

Do the same for all of the cracks, if they are difficult shapes that you can't get into one camera view, then break up the maps and we can sew them together later.

Organizing All of the Cracks

Now with all the cracks mapped and over to the side, we can scale them all equally at the same time. There is an issue regarding what is known as tensile density and the use of checkerboard maps, but we are not going to concern ourselves with that for rubble right now. More on tensile density issues later.

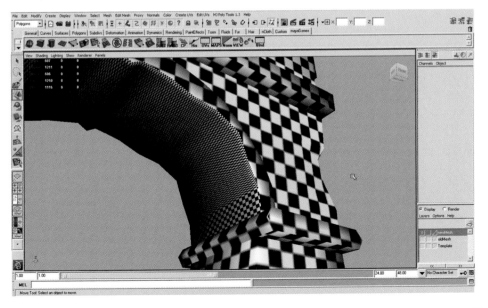

Finishing the UV Layout

There is no need to separate these UVs from being overlapped right now. We are going to create a duplicate model and separate the UVs properly in a moment. For now, focus on getting all of the faces mapped with a texture and without stretching whenever possible.

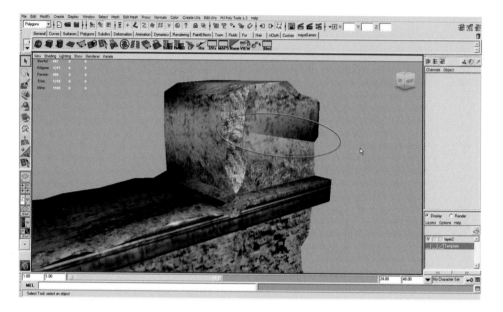

Now the maps have been corrected on our wall. It's time to end this lesson and move onto a new project, but I will show you how to take this model even further in Chapter 11, Texture Mapping Techniques (Technique 9: Transfer Maps), where I will demonstrate a technique known as transfer maps. The transfer maps technique will allow us to use the template image as a starting point for our final texture map.

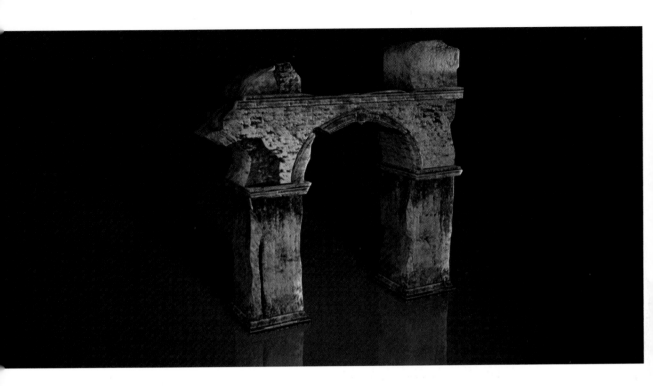

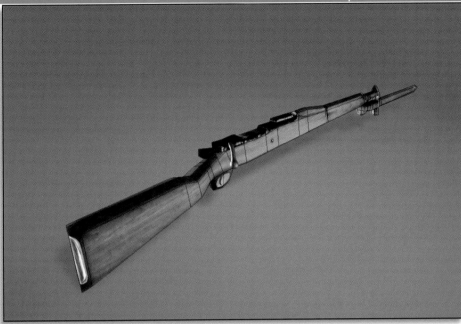

The Springfield Rifle

What We'll Learn

The Springfield rifle was the staple weapon used by the American doughboy soldier during World War I. In this next lesson, we are going to create a low-poly model of this weapon, then we will create a normal map to simulate a high-poly version. We'll also discuss level of detail (LOD) regarding mesh design along with mip mapping, which is the LOD of texture maps.

What Is LOD, and How Do I Determine Poly Count?

LOD (Level of Detail), refers to the mesh poly count. Mip Mapping refers to the texture map size. Both are equally important toward determining today's game assets and rely on many factors, most importantly that of the asset model and it's proximity to the camera view. Objects closer to camera should be of higher resolution in both polygon count as well as texture map size. Below are a few examples of mesh LOD's:

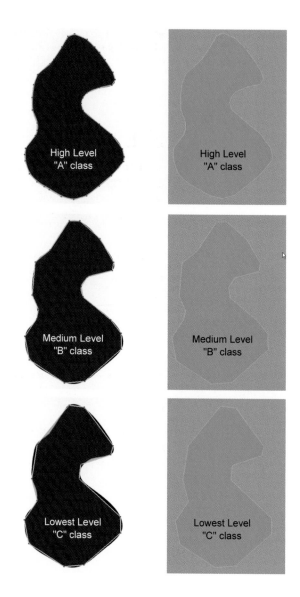

Knowing Your A's, B's, and C's

"A" level models, also referred to as "Hero" models, are the highest in poly detail and quality. Although it depends on the object, most assets will fall in the 3,000 to 10,000 poly range on average. Characters obviously make up the higher end of that range, and some game studios may allow modelers to reach as high as 20,000 polys for a character. More than 20 K isn't necessary, because an experienced modeler can create just about anything of high quality and detail within that range.

On the lower end are "C" level models. These tend to have the absolute minimum number of polys required to create an object effectively. A C-level model may have around 200 to 300

polys or triangles depending on the studio's standards and is usually reserved for props and objects that populate an environment. Our Springfield rifle lesson will focus on the C-class low poly, which you can further detail to a higher poly once you understand the process more clearly.

Hitting the Highs and Lows Is Key

The easiest way to determine how and where to place vertices is to follow the objects extremities. Placing verts at the high and low parts of the structure will ensure the basic "cage" is formed. We also call this the "proxy" model, and sometimes a level designer will have already modeled it to establish size and scale. Cages or proxies can also become useful later in the game level development as collision objects.

The three examples shown are good representations of a shape that was modeled from a low, medium, and high poly. The high poly was imported directly as an Illustrator Bezier curve path, a technique we'll learn later in the book.

They'll Let You Know

Most studios will have already established their processes and guidelines and will tell you what the target poly count should be for each asset. The best way to start any model, however, is always keep the count very low and build up as you progress.

We will begin this project as an image-based model and build up to a low-poly box model. This lesson focuses on creating a convincing high-quality but low-poly C-class model with a Photoshop-generated normal map that will make it look more detailed in quality and poly count than it is.

Getting Started

- Create a new project folder.
- Name it Ch04_springfieldRifle.
- Remember to set the project folder.
- Copy and paste the template map rifle_Lowpoly.tif to the project's sourceimages folder.
- Create a front template only (Z axis).
- Create a new template shader, and load the rifle map.

You'll notice on our template map that I created both the rifle image and a solid red image. The red image is a block version of the rifle in its lowest form possible to still represent the rifle as a C-class asset model. Using the same image-based modeling (IBM) techniques, we will rough out the shape and build up from there. In this lesson, we will create the low-poly version, duplicate it, and modify it into a high-poly asset to be used for an A-class model and also for creating the realistic normal maps.

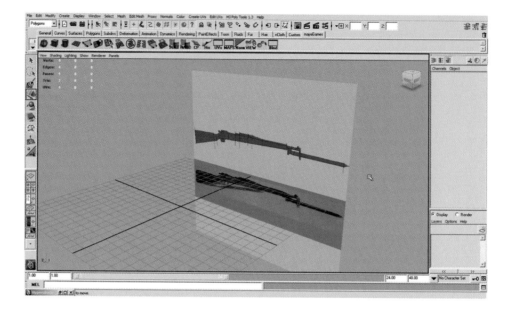

Step 1: Begin Modeling

- From the Front Orthographic view (Z axis), begin with the Create Polygon tool.
- I created four shapes that I will now combine and merge vertices.
- Next I split vertices, then I cleaned up by moving all vertices to their grid positions.

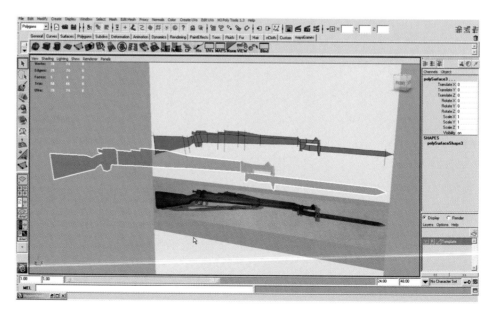

The final mesh came in under 100 polys. We are now ready to add some dimension by extruding and adjusting verts.

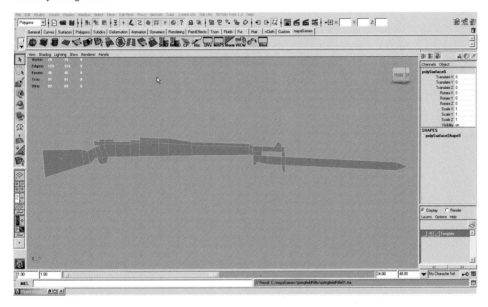

Adding Dimension

This part may take a few minutes. By experimenting you will learn several unique ways to thicken the rifle without necessarily adding more polys.

• Select the mesh, and extrude the faces.

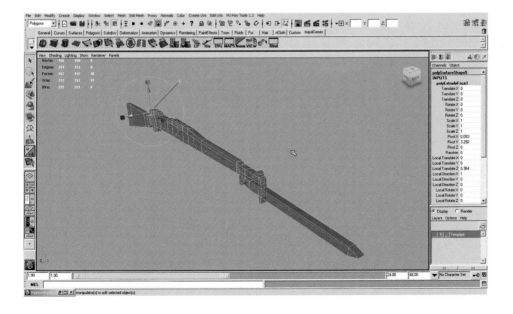

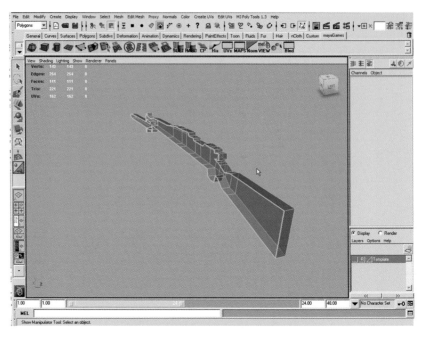

- Delete the back faces completely. We are going to mirror the front faces *after* we adjust them.

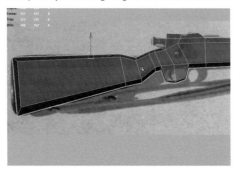

- Select vertices or edges, and move them to create a beveled edge to the geometry. Don't be concerned about the thickness or thinness of the mesh. We will focus on the girth of the rifle after we mirror the geometry.

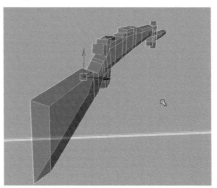

Mirroring the Geometry

- Mirror the geometry in the –Z axis.
- Select vertices down the middle and merge.

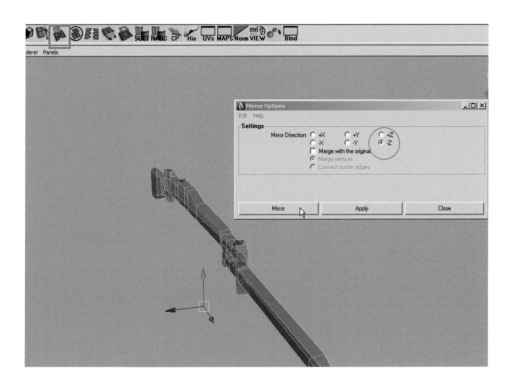

Using Deformers to Quickly Shape Objects

There are several types of deformers that allow us to quickly shape a mesh in ways that would be too time consuming or impossible to do otherwise. To quickly taper the gunstock, we will use a Lattice Deformer.

- Change modes from Polygon to Animation.
- Make sure your rifle is in Object (green outline) mode.
- Go to the Create Deformers/Lattice options box.
- Make values of 2 in the X, Y, and Z.

75

This will make a simple lattice box with only two lattice points, allowing a triangular shaping.

- Right-click on the lattice, and select Lattice points.
- Drag over the four points at the front of the rifle, and scale in the blue box (Z axis). This will taper the front of the rifle down.

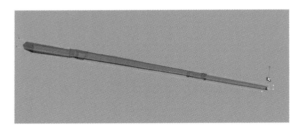

When you have the shape the way you want it, delete history. This will remove the lattice and allow further modifying.

Applying Texture for Inspecting the Mesh

- Apply the Template map to your rifle using a planar map (Z axis).
- Remember to shift + select the template to ensure correct scale of the UV set.
- The new model is now: 223 faces/444 triangles/221 vertices.

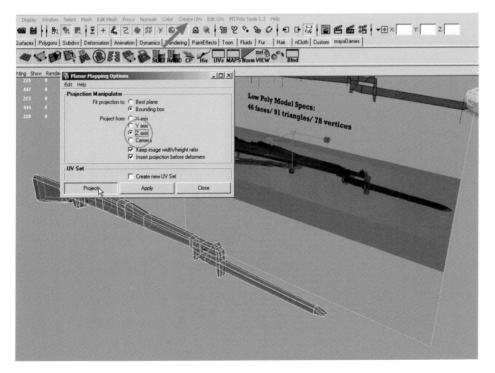

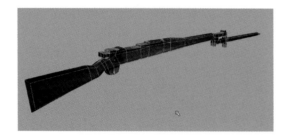

Finishing the Low-Poly Model

Now take time to go over each area, such as the bayonet thickness and bolt action, for final finessing.

- To create the bolt, create a poly sphere.
- Set the Inputs to Subdivision Axis 8, Subdivision height 6.
- Remove the top and bottom faces.
- Replace them with the Fill Hole tool.
- Extrude the top face, and do 1 edge loop split.
- Reshape into the correct shape for the bolt, and fit it into place

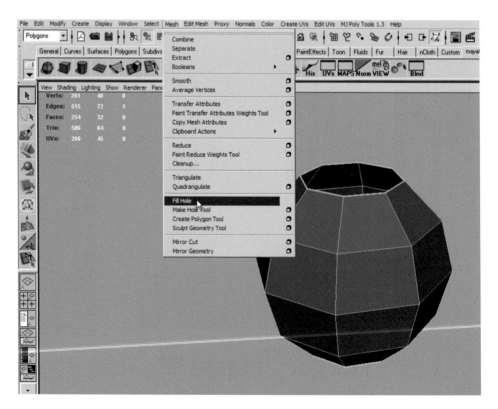

Using Your Judgment

You have probably noticed that my instructions are becoming more vague and generalized. You should be feeling comfortable with Maya's tools and techniques by now, so there is no need for me to be too specific. Much of what you do with modeling will take a good eye and much practice.

Practice Makes Perfect

I have also learned over the years that no two models are the same. Each has its own unique challenges that need to be troubleshot. But I have found that when you do a model over again, the second or third time it becomes easier and improves greatly. My advice is to recreate this

rifle several times. Each time you will find better and more efficient ways to split the faces and make it more realistic than before using the same number of polygons.

Our final mesh has come out rather well and remains an average of just 280 polys.

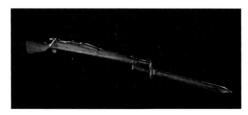

Adding Further Details

We are ready to lay out the final UV maps for texturing. If you would like to have a higher-poly model, now would be a good time to add more details such as adding more edges to the rifle for a smoother appearance close up, detailing out the bolt action, and opening up the trigger guard.

Step 2: Applying UVs to the Finished Rifle

The next step will be to apply better mapping coordinates to the rifle. At this point, you can use the Transfer Map technique effectively, as we did with the earlier Broken Archway model. For this model, however, I would like to show you how to use the automatic mapping coordinates effectively. We will let Maya do the basic work of laying out the base UV set, then we will clean up each section using a variety of tools in the UV editor. This lesson will familiarize you with the many options you have available to work quickly and efficiently.

The UV Editor Window

The UV editor features a grid of four panels and a series of menus. The top tool shelf icons represent many of the same, mostly used tools found in the Polygons drop-down menu. For now, we will focus on the following tools:

- Flip
- Rotate
- Unfold
- Layout
- Cut UV Edges
- Sew UV Edges
- Move and Sew Edges
- UV Snapshot
- Select Shell
- Display Image

Preparing the Rifle UV Layout

- Start by selecting the rifle.
- Go to create the UV/Automatic Mapping options box.
- Take a look at the option default settings:
 1. Planes are the planar maps and how many different directions they will project from.
 2. You have a choice for fewer pieces or less distortion. Keep fewer pieces selected.
 3. Shell Layout into Square will organize our UV shells into the upper right 0,1 square.
- Select Project.

- Open the UV editor window.
- Right-click and select UVs.
- Drag over all of the rifle uvs.
- Press the F key to frame and maximize the view.

You will notice the rifle has opened into many UV maps, some good and others in very small pieces. Because this is a symmetrical object, we can delete half of the rifle and save much time focusing on just one side.

• Select half of the rifle faces from the side Ortho view panel and delete.

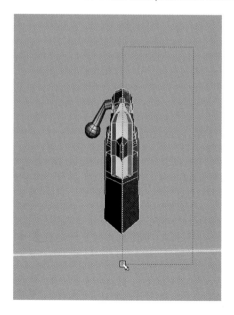

Now we can begin sewing together the UVs.

- Right-click and select Edges.
- Select an edge on the rifle stock, and notice where the connecting UV face is.
- Select the Move and Set UV button.
- The face snaps to the stock handle.

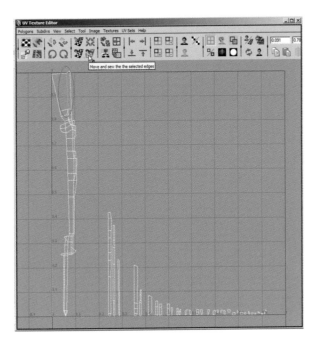

The Good, Bad, and Ugly of the Move and Sew Tool

- The Good: You can attach UV faces and rebuild quickly.
- The Bad: Some faces overlap, which is not acceptable, especially for normal mapping.
- The Ugly: Just moving a few edges out of the way will distort and skew the final results.

What to Do?

Welcome to the headaches of UV layout. It actually can be an art form to lay out good UVs. Chances are, if you like puzzles, then this is the job for you! I have seen many modelers just automatically map and leave the headache up to the texture artists—not very nice to do. So let me show you a few workarounds and tricks that will make layout a little less grueling (just a little).

Separating the Rifle into Smaller Pieces

- Z undo until the handle reverts back to the state it was in before we moved the faces earlier.
- Break up the handle, barrel, bayonet, and so on.
- Select the faces of the handle, and hit the Flip button.
- Hit the Flip button again.

What we just did was cut the UV in one easy step rather than use the Cut UV tool, which then requires us to select the shell and move it. Now we can select the uvs and slide them over for the moment.

- Do this to various sections until the main rifle stock is dissected, similar to the one in the diagram.
- You may find that the UVs are easier to work with when they are horizontal. Select the Rotate button twice to do this.

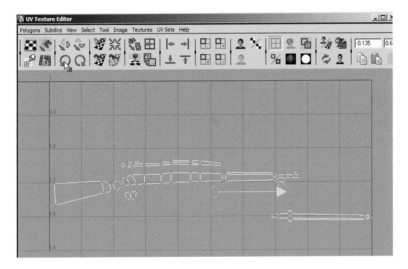

- Create a new shader, and apply the checkerMap.tif to it.
- Apply the checker shader to the rifle.
- Now use the Move and Sew Tool to start reassembling the UV layout.
- Watch how the checkers begin to work out or distort.

This is a challenging object, but it is worth spending the time you need to get a better understanding of how the UV tools work. This lesson will train you for the small UV fixes you will encounter on most modeling projects.

After a bit of trial and error fitting edges together, I have arrived at a fairly clean layout. Keep in mind, you will rarely get a *perfect* UV layout. There will tend to be some distortion. The trick is to hide the distortion as much as possible in either hidden corners or with dark texture color such as black metal.

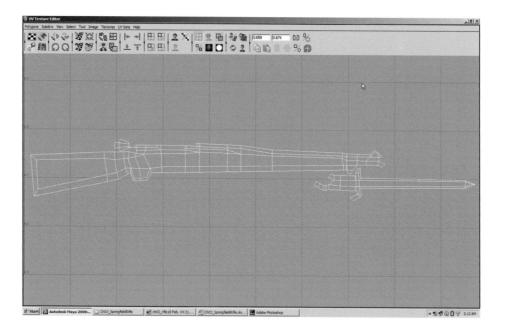

You can now break the rifle into more unified chunks and distribute them over the entire map to get better resolution and utilize more texture "real estate." I will do that now by using the Flip UV tool to follow the same techniques as before. You can see just how little texture space was being used from the rifle in its one-piece state.

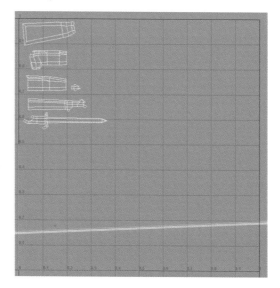

At this time we'll need to mirror the geometry for the second side of the rifle and move our UVs over (and flip them too).

Mirroring the Rifle Geometry

- Select the rifle.
- Go to the Mesh/Mirror Geometry options box.
- Make sure Merge with the original is unchecked.
- Set the mirror direction to the correct position, which you can check the bottom left corner of your viewport to see what the icon compass is reading.
- Choose faces, and select the faces of the new half of the rifle.

Fixing the UV Map

- Open the UV editor window, and you will see the UV set selected.
- Click the Flip UVs tool.
- Right-select UVs, and drag over all of the UVs in the editor.
- Move these to the right of the existing UV from the original rifle half.

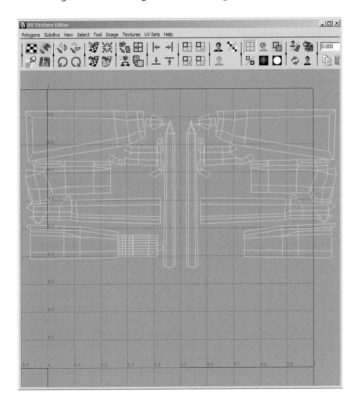

Now comes the most crucial part of the UV layout. We begin to organize and optimize the layout, sewing together similar sides to clean up the map as much as possible. It is not imperative that we do this, but creating clean UV sets is an art and the correct method is to sew similar edges together.

Using the Move and Sew Tool

- Select the edges of one UV side.
- The joining side will highlight automatically, indicating joining edges.

We are now ready to move on to the next step of generating a UV snapshot and painting a Block-Out texture map.

Step 3: Blocking Out for Texturing

Base Texture Map

I call this technique "blocking out" because I use basic color tones to represent different parts of a map. For example, the rifle stock will be a medium brown, the barrel will be deep blue, and so on. This makes it easier in the texture stage to immediately identify each part. It also can lend a base color onto which you can paint.

Creating a UV Snapshot

- Select the rifle mesh.
- Open the UV editor window.
- Select Polygons/UV Snapshot.
- Browse to your project folder. I place my snapshots in the Images folder.
- Make sure the setting is 1024 × 1024.
- Select OK.
- The snapshot is now waiting in your folder to be opened in Photoshop.

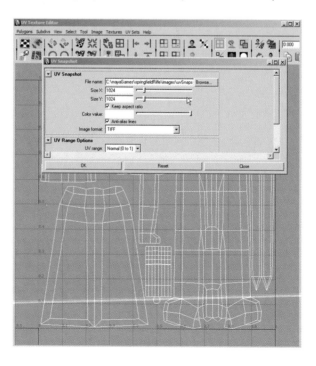

Creating the Block-Out Map

I like to create a quick color map that I call a "block-out" texture. It is a simple 2D coloring that places a base color on the appropriate faces of a mesh. It comes in handy during productions because textures can take a few days to be painted at times and also may be scheduled out a few weeks. The block-out makes objects more appealing rather than having the mesh display in game as a checkered shader or flat gray. It also can show immediately where there may have been a UV mistake, especially on small faces.

- In Photoshop, open outUV.tif file.
- Create a new layer, and place it under the snapshot layer.
- Change the layer setting to Screen; this will make the black background transparent.
- Apply a brown base color to the layer below the snapshot.
- Carefully begin to add different colors to the base for the barrel (dark blue) and bayonet (silver).
- Save your PSD file in layers.
- Save a copy file as a TIFF file, keeping the outline visible.

If you keep the outline on, any mistakes or stretched UVs will be easier to recognize.

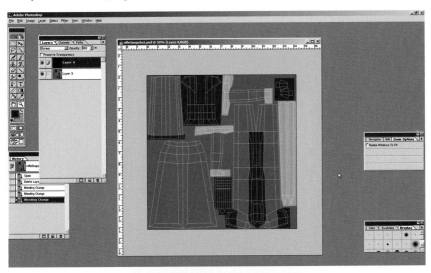

Adding Detail and Realism to the Texture Map

With the initial base color in place and the mapping checked, I will begin to add realism to the texture map. I'll start by gathering a few images of metal and wood similar to that of the rifle. Here are the few images/photos I will be working with:

There is no need to make these seamless, because they are being overlaid to each unique UV set and not tiling. I will paint out any seams later. The basic idea is to begin overlaying photos of wood and metal textures or hand-painting the details depending on art style and your skill level. For a photo realistic gunstock, I am going to use a photo rather than paint the grain by hand.

I'll cut up parts from the template image photo and add them as an overlay to enhance the shadows and highlights of the rifle texture.

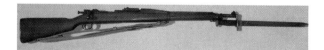

Here is the finished parted out image map before it is combined with my block-out map.

And here is the final composite texture after retouching and finessing it in Photoshop.

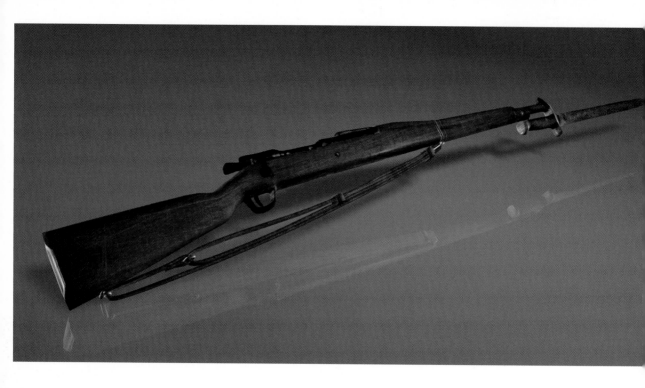

Fake Camera Projection Modeling

Camera projection is a process used mainly in the film industry. It is a technique that allows models to be made over a background plate (video still or photograph). The 3D elements are then mapped with background image projected onto them to create a faux (fake) 3D set design, both quickly and rather easily.

The main difficulty of the process is getting the perspective in your 3D camera to match that of the camera used in the photography. This can be a challenge, even when you know the focal settings that were used. Trying to match a hand-drawn conceptual image, therefore, is even more difficult and poses even more challenges because the artists may not have used proper perspective points.

So why demonstrate this modeling technique? Simple. In my experience in the gaming environment, a modeler cannot always rely on being supplied orthographic drawings (top, side, and front blueprint sketches). Even with the extra time spent setting up the camera, building the models, and later readjusting the model, three things will become apparent. First, this process will still be faster than the conventional method of eyeballing the concept art. Second, the ability to match the original will be much more accurate. And third, the concept art can be used as a base texture, making it easier for you to create texture maps.

Why Fake the Camera Projection?

Getting the proper angle and focal length can be a difficult task, especially when you have to get a model out quickly to a waiting development team. So here is another "cheat" method that still works just as well and gets great results.

The Reality Is...

In a perfect world, a modeler would be supplied with a three-sided orthographic view of every model, building, or vehicle to aid in precise modeling. But many times in a real-world setting, projects have rushed deadlines or there is a shortage of concept artists on staff. So we need to get real creative, real quick. Over the years of my experience in trying to "hit" the comp art spot on, I have devised a technique whereby I model from a perspective image then "correct" the mesh once the initial shape is roughed out. I can then also generate a new image map from which the texture artists can continue to add more and better detail.

 TIP: *Rather than a linear start-to-finish workflow from concept to model to texture map, I recommend a back-and-forth flow of an asset. For example, the concept department provides a rough sketch or color comp from which the modeling department can build out a mesh quickly. The staff lays out the mesh with clean UV maps (planar) and sends it back to the comp or texture department for a more detailed composition. At this time, the modeling department can enhance or rebuild the mesh to more detailed and exacting specs. Once the model is completed and only the texturing remains to be done, it is then passed back to the texture department for final detailing and normal map creation.*

Step 1: Getting Started

Preparing the Template Image

I had my good friend Andy Hoyos, a professional concept artist working in games for nearly a decade, create this art to the same standards as would be necessary if it were to be submitted

to the modeling department at a major game studio. Of course, one could eyeball the buildings and get a good representation of the original concept. But once again I am going to show you some methods and techniques for achieving a close model without much guessing or redo.

Because this is an artistic rendering, it will have some flaws, such as perspective that is slightly off. To help in modeling, I drew my horizon line (in green) and two point perspective lines (in red).

To further illustrate the modeling we will generate in this lesson, I also created a blocked-out template to show the basic primitive shapes we will be constructing.

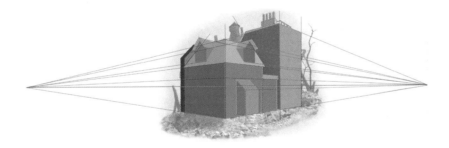

Finally, this exploded view shows all of the individual shapes.

Starting the Scene Setup File

To make this lesson easier and to avoid complications, I have provided a scene file complete with proper camera setup and template placement ready to begin modeling. You can even save this file and use it for future modeling projects by simply swapping out the template image. Begin by opening mayaGames/Ch05_DestroyedBuilding/scenes/startScene.ma.

Step 2: Setting up the Camera

The Camera Setup Process

After you set up your initial modeling template with the concept art applied, be sure to line the image horizon line with the grid level. The next step is to set up a camera and lock its aim target to the grid base at 0/0. This will ensure the camera will always look at the proper horizon line, and it's why we created a horizon line on our template image too.

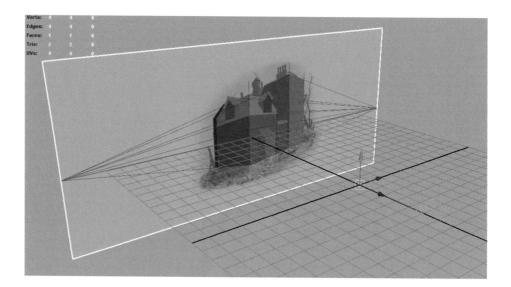

Currently, anytime you wish to view an object's attributes (containing all information regarding that asset), the window defaults to embed in the channel controls on the right panel. It can become frustrating to keep changing this feature while working; also, having the Att Ed on a separate window allows me to minimize, so I can continue working yet view it anytime I wish.

- Select Create > Cameras > Camera and Aim.
- "X" snap (grid snap) the Aim to the grid 0/0 position.
- Move only the Z or Y axis of the camera to position it.
- Once positioned, highlight all channels of the modelCam, and right-click/select Lock Selected from the drop-down menu. This will ensure the camera is not accidentally moved during modeling.
- If desired, Lock the template plane to prevent movement.

Step 3: Begin Modeling

Creating a Poly Cube

You will create a primitive cube; translate, scale, and rotate it into position; then extrude faces for much of the process. You can use multiple cubes for each building if you wish; however, in this lesson I will demonstrate how to create the building by using one extruded mesh.

- Select Create > Polygon Primitives > Cube.
- Press insert. Hold the V key, and snap pivot to the lower cube corner.
- Press insert again to reset the manipulator properly.
- Translate the cube into the lower corner of the blue building.

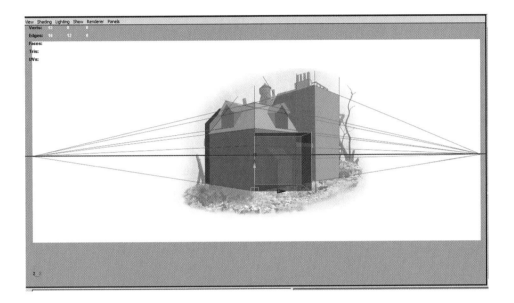

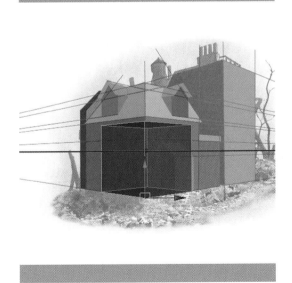

- Rotate and scale the cube accordingly so it occupies the complete lower section of the blue building.

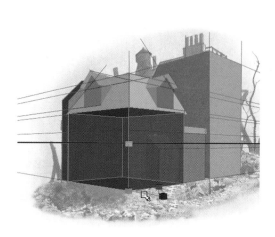

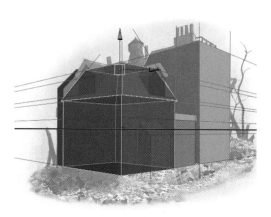

Extruding the Roof Faces

Now we will begin the process of extruding faces. You may find it helpful to split your viewport panel into two sections, one displaying the Persp view and the other displaying the modelCam.

- Select the top face of the cube.
- Select the Extrude tool from your custom shelf.
- Click on any square on the extrude manipulator to activate the blue center scale.
- Scale the underside of the roof. Press G (redo command) and extrude the top of the roof.
- Use the scale manipulator to scale in the roofline.

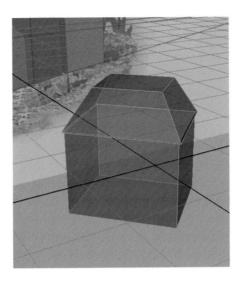

Creating the Tool Shed

Continue the same process throughout the lesson. I will not go into detail for every step, only for the parts that require explanation. Let the images guide you.

- After extruding and scaling the shed face, move the face down using the green arrow.

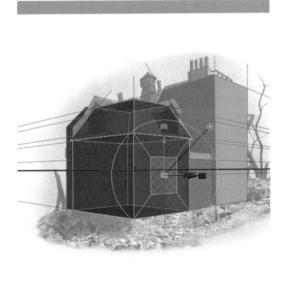

- Finish the shed form. Do not be concerned if your mesh is not exactly the same as the image in terms of proportion.

99

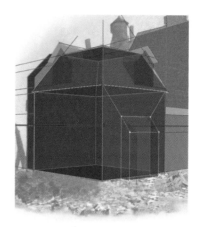

- Extrude the side wall to create the lower and upper sections of the brown building.

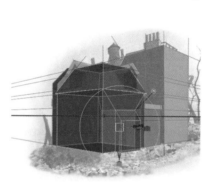

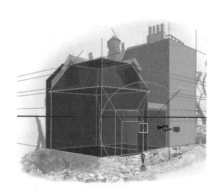

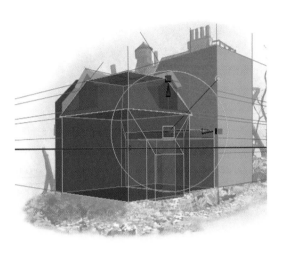

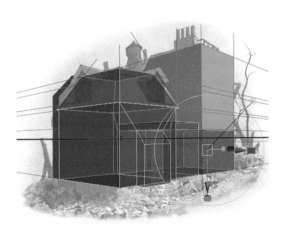

The pink building will have two sections because you are extruding from the lower brown building wall. We are going to clean up all of our unnecessary edges later.

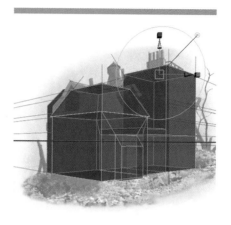

- One final extrude brings the front wall out to the proper distance, finishing the pink building.

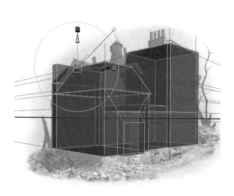

The Final Wall

One more object is required using the extrude technique. The top angle might be difficult to scale from the modelCam, so use the perspective view if necessary to get the angle to match.

Fixing Other Walls

Now is a good time to save your model and to fix any wall shapes to match the concept image more closely that might have been difficult from the modelCam camera.

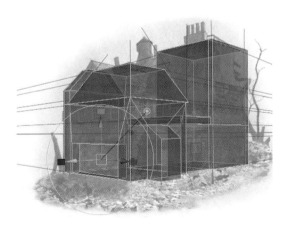

Creating the Garage Doorway

One final extrude is needed to create the garage opening.

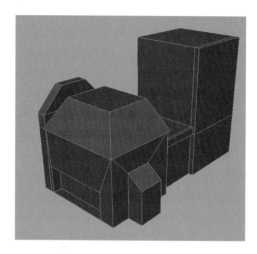

Reviewing Your Progress

It's also a good time to apply a new shader without transparency to see your model more clearly. I'm sure you'll agree, this is an easy and fun way to model. The coolest part is that we can even use the concept art as a base texture map if desired.

Cleaning up the Garage Floor

Delete two faces that are no longer required.

- Select the face on the garage door floor and delete.
- Select the face on the entire underside of the building and delete it also.

Step 4: Building the Windows

To finish our model, we will build a simple rooftop window. You can complete the same process as before using the modelCam to model within. I am going to quickly block out the mesh by eye and rescale it accordingly in the camera later.

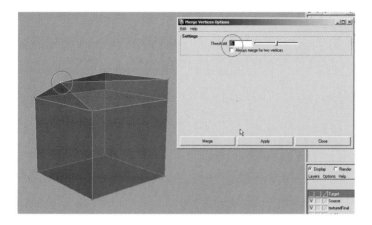

Start again with a primitive cube. Split the face once horizontally, then merge the top front and back vertices to create a quick angled roof.

- Create a cube shape.
- Edit Mesh > Insert Edge Loop Tool. Adjust the height.
- Merge the two front vertices and two back vertices to create the top angle.

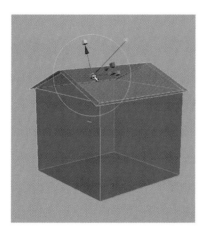

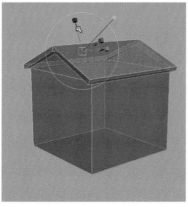

Extruding the Roof

Follow the same steps as before. Select both roof faces, and extrude shapes accordingly.

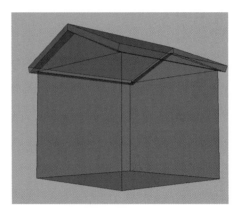

Look at the final window shape before cutting the face angle.

Using the Cut Face Tool

Maya's Cut Face tool is a fun one to use. It still amazes me when I consider how powerfully it can slice through any mesh or any complexity and from any viewing angle. Be careful with this one, or you may cut yourself!

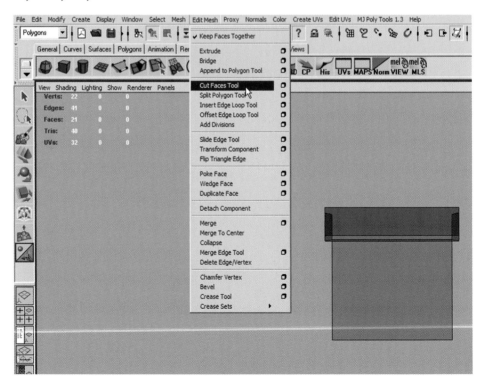

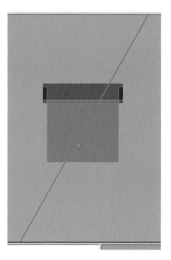

Switch to a side viewport to perform this operation correctly. I also isolated the object so I can focus on the window without the building interrupting my view.

• Edit Mesh > Cut Faces tool.
• The cursor will become an arrow that rotates visually to a desired angle.
• Holding the shift key will constrain the adjustment to 45- and 90-degree increments.

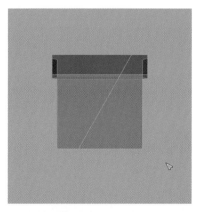

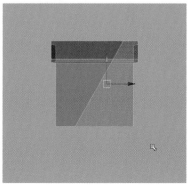

Select the unwanted faces and delete them.

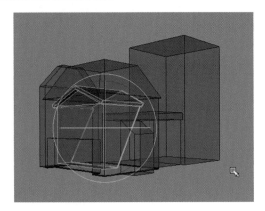

Fitting the Windows in Place

Now we will move, rotate, and scale the new window shape within the modelCam to position them to the building. This part can be challenging, so it is recommended that you work with both viewports simultaneously, as before.

Scale One Window First

It's important to get one window in place and scaled until you are pleased before duplicating it for the second. Because this is artwork, chances are the windows won't match the image exactly in scale; more important obviously is that both windows *are* the same shape and scale.

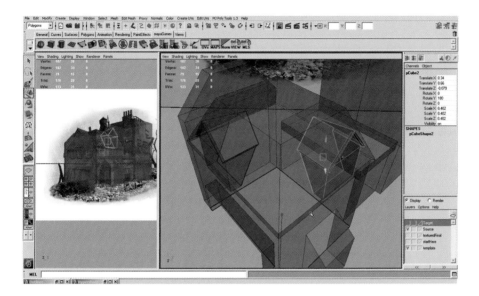

Getting the windows in place may take some time and patience. Stay with it, and make sure the bottom section is completely inside the roof properly.

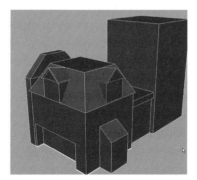

Viewing Your Progress

Now it is time to shade the window shapes with the opaque shader. Take a moment to review your work, sit back, and take a break too. You've done well, young Jedi. Give yourself a high five!

Step 5: Projection Mapping the Mesh

Applying a Camera Projection UV

Okay, so you're not ready to call it quits for the lesson. Well, let's continue onto applying the concept image as our base texture image.

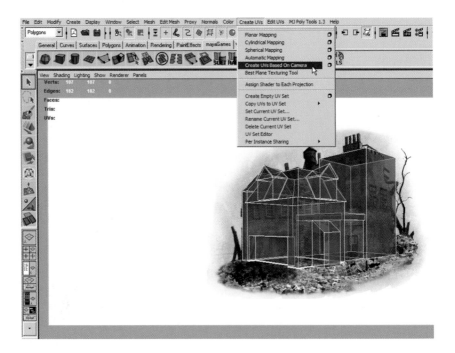

You may wish to reapply the transparent shader to the building before continuing.

- Select Create UVs > Create UVs based on Camera.
- Open the UV Texture Editor (UTE), and view the layout.

Fixing the UV Proportion

The first thing you will notice is that the UV layout is not exactly proportional; neither is the template map because it was an unusual size (done purposely). So let's make a few changes.

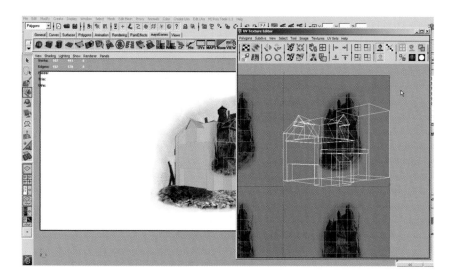

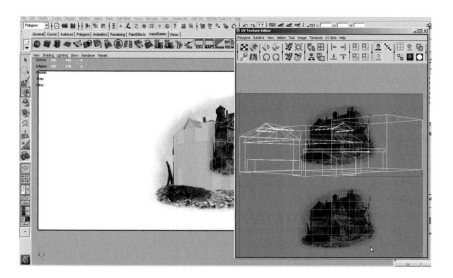

Changing the UV Image Ratio

In Maya you have two options. Either the UV editor will scale your image to fit a square format, or you can change the format ratio to fit the proportion of your image. The first option displays

your object UVs in scale, the second stretches them. Either way, we have some work (and a good eye) ahead of us.

- In the UV editor, select Image > Use Image ratio.
- Select the UVs and scale to fit best within the template image.

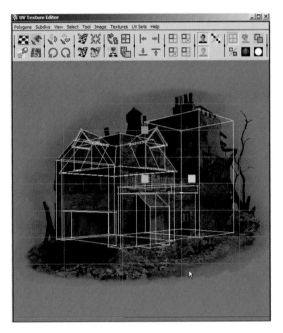

Taking It to the Next Level

With a little time and work detailing out the windows, doors, and broken rubble, you can achieve a film-quality model in no time. The "rubbleizing" techniques shown in Chapter 3, Broken Wall, would be a huge improvement toward "destroying" this building further.

Wrapping Up

Once you scale the UVs, you have the option to transfer the maps onto a duplicated building that has properly laid-out shells. You could also leave it as is if this model was for a background scene with minimal camera panning. Try creating a new camera and rotating the model slightly in all directions. You'll notice you can get away with a 15-degree rotation and pan in most directions.

Go ahead and add some lights. Maybe even play with a bump map just to see how far you can push this simple scene.

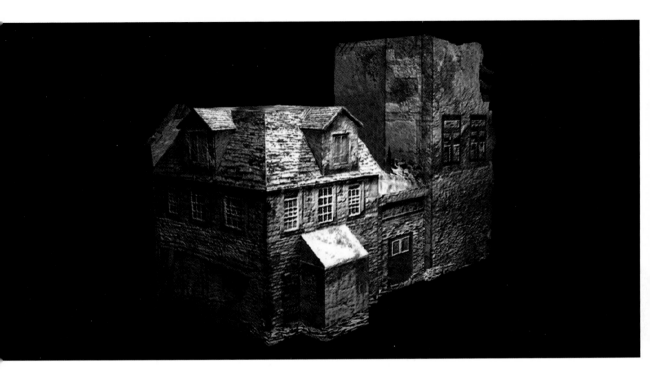

Here is the final rendered image. Please note that no special texture or UV maps were created to generate this render. It is simply the concept art projection mapped onto the building mesh.

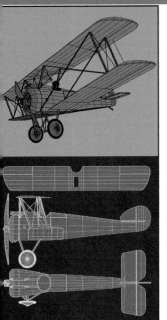

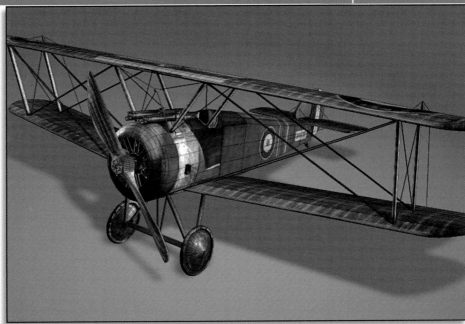

The Infamous Sopwith Camel

My Thoughts on the Sopwith Camel Biplane Project

As I began doing research on the Sopwith Camel biplane, I found that original factory blueprints and plans were next to impossible to acquire. Many scaled model plans are available, but they all vary to some degree, so finding exact plans for the Sopwith was challenging.

What resulted from my extensive research was a great deal of in-depth knowledge behind this aircraft, which became infamous when, on April 21, 1918, ace pilot Roy Brown shot down the most feared flying ace of World War I, Baron Manfred von Richthofen, notoriously "The Red Baron."

The templates I have provided for this project were corrected and modified each time a more exacting set of plans came before me. I cannot stress the importance of research and finding reference images before beginning work on any 3D model (or concept image, for that matter). But this one project made me go so far in depth in terms of research that I have become immersed in the history of the Sopwith, learning as much as I can about its past history, its

pilots, and, of course, its construction. I hope you find building this model as much fun as I found creating it for this book.

Before We Start

Breaking Down a Project into Manageable Pieces

The primary purpose of all lessons in this book is to teach you the tools and techniques of creating next-generation-quality 3D models with Autodesk's Maya and Mudbox, but making these lessons extremely interesting and fun was also important. So the process of building a complex model such as the Sopwith Camel biplane needs to be broken up into bite-size pieces to make it understandable and more manageable.

The Sopwith's 10 Primary Parts

- Tire
- Wing
- Fuselage
- Tail
- Rear wing
- Cockpit
- Machine gun
- Propeller
- Struts
- Wires and bars

So the plane is composed of 10 primary parts. Even more exciting is that each of these objects is symmetrical, meaning only half or in some cases one-quarter of the part requires modeling. Here is a rough layout of all the parts that make up this model.

Let's take the wing as an example. We have two wings, which are actually four half wings, so only one small mesh requires physical modeling, UV layout, and texturing. The rest of the process involves duplicating or mirroring the geometry.

That's about all there is to modeling this biplane. Easy huh? Well, not really. Although getting the basic shapes can be easy, modeling them so that they are historically accurate can be quite a challenge. I'm telling you this because your job as a modeler is to gather as much reference and research on your subject matter as you can before creating the first polygon. I spent over a week online and at several bookstores doing general research to find out as much as I possibly could before even thinking of modeling this plane. I know how to model; that's the easy part. But modeling this plane accurately had me at times screaming. No surviving blueprints are available for this great aircraft. I did manage to locate one company that could provide a set of historically accurate plans—for $5,000!

I also managed to build a stock Sopwith photo library, which now comprises more than 500 images from a variety of sources. Using the internet, libraries and even the Seattle Museum of Flight provided me with a wealth of imagery for this project and I highly recommend you do the same befor modeling and texturing a historically accurate project such as this biplane.

One More Thing before We Start

To make life easy, we will lay out the UVs for each of these objects before assembly. By laying out the UVs early, we save ourselves a great headache later on.

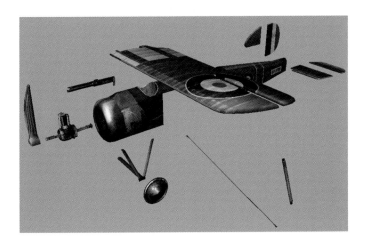

Review the Finished Scene First

Take a Peak before Modeling

I think you will enjoy the finished model: Ch06_SopwithCamel/scenes/planeComplete.ma. Much time and care went into every step of creating this plane, while attempting to keep the mesh and modeling techniques simple and easy to follow. Pay particular attention to how each part resides on its own layer, properly named, frozen transforms and pivot-snapped to the origin. Take a close look at how I laid out the UV map and, of course, the finished texture map painting.

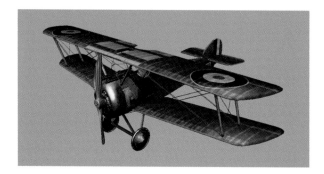

Getting Started

Begin by using the prepared template scene: Ch06_SopwithCamel/scenes/planeStart.ma. It has all the templates laid out in their proper positions, and all of the necessary layers have been set up according to each of the modeling steps.

The start scene has layers that have been prepared for all parts necessary.

Step 1: Creating the Tire

Creating the tire will be easy because we will let a primary torus do much of the work. Let's discuss level of detail (LOD) first. To make the tire look smooth and not the chiseled, old-generation type, we'll invest in polygons for this object; because the fuselage and wings require few polygons to achieve their shape, we have a surplus that we can utilize here. Let's start by creating a poly torus shape.

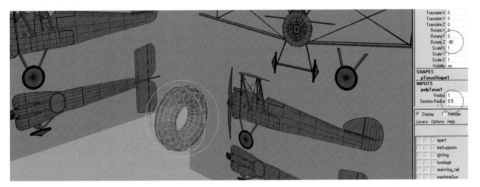

• Create > Polygon Primitive > Torus.
• Rotate −90 in the Z axis.

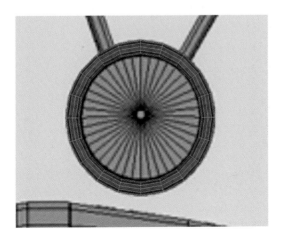

- In side view panel, set the INPUTS channel of the torus Section Radius to .1.
- Scale the torus shape to match the blueprint size as best as possible.

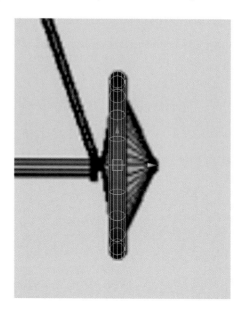

- In the front view, move the torus to line up with the front blueprint too.

Extruding the Hubcap

Here is an easy way to extrude the inner hubcap.

- Select > Select Edge Loop Tool > Double-click the arrow on the inner center edge.

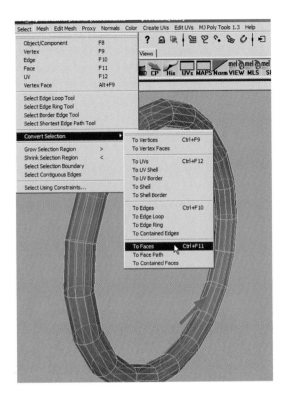

- Select > Convert Selection > To Faces.

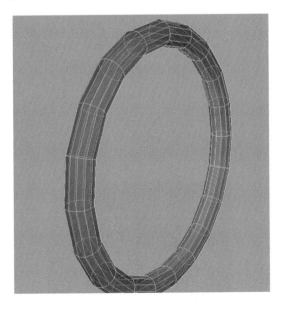

The faces on either side of the edge loop become highlighted.

- Extrude the faces inward (blue arrow) to the approximate diameter of the axle.
- Delete the faces while they are still selected, creating a hole on both sides.

Creating the Axle

- Select one edge of the front hole and Mesh > Fill Hole.
- Repeat for the inside hole.

- Select both outside and inside axel faces, and extrude outward in both directions.

- In the front view, select the vertices of both sides of the axel, and adjust them in the X axis to fit the blueprint.

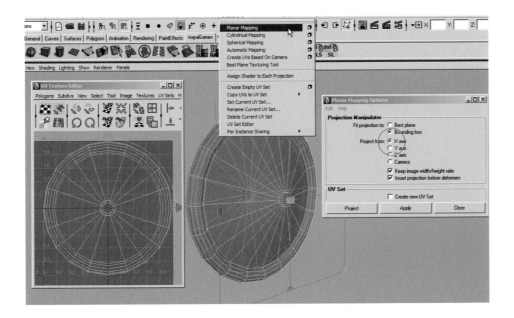

Applying the UV Set

We are finished with the tire model and will apply a simple planar map to the mesh.

- Create UVs > Planar Mapping Options > X axis.
- Project.
- Right-click on the tire layer channel, and drag-select Add Selected Objects.
- Turn the layer visibility off for now.

Step 2: Creating the Wing

Creating the wing is simple and fun. When using the Create Polygons tool, remember to use as few vertices as possible, and use the same vertice count on each side if you are intending to split the faces into equal sections.

Creating a Simple Polygon Shape

Modeling the wing from one unique shape is easier than trying to extrude a series of box shapes. Here is a simple and powerful workflow to help you achieve great results.

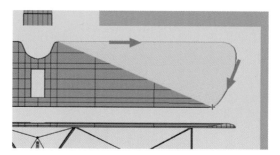

- Start in the top view.
- Mesh > Create Polygon tool.
- Beginning at the top row, follow the vertice edges in a clockwise direction.

Do not be concerned if some vertices are not in the exact placement. We will fix these later.

Once complete, we will begin to divide the mesh face using the Split Poly tool.

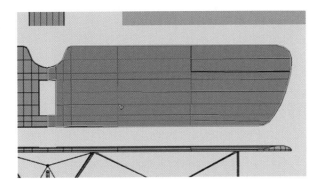

Follow the pattern, splitting the vertical rows first and the horizontal rows next. Again, do not be concerned if your edges are uneven.

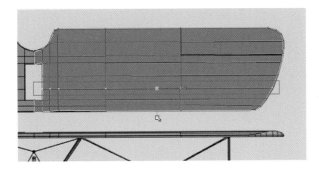

Fixing uneven edges is simple.

- Drag over an entire row of vertices (one row only).
- Use the Scale tool to even out the edge (in this case the green scale box).

Use this technique for the vertical and horizontal rows. Use alt + page to move arrows and thereby finesse the vertices one pixel at a time if necessary.

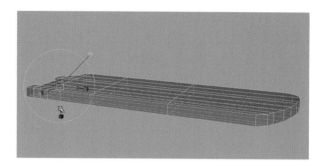

- Once completed, select the shape.
- Apply an extrude, and pull down to create the wing's thickness.

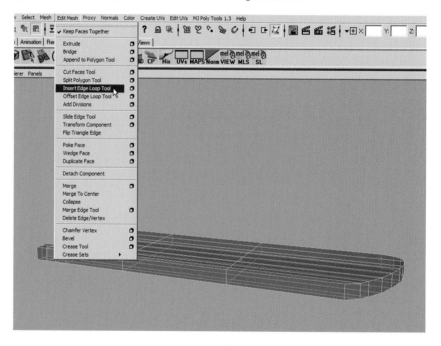

Because the top of the wing will have a slightly different profile, we need to split the wing's thickness in the middle.

- Edit Mesh > Insert the Edge Loop tool.

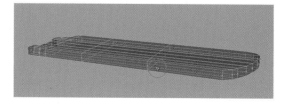

- Place the arrow on any of the vertical edges and click-drag.
- Release when you are happy with location of the highlighted edge.

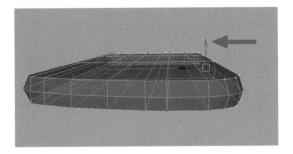

- Begin to define the bevel of the edge curves by selecting the top and bottom rows and moving into the wing slightly. Do this all the way around the outer wing shape.

Caution: *Do not bevel the inside wing area that will be mirrored later.*

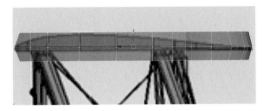

- Go to side view, and adjust the top row vertices to the pattern shape. The middle and bottom row should remain flat.

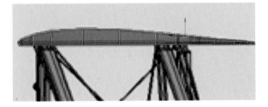

Here is the finished wing profile.

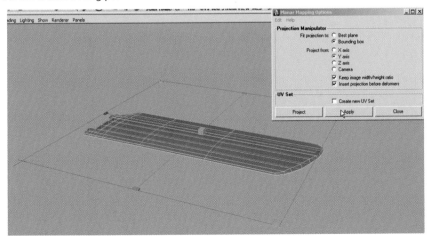

- Now is a good time to add UVs: Planar Mapping > Y axis.

Now we'll detach the aileron from the wing.

- Select the green faces in the upper right corner as shown.
- Mesh > Extract.

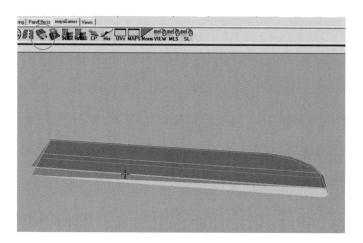

Repairing the Mesh Holes

- Hide the large wing by selecting the aileron and on the menu bar of the View panel.
- Show > Isolate Select > View Selected.
- Mesh > Append Polygon tool to repair the hole on one side. The purple arrows indicate which direction you will use to connect the edges.

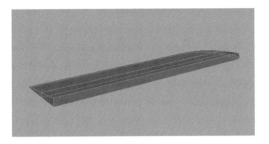

Here is the completed aileron with faces repaired.

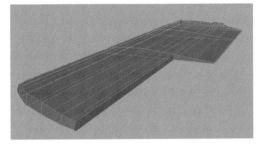

Here is the completed wing with faces repaired.

Here is the finished wing mesh. With both the wing and aileron selected:

• Right-click on the lgWing layer and Add Selected Objects.
• Now is a good time to Delete All History and save your project scene.

Step 3: Creating the Fuselage

As Easy as Tapering a Cube

Once again, this appears to be a complex shape to model, but I will show you an easy solution.

Removing the "Wing" Template

Recall those two stacked templates on the floor plane of our grid? Because we have complete the top wing model, we can Hide (H key) or delete the upper template to reveal the bottom template so we can view our fuselage in the proper direction for modeling.

Why Can't I Select the Template?

You cannot select the template because it has been locked into Render "R" mode. Click on the templates layer R until the box is empty. Now try selecting the image plane. Remember to click again once you're done to lock the other templates.

- So we'll start with a simple Cylinder shape.
- Rotate it 90 degrees in the X.

- From the top view, scale and size it to roughly fit the first section of the fuselage.

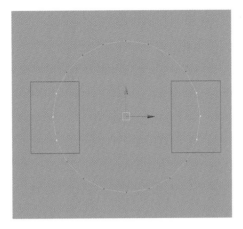

- The three vertices on the bottom and both sides will become flattened to quickly form the shape.

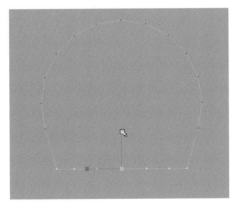

- Use the same procedure for selecting verts and scaling them flat.

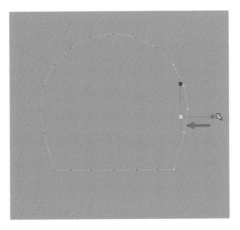

- Then select the three side vertices plus the bottom corner vertice, and scale in the X axis to flatten the wall.

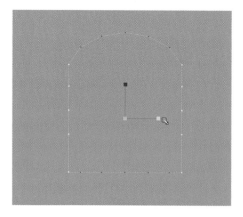

- Do the same for the second side, then adjust the shape evenly.

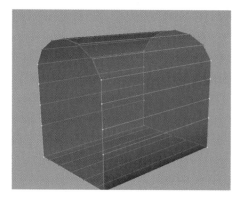

Here is the shape you should have before continuing.

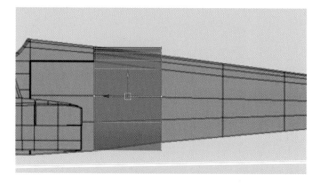

- Adjust the two side edge rows to line up with the blueprint.

- And pull out the back section to line up with the end of the tapered angle.

- Scale the back section too if necessary.

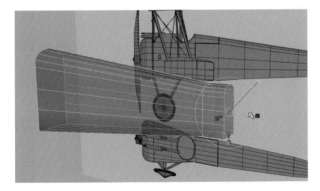

Select the back face and extrude once to finish off the end of the fuselage.

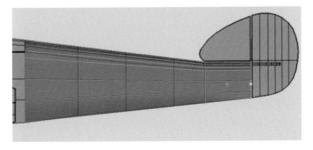

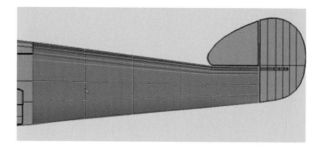

- Now add edge loop splits to the remaining sections as shown on the blueprint.

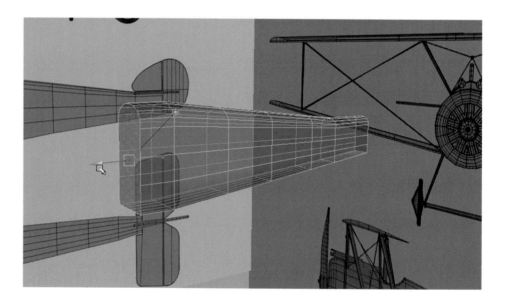

- Do another extrude, this time to the front section face.

- Move the front part up to the cockpit section as indicated, then just the bottom front row as necessary; the top section will be deleted, so don't bother to angle the edges.

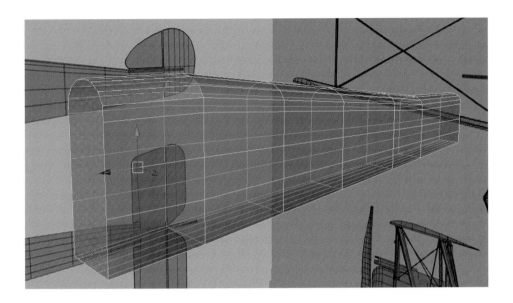

- Now select the faces that need to be removed from the front and top of the fuselage mesh and delete them.

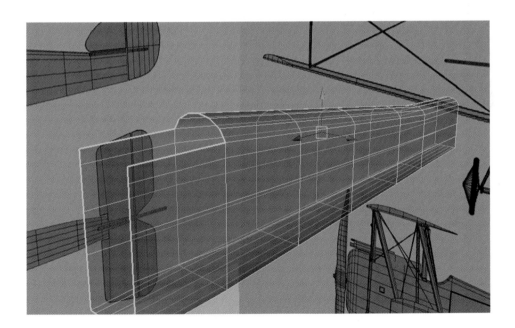

Yeah, but What about That Extra Row of Edges?

- Oh, right. Now select the row of edges on both sides of the fuselage and delete.

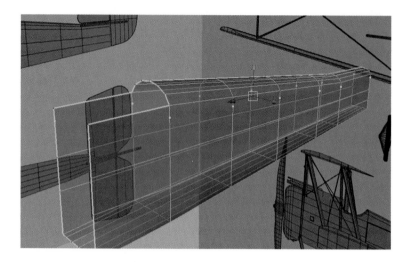

Just don't forget you have to also delete the remaining vertices that once connected the edges.

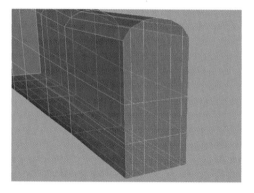

- Finally, split the polygon edges in the back of the fuselage to clean up the mesh.

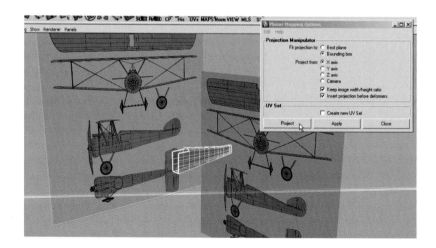

- Select the fuselage and the template mesh together.
- Apply Planar map from the X axis.

How easy was that?

Step 4: Creating the Rear Wing and Tail

Quick and Easy Repetition

Like the shampoo bottle says, "rinse and repeat." For the rear wing and tail sections, follow exactly the same process as you completed for the top wing earlier. So no real explanations are needed here.

Here are a few points to remember:

1. Try to keep the number of vertices equal on both sides of a symmetrical polygon shape.
2. Remember to apply planar UVs from the correct axis (you can always check the axis indicator in the lower left of the View panel to check direction).
3. Always delete All History during and especially when finished with a model section.
4. Add the mesh to the appropriate layer named rearWing_tail.
5. Save scene file.

Guess What? You're Halfway Done!

Great job. Now grab some tea or coffee and take a break. It's important when working in the computer industry as long as I have that you walk around periodically to give your legs, neck, and wrists a break. This can be a grueling industry, and *you will burn out quickly* if you don't allow some time for your body and mind to rest and refocus.

Defeating the Red Baron: A Brief History of the Sopwith Camel

The Sopwith Camel's Most Famous Victory

Controversy remains over whether Canadian ace pilot Roy Brown deserved to claim a kill or if it was allied ground fire that dealt the fatal blow toward downing one of the most feared pilots

ever, Manfred von Richthofen, also known as "The Red Baron." As the story goes, on the faithful day on April 21, 1918, Camel pilot Roy Brown had chased the Baron's triplane as it strayed behind "Wop" May, a fellow ace pilot with 13 victories himself. Brown came to May's aid and attempted to put off the Baron, which caused von Richthofen to stray too far over the Allied line. As he turned for home, he was fatally wounded by ground fire and crashed.

Step 5: Creating the Machine Gun

The Vickers machine gun has been simplified for this lesson because it will hardly be seen in a game unless used in a closeup cinematic shot. I simplified the modeling by extruding only the necessary parts and using photo reference in the texturing stage.

Simplifying Detail

The steps ahead are simple. I mostly used a box model technique, which you know how to do effectively, so my directions have been kept short for this lesson.

- Create a cylinder.
- Under INPUTS make it 8 sides, 0 caps.
- Rotate it 90 degrees in the X axis.

- Extrude the front and back face twice to create the outer rim.

- Extrude the front face once more, reducing it and moving it downward vertically to create the front muzzle.

- Be sure to use the blueprints for proper scale and placement of the shapes.

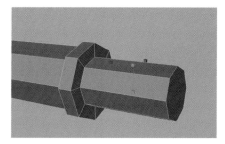

We will modify the back octagonal shape into a cube.

- Select the top three edges.
- Scale them in the Y axis.

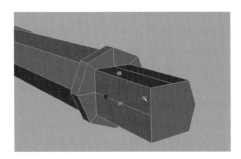

- Do the same for the bottom and side until you have four square sides.

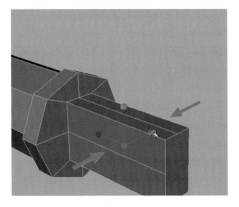

- Scale the two sides narrower.

- Extrude two more times to create the handle/trigger.

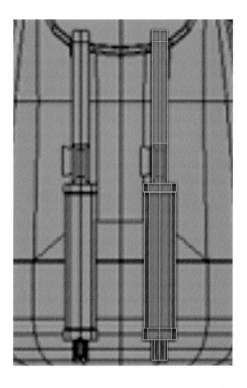

Use the top view to ensure proper scale of the barrel and stock.

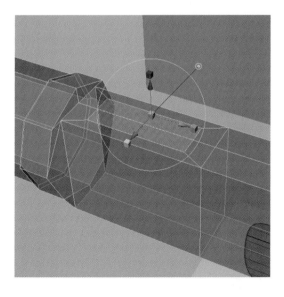

The top requires one extrude scaled inward.

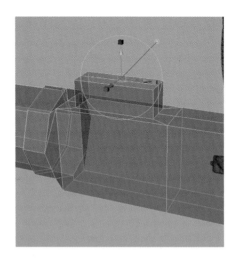

Extrude again, this time upward.

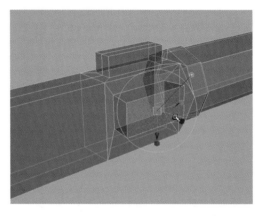

- Complete the same process for the side ammunition chamber.

The handle is made from two more extrudes, one scaled to a taper, the other extruded downward as shown.

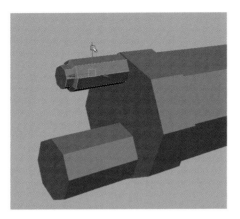

The secondary muzzle is created from a new cylinder with two simple extrusions and moved into the main gun mesh.

Combine the two objects into one mesh.

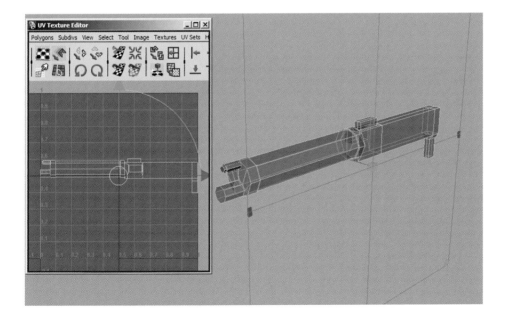

- Select the gun.
- Apply a planar mapping from the X axis.

Step 6: Creating the Engine

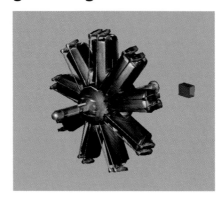

The Power of Duplicating

Creating the engine is fun and easy. The engine looks complex, but it is a simple collection of small objects that are easy to model. Once one piston is assembled and the main shaft modeled, the rest can be put together with the simple click of a duplicate button.

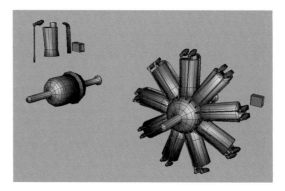

Breaking down the engine assembly is similar to breaking down the complexity of the entire plane. It is composed of five simple shapes that are easy to model.

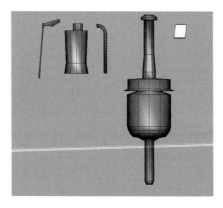

There is nothing here regarding modeling that you haven't learned how to do in this book. Rather than investing pages to show you the simple steps, I encourage you to give it a try by yourself. Here are a few suggestions:

- The main shaft is nothing but a cylinder that has edge loop splits or extrusions and is scaled to the blueprint.
- The piston is also a cylinder extruded three times.
- The piston exhaust pipe is a flattened cylinder with a bend at the top.
- The piston rocker arms are simple extrudes from a cube.
- The engine exhaust is a square cube with a small extrude cavity inward.

Working from a New Scene File

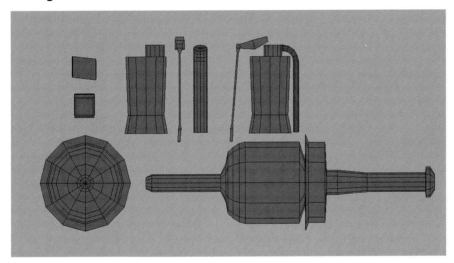

To make modeling the engine easier, I created a new scene file with a template of the engine. The file name is planeEngine.ma.

- Once modeled, position the shapes as shown, and combine them into one mesh.
- Press insert to V-snap the piston to the shaft center point.

You could unwrap these shapes individually first before combining, but because much of the engine will be hidden inside the casing, we can get by with a few simple planar maps.

The piston, for example, was mapped with a planar to the front few faces. The remaining faces had a side planar mapping applied. This will also make painting the texture map much easier.

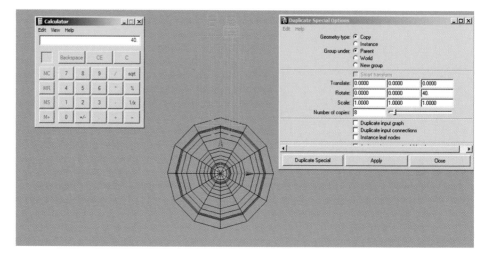

Using Duplicate Special

Newer versions of Maya have a new menu item, Duplicate Special. The Duplicate in older versions will also work the same for this demonstration.

Here is where a little math comes into play. We have nine pistons, which need to be equally rotated around a 360-degree shaft. The value is 40 degrees for each rotation.

- Open Duplicate Special > Options.
- Enter 40 in the far right Z axis value box of Rotate (the values are X, Y, Z from left to right).
- Set the number of copies value to 8, because we need nine objects and already have one.

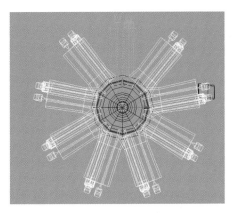

The result is a perfectly symmetrical series of duplications. After laying out the UV mapping for the shaft and exhaust pipe, combine the engine into one mesh.

Step 7: Creating the Propeller

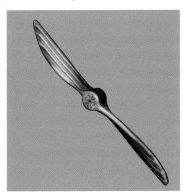

Looks Can Be Deceiving

The propeller has a beautiful style and grace to its shape. It also looks as though it would be nearly impossible to model it effectively. As you will see, however, it is a simple model to create when you understand how.

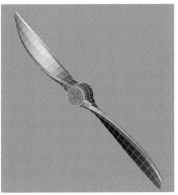

Start with a Cylinder Poly Shape

- Rotate the cylinder forward (90 degrees in X axis).
- Adjust the INPUTS channel to Subdivision Axis-12.

- Select the top two faces, and extrude upward (blue arrow).

- Use the Scale tool with the top vertices selected to flatten the top faces and straighten the sides inward.

- Do one more extrude up to the tip of the prop height.

- From the side view, adjust the middle vertices to the thickest part of the blade.

- Add a few edge loops in between to equal out the mesh topology and allow proper smoothing.

- Adjust the front row of vertices to create a sloping inward shape. *Do not* follow the actual blueprint shape at this time. You will see why in a moment.

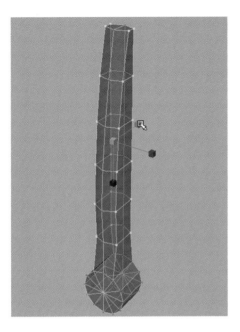

- Now select the outer edge vertices, and scale them in to help create a rounded shape to the blade.

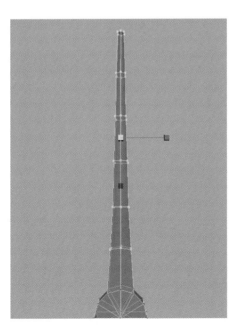

- From the front view, begin to scale inward (red scale box), each level moving up vertically. Make each higher level taper inward more to resemble the shape in the photo.

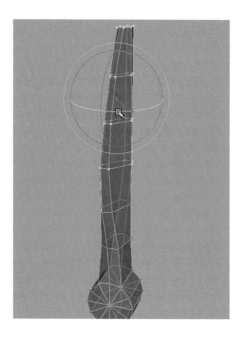

Now just as you did before, working from the lowest row of vertices, begin rotating the blade to the left. Make sure all of the vertices are selected when doing this, but unselect the bottom row after each rotation. This is a visual process, so you may need to go back and forth a few times to get the right curvature shape.

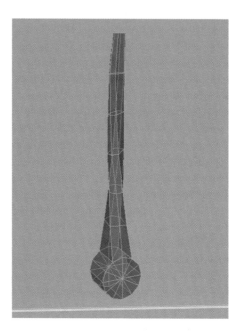

Inspect the shape. Once you are pleased, you can prepare the prop for duplicating.

- Select the edges of the center and delete. This will make extruding the middle face easier.

- Do two extrudes to both the front and back middle face.
- Scale the first extrude inward
- Scale the second one outward as shown.

- Use the Split Poly tool to cut the prop in half.
- Select the bottom half faces and delete.

- Select the half prop shape.
- Mesh > Mirror Geometry Options > Set to −Y axis.
- Mirror.
- Select the middle vertices and merge.
- Move the Split Poly tool once more down the middle of the front and back of the face as shown.

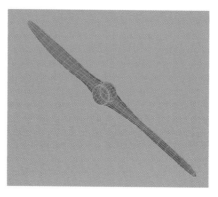

- Apply a Mesh > Smooth to review the overall shape. If you need more curve, then simply back up your steps (ctrl + Z) and add more twist to the blade.

Step 8: Creating the Cockpit

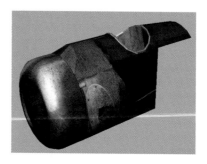

Saving the Hardest for Last

This lesson is actually not too difficult, but writing it clearly and providing the best images to explain the steps has been. I tried to simplify this section as much as possible. It's a fun part of the plane, and modeling the cockpit this way presents a great learning experience. Let's get started.

- Create a poly sphere shape.
- Rotate it 90 degrees in the X axis.
- The default 20 Subdivisions Axis and Height is fine.
- Scale it inward until it is close to the blueprint shape.

- Now delete the back half at the middle point.
- Select row 7 and scale to the same diameter, and select row 6 to create the rim of the prop casing.

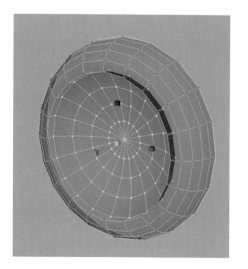

- Now scale rows 7 and higher in the opposite direction, causing them to go into the casing.
- Use the Move tool to further position it correctly.

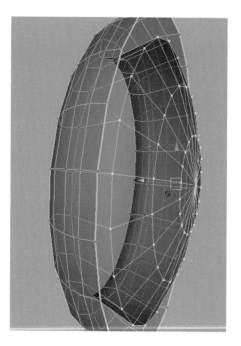

- Once you are pleased with the inside, delete the unneeded faces inside the casing.

- Select one of the outer rim edges and Fill Hole to create a new face so we can extrude the sides.

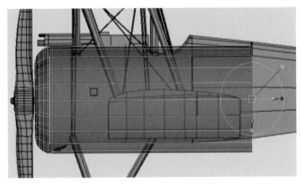

- Do an extrude, and pull out to the end of the shape needed.

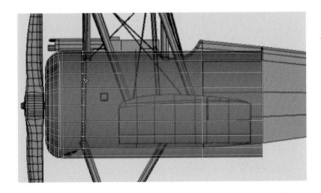

- Add two Edge Loop Splits as indicated on the blueprint.

Here is the finished shape so far. It should be completely symmetrical.

Looking downward, add four splits in the shape shown for the "hump." This is why the Sopwith was nicknamed "Camel."

- Select the edges (selecting the vertices is fine too), and pull up slightly.

The reason we didn't worry about any distances is because we are going to Vert Snap these to the fuselage, forming a perfect seam.

Two Ways to "Vert Snap"

1. One way is to hold down the V key and select the circle region around the vertice while dragging it to the vertice you wish to snap it to.
2. The second way is to pull the vertice from its **arrow handle**. When using this technique, the vertice will be constrained to its axis direction and distance, without snapping on top of the actual vertice.

To modify the bottom and sides, you will follow a procedure that is similar to the method you used to create the fuselage bottom and sides.

- Select the bottom row of vertices, and scale them in the Y axis to flatten. Then move them all by V-snapping.

- Follow the same procedure for the side. Be sure to V-snap.

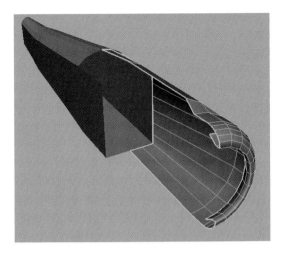

- Select the faces on the opposite side and delete.

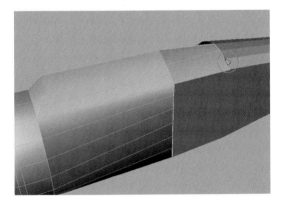

- The final step is to add a split from the triangle part of the hump toward the back.

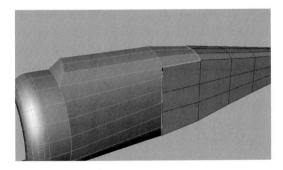

Notice we have more edges on the cockpit mesh than on the fuselage mesh. This was intentional. Both meshes have different shapes and will also have different features: one is metallic, where as the other is fabric. You could add more edge loops to the fuselage if you wish to connect the two parts.

161

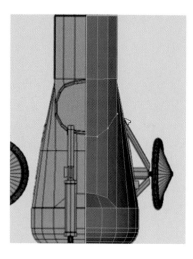

- Move to the top view, and begin splitting edges for the cockpit opening. Three splits for the front and the back are sufficient.

Move them according to the blueprint position.

- Select the inner faces and extrude. Be sure to scale uniformly inward to create the edge of the cockpit trimming.

- Extrude once more downward to create the seat area.

- Add an edge loop split in between the new trimming.

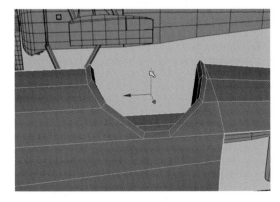

- And pull the edge upward to create the curved shape. You can also extrude the face rather than split it to create a quad trim instead of a triangulated trim shape.

- The cockpit interior is no longer in the center of the mesh, so select the vertices and scale them sideways to even them again.

The newly scaled vertices will need to be V-snapped to the center mark again. Here is where snapping from the arrow handle is useful.

- Even out the seat using the scale technique too.

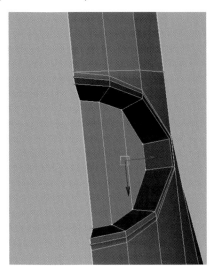

- And move the remaining vertices visually to form a nice interior cockpit shape.

We are now ready to unwrap the cockpit UV map.

Laying out UVs for the Cockpit

UV Unwrapping Complex Shapes

Because of the cockpit's unique shape, I decided to use this model to demonstrate the UV layout in Chapter 11. To see how the cockpit can be unwrapped effectively, take a look at technique 1 in Chapter 11, Texture Mapping Techniques.

Step 9: Struts, Supports, and Final Assembly

Creating the struts and suspension cables will be our last step in this project before assembly. Both of these objects are easy to create and can be simply modified to make different shapes and sizes as needed.

The Struts

The strut has a tapered profile similar to the wing. It is an easy shape to make.

- Create a cylinder shape.
- Adjust the INPUTS to 10 Subdivision Axis.

- Extrude and taper both top and bottom faces at the same time.
- Extrude once more. Don't worry about the height of the strut at this time.

- Line up the shape, and scale it appropriately to the blueprint from both the front and side views.

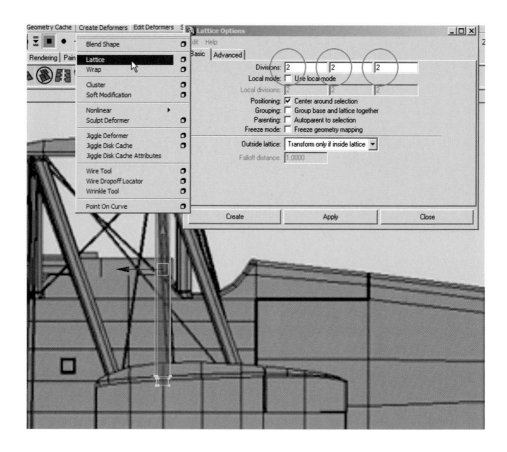

- In the Animation mode, select the strut and apply Create Deformers > Lattice Options.
- Divisions 2, 2, 2.

- Right-select the lattice point and drag over the top and move into position. Do the same for the bottom lattice point.

- Now apply a planar UV projection from the X axis before duplicating any struts.

Cables and Supports

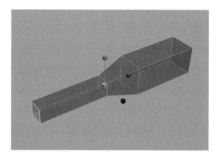

- Start with a cube, and extrude and taper the face.
- Extrude once more, and delete the end face.

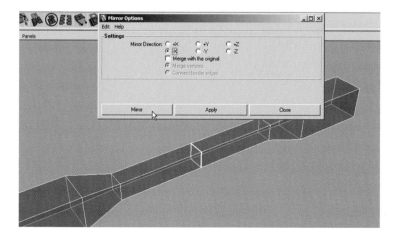

- Mirror geometry in the −X axis.

- Select the middle edges and delete them.
- Select the middle vertices and delete them also.
- Now select one side and translate to make the length shorter or longer as needed.

 TIP: *By pressing insert and V-snapping the pivot to the end, you can easily rotate the cable into position from the center of the cable.*

Putting It All Together

In this part we will discuss putting all of the parts we've created together into one cohesive mesh. There are also many detailed objects such as cables, supports, and cockpit panels that will consume a great deal of extra time if you wish to add them to your model. I am not going to show how to model all of the simple cables required, because they are rather easy to do. I did include them, however, in the planeComplete.ma file for you to review or simply import into your scene to use.

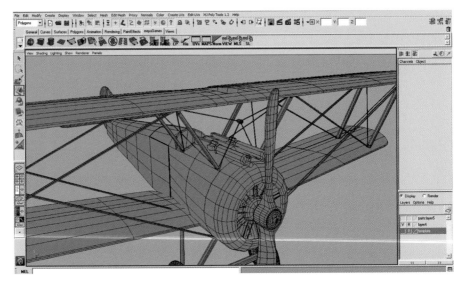

Beginning the Duplicating Process

Now comes the process of mirroring geometry, duplicating, combining, and merging meshes. Let's begin with the top wing.

Wings

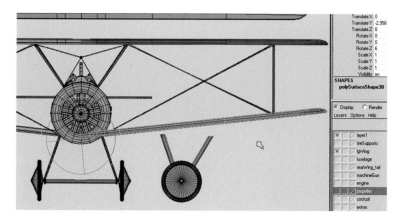

- Press insert, and V-snap the pivot to one of the end vertices on the middle of the wing.

- Press D to duplicate the wing.
- Translate it into position.
- Rotate it to 6 in the Z axis (this should match the angle of the blueprint).

- Mirror the two wing halves.
- Merge vertices on both wings.

- Select the middle faces of the bottom wing that contain the curvature section and delete them.

Propeller

- The propeller cannot be mirrored; it must be duplicated then rotated 180 degrees.
- Combine the two meshes, and merge the vertices to complete the blade.

Fuselage and Cockpit

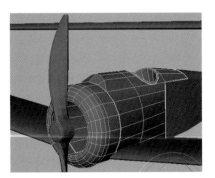

- We completed the fuselage earlier, but the cockpit section needs a simple mirror geometry in the −X direction.
- Merge vertices.

Tail and Rear Wings

The rear wings are similar to the large wings.

- Combine the front and rear wing sections into one mesh.
- Mirror the geometry in the −X.
- You will need to select the faces of the new side and move them slightly into position.

Wheels and Supports

The support struts can be made also from the wing struts.

- After shaping them to the blueprint, combine the two pieces into one support strut.
- Combine them into one mesh, and mirror the geometry in the −X axis to create the second tire and support.

Machine Guns

- Create another simple duplicate, and move to the side operation.

Do not mirror the machine gun, as this will reverse the ammunition chambers.

Struts and Cables

Position all of the struts and supports into their proper positions on the blueprint. It may take time to get the rotations and scales just right on the cables and wire, but it is worth the investment in time, as the final rendering results will look great and have realistic shadows cast from all of the support structures.

Step 10: Finishing the UV Layout and Textures

Everything on One Map

Most of the UVs I laid out for this model are simple planar coordinates of just one side. The alternate sides or duplicates all share the same map; for normal mapping, you will need to include the opposite sides, but because I chose to use this model for a cinematic animation (not a game), I am free to use a bump map. You could also simply use two maps, one for each side of the model, should you want to use normal maps. Here is the outUV template exported from Maya.

In Photoshop, I created a basic Block Out texture to get all of my colors roughed in. You will find that this technique offers a great way to start building your color maps. I demonstrate how to create one in Chapter 11, technique 2.

The final stage for the texture is to add detail by creating a "dirt" map, which I will use as an overlay onto my color map. I tend to use images, photos, and hand-painted work for creating the gritty details. I also demonstrate this process in Chapter 11, technique 3.

Wrapping Up

Little additions such as a windshield, flags, a cockpit instrument panel, and a rear tail brace, are all small parts that are easy to model but have been omitted here because of space limitations. You can easily find references for these online. Take your time with the extras, and your model will be a showcase piece for your demo reel.

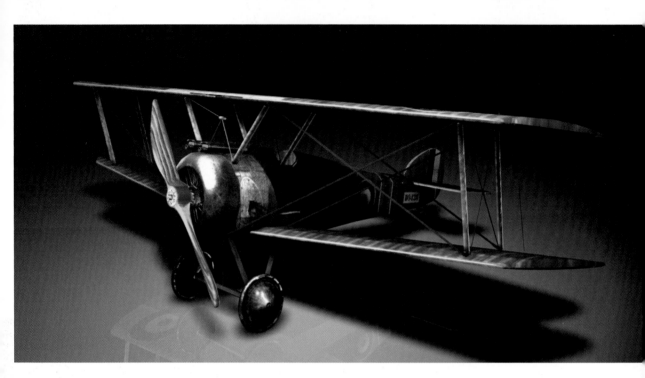

Here is the final rendered image. The addition of a simple ground plane image, slight environment fog in the distance, and two companion aircraft add to the effect.

In Chapter 7, we'll learn how to model the pilot bust.

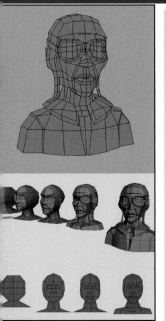

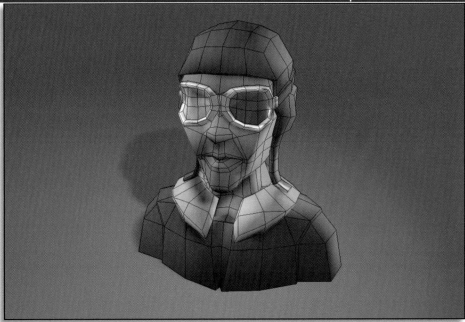

The Pilot Bust: Low-Poly Head Modeling

This lesson will show you how to create a low-poly human head model quickly. The human head is probably one of the most complex model types there is, and later in Chapter 9 we will explore a more detailed and realistic head model. For this lesson, our goal is simply to create a quick-and-easy pilot to include with the Sopwith Camel biplane we created in the previous chapter. This model is meant for a distant camera shot, so minimal detail and texturing is required.

177

Starting the Scene Setup File

To make this lesson easier and to avoid complications, I provided a scene file complete with proper camera setup and template placement ready to begin modeling. You can even save this file and use it for future modeling projects by simple swapping out the template image. Begin by opening mayaGames/Ch07_PilotBust/scenes/startScene.ma.

Step 1: Getting Started

About the Template Images

We are now going to create a simple model of a human head. This model is not meant for facial animation such as lip-sync, so we do not need to be overly concerned with necessary edge loops around the eyes and mouth. We'll use a box modeling technique for this model.

The template to start with has already been set up for you. You will notice the two template planes, front and side views; you will also notice in the sourceimages folder that I have included, along with three other template versions to be used throughout the modeling process. Each template simply shows where the edges should be created as you work through this lesson.

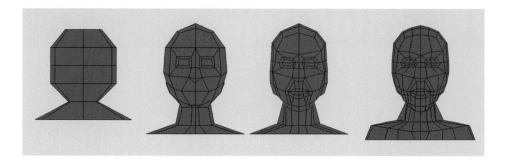

 TIP: *As you become more experienced at modeling, you will find that keeping all of your template images on one map will save you time when setting up template shaders. You will see why this becomes a time-saver as we progress through this lesson.*

The Box Modeling Progression

From a simple box mesh, you will extrude, push, and split vertices to eventually create the pilot bust model. Like the lesson earlier where we modeled the biplane, I cannot stress enough how important it is to find and use reference images when modeling. I purposely did not include any for this lesson, as I want you to search online for a few images yourself.

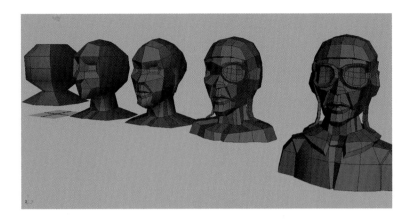

Step 2: Beginning the Modeling Process

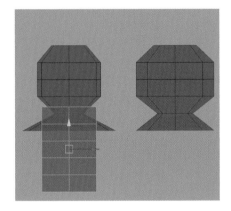

Creating a Poly Cube

- Width, Height, Depth set to 24 units (we'll scale it down later).
- Under the Inputs Channel, set
 Width: 0, Height: 1.5, Depth: 0.
 Subdivision Width: 2, Height: 5, Depth: 2.

> **TIP**: *I prefer to keep my vertice count very low when modeling. Beginner modelers often overcomplicate their modeling by adding all of the vertice edges right from the beginning. This is a mistake, and it will make creating the general shape mass much more difficult.*

> **HINT**: *Try to think of box modeling like cutting a sculpture from wood. Block out the major mass shape first, and slowly chip away at the details afterward.*

Scaling the Cube

Now we will move the cube to match the template and begin scaling the shape to match.

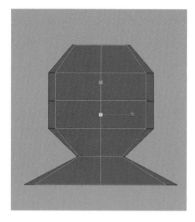

- Moving the cube up Y-26 will place it in the correct position.
- Selecting the second row of vertices from the bottom, I scale them uniformly inward to create the chin-neck area. Scale in the top vertices to begin shaping the top of the head too.

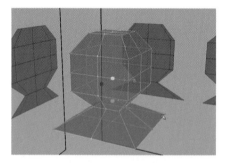

Select the vertices down the middle of the cube, and scale the Z axis to match the side template.

Do the same for the middle vertices on the side of the head to round out the head shape.

Creating the Eye Sockets

You will be creating extrudes and split polygons all the way.

Scale one Eye Socket face using the Extrude tool.

After shaping them more rectangular, I do one more extrude to create the eye cavity.

I add a new split between the eye, nose, and chin to begin shaping the nose and mouth region.

Pixel Pusher

Yep, this is where the term comes from. It's the heart of a modeler's life—pushing vertices to and fro as you try new ways of shaping polys to improve your workflow.

Now I spend some time shaping all the vertices into a visually pleasing head shape. This is a good practice for hand-eye coordination, as will become evident later on when we begin working in digital sculpting.

It's okay if you do more detailing to just one side of the head, as long as it's on the same side. We can delete half of the head and duplicate a mirror geometry section afterward.

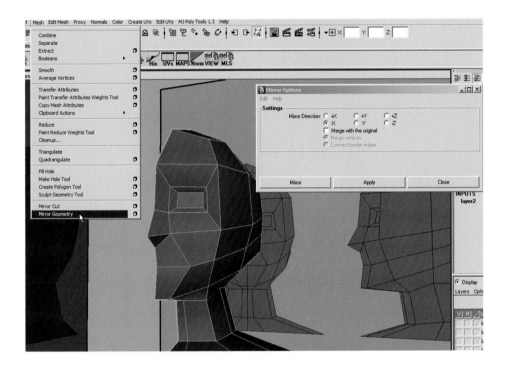

Mirroring geometry is a big part of box modeling, especially when it comes to character modeling because both sides of the model tend to be symmetrical.

- Mesh > Mirror Geometry > Options.
- Select the appropriate axis direction.

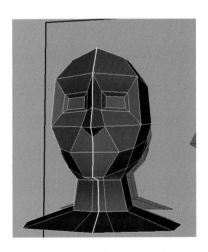

Although the mesh is one object, it has open seams that require "merging."

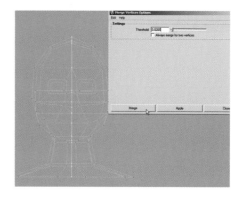

- Select the vertices down the middle of the head.
- Edit Mesh > Merge > Options.
- Setting a low value like .002 will allow you to merge the selection at one time.

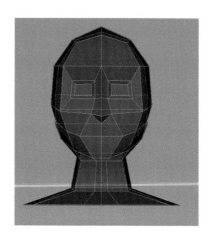

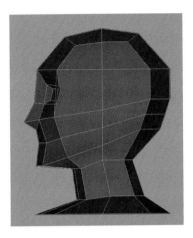

We are now toward the end of modeling this template and are ready to go to the next level.

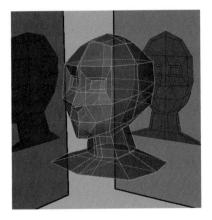

Adding Further Details

More splitting and extruding will continue to develop our head shape.

Now I have added more details to the lips, added a horizontal split through the eyes to allow me to form them into a more oval shape, and will begin to define the chin line and cheek crease regions.

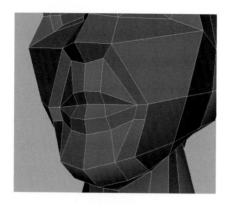

Try to work both sides of the mesh simultaneously using the scale, rather than translating vertices. Take your time at this stage, and rough in all of the features such as the nose, neck, and chin areas.

A Word about Triangles and Quads

At times you will find it easiest to split faces, creating a triangle rather than a quad. That's okay for now, and don't stress too much over it. Too many times modelers focus on quads, although I find in the early stage it's more important to get the general shape in place first. We can clean up triangles later. One way to watch your character's face take shape is to apply a smooth to the mesh. Doing so will point out specific details and maybe call attention to issues you have overlooked, such as multiple faces on top of each other (happens often to beginners) or maybe open vertice faces too.

I've worked out much of the definition now, and I am ready to begin taking this model to the next level. I have a few triangles and even n-gons (broken edge loops). Again, all of these will be cleaned up and addressed momentarily.

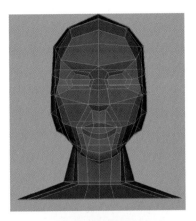

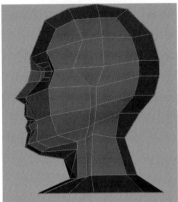

Our head is really taking shape now, and we can begin to add finer details to the mouth, eyes, and nose regions.

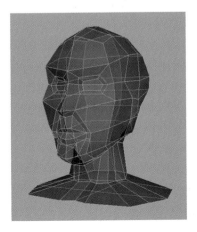

Because this model will have a leather flight helmet and goggles, we do not need to spend much time on the facial features. Also, this is intended to be a low-resolution model for distance shots, not camera closeups.

> **SUGGESTION**: *Although ears are not required on this model, you may decide to add them should you consider using this head for a more detailed closeup model afterward. But it is not necessary that you do so, as this will add more work than is required for this lesson.*

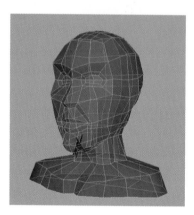

I continue shaping and finessing details. I have also extruded the bottom faces and scaled them outward to create the shoulder and upper chest mass. I'll be adding one more later to prepare the basic torso shape.

Modeling Trick

At this stage, I like to make a duplicate head. I create a blend shape and turn it up to 100%. Then I take the original and apply a smooth (usually two divisions). Now I can fine-tune vertices and see them update on the smoother mesh. This is similar to Maya's Proxy Modeling tool, but I prefer this method personally. The only drawback is you cannot split or extrude faces without destroying the smoothed version. But for simple finessing, this is a quick technique I like to use. Once I'm happy, I delete History and delete the smoothed version.

You can find out more about this modeling technique by reviewing Chapter 8, step 3, where I describe the process in detail.

Part 3: Extruding Clothing and Accessories

Before we start creating clothing and accessories, I need to define two methods you can use at this time. You can retain your pilot as a low-poly character, keeping the head, helmet, goggles, and coat as one simple mesh, or you can build separate assets from the existing head mesh, which will allow more freedom and options should you decide to rig and animate your pilot later. A separate head mesh will also make creating blend shapes for expressions and lip-syncing easier, should you decide to go in that direction.

Creating the Leather Flight Cap

Clothing and skull caps are extruded from the base mesh then extracted as a separate mesh to be refined later. We'll do that now with the leather cap.

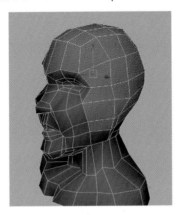

- Create a duplicate head, put it onto a layer, and hide the visibility of the layer.
- Select the faces as shown.

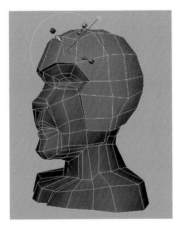

Extrude the cap shape slightly from the skull.

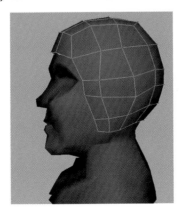

- Mesh > Extract the cap surface.
- Delete the head, leaving just the newly created cap.
- Open the visibility of the duplicate head.

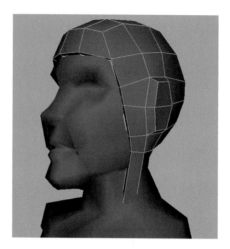

Continue shaping the cap into a desired look, similar to the images shown here.

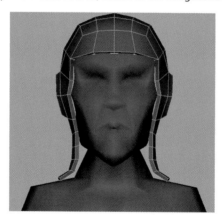

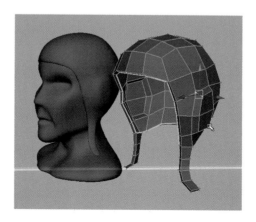

I apply a smooth to the cap to check the shape and any edge loop issue I may have missed. Always remember to revert the Smooth divisions back to 0 and delete History.

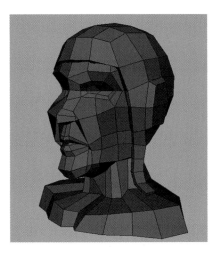

Now our mesh is ready for us to add the leather helmet and goggles. We'll create the helmet by using a duplicated head mesh.

- Select faces surrounding the skullcap.
- Extrude the face, and pull out slightly using the blue arrow.
- Reshape some of the vertices on one side to flow better with the helmet shape.
- Extrude an oval ear cover and helmet strap.
- Now delete the older half of the helmet and mirror geometry.
- Merge the vertices to ensure a "waterproof" mesh.
- Now you can delete the faces of the head, leaving just the helmet.

You could keep this as one mesh if you prefer, or you can work on the parts separately and combine the accessories to the head mesh when we are finished modeling.

Creating the Goggles

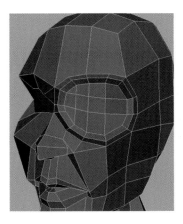

The glass lens is easy to create. Remember to once again duplicate the head and hide it on a layer before modifying the original. Simply model and enlarge the eye socket area as shown to create the lens and frame.

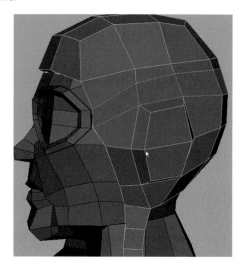

Unhide the cap mesh, and add a split loop so you can extrude the leather goggle strap.

Again, extract the newly shaped lens from the head, or simply delete the unwanted faces.

You can seam the goggles many ways by creating a simple buckle as I did or by making a more elaborate one. Have fun with it.

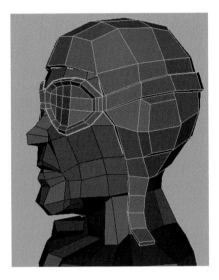

Here the complete goggles and flight cap have been combined and merged into one clean mesh.

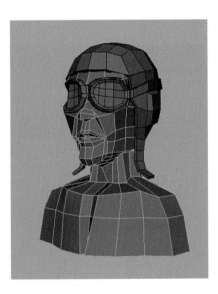

Open up the duplicated head once again, and extrude downward to create the upper torso.

Building the Pilot's Coat

By now you should be doing well on your own. I have shown and explained many times the processes and tools, so I will allow images to guide you along for visual reference. Keep in mind that you do not have to adhere to my exact edge loops or level of detail.

Once again, delete the head faces and repair the open hole with the Fill Hole tool or the Append Faces tool. This will give you a separate coat mesh.

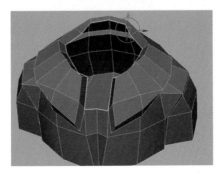

To Fill a Hole
1. Select one edge on the open area of the hole.
2. Mesh > Fill Hole.

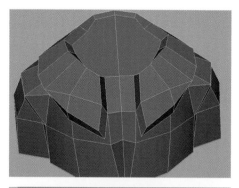

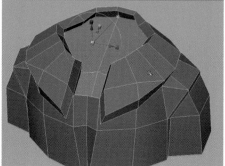

Select the head mesh's bottom faces, and do an extrude. Scale and shape the vertices accordingly. Get creative here; split and extrude to create a collar shape. Make sure to leave some collar overhanging the coat.

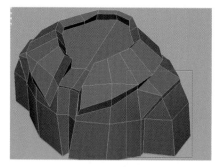

Add an edge loop split around the arms to help define the sleeves. Push the sleeve edges inward; this will create a crease in the arms.

- Apply a smooth to the mesh.
- Increase divisions to 2.

Inspect the shape, and look for any open edges that need adjustment.

- Z back or change divisions to 0, and delete History.
- Now is a good time to save too.

Assembling the Parts

Back to the original head, let's delete the body now. Create an edge loop around the collar. Select all faces below the collar and delete.

We have completed our final head shape.

Here is our completed model. All that remains is UV layout and texturing, which we'll learn more about in Chapter 11, Texture Mapping Techniques.

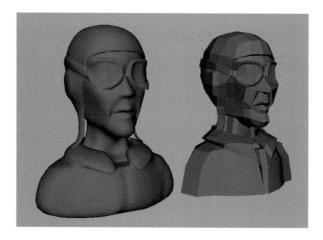

I now review my progress so far. The pilot is beginning to take shape. I prefer to make a duplicate copy and add a smooth to it so I can see how well the edge loops are defining the overall shapes.

Wrapping Up

Of course, you can add simple blockout textures similar to how we textured the Springfield rifle in Chapter 4, or perhaps you want to import in the parts into Mudbox and try your hand at digital sculpting.

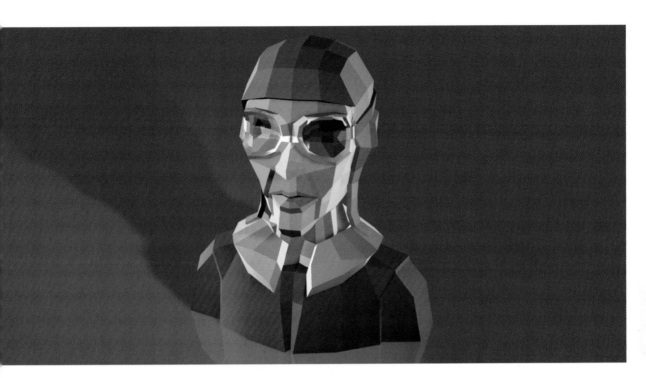

Here is a work-in-progress (WIP) image rendered with a simple three-point lighting setup, which is provided within the Bonus Chapter at the end of this book.

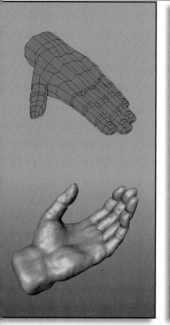

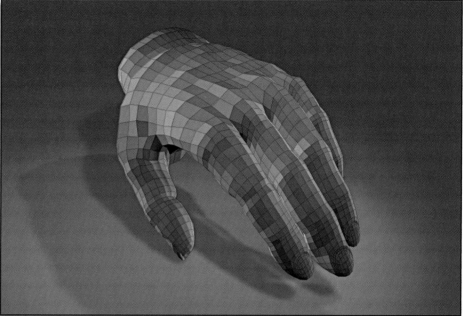

Modeling Realistic Hands

The Importance of Hand Modeling

By far one of the most difficult modeling tasks you'll face is the formation of realistic human hands. In this chapter, we are going to learn the benefits of creating a high-level hand model using a variety of tools, including joints, to help us achieve great results.

The hands are very expressive with wrinkles, folds of skin, age spots, fingernails, and other features. Even from a distance, poorly modeled, textured, or even scaled hands can ruin the believability of an otherwise great human model.

The Common Mistakes Taught

I cringe every time I see a tutorial that shows modeling the fingers and especially the thumb in a straight, linear pose. Obviously this is the easiest method to model and rig, but it's also wrong unless your goal is to create a simple cartoon character. For realism, we have to study reality.

It is common for beginners to model hands in a straight, rigid pose. This makes rigging easier but causes many issues later on regarding the proper bending of fingers and folding of skin around knuckles. If you view a real photo of a relaxed hand compared to that of a rigid one, you will see a great deal of difference in the shape and edge flows. As you become a better modeler, you will begin to add these nuances into your models, creating more realistic and better game assets. Do not worry about rigging because there are ways to rig curved geometry that any technical director worth his or her weight in salt should know how to do effectively.

Unique Methods You'll Learn

I designed this lesson to include a few unique methods that I use for my modeling. We'll explore using Blend Shapes, Joints, and setting up UVs before the model is completed. All of these methods work well, but for beginners who may not be ready for a challenge, you can substitute these new methods with simple pixel pushing.

Step 1: Getting Started

Using Good Reference Photos

Again, to be a good modeler you have to spend time researching and acquiring great reference images. Anytime I begin a model I will easily invest a full day at the bookstore, at the library, and on the Internet to gather as many visual references as possible.

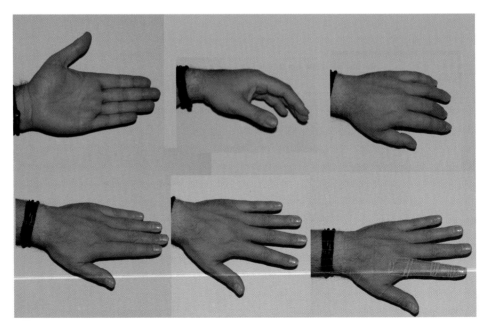

For this project I simply needed to photograph my own hand in several relaxed and rigid states. We will start with a straight hand and finger then deform it into the proper pose before adding fingers and completing the model.

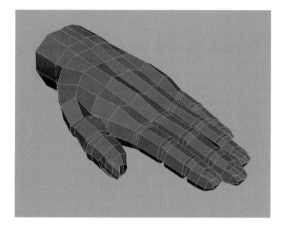

We are going to model a basic beginner hand just to see the fundamentals of the modeling. Once complete, we will go back and make changes to the anatomy of the hand so that it more correctly resembles a realistic human hand that will grip, flex, and animate much more convincingly.

Step 2: Setting up the Template

Which Axis Is Best to Model In?

I began this model quickly in the X axis but changed direction once I started work on the fingers. I would recommend modeling the hand in the Y axis, because it is easier to rotate around the fingers within Maya.

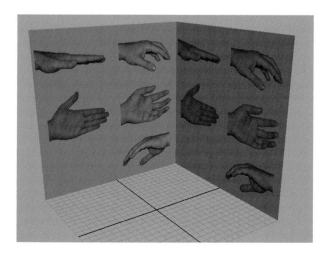

Beginning with a Cube

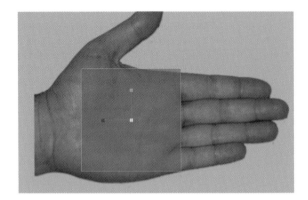

Create a cube with divisions, or edge loop split, whichever you prefer.

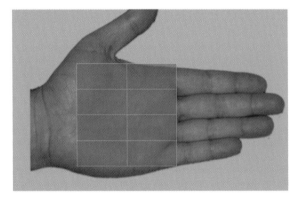

Divide the cube into four rows (one for each finger) by two rows.

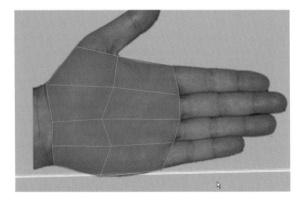

Begin shaping the hand, allowing the edges to flow according to the natural curvature of the palm.

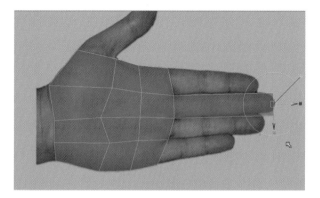

Select the face for the middle finger. We'll model this finger because it's the longest. All of the other fingers will be scaled down to match their proportions.

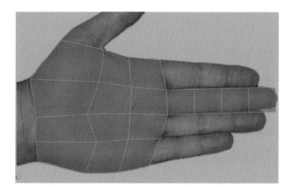

Split the finger into quarters, and move the edges accordingly to the knuckles.

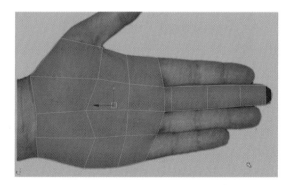

Once the edges are lined up properly, select the tip face and do one more extrude, scaling it in slightly to create a chamfer beveled edge.

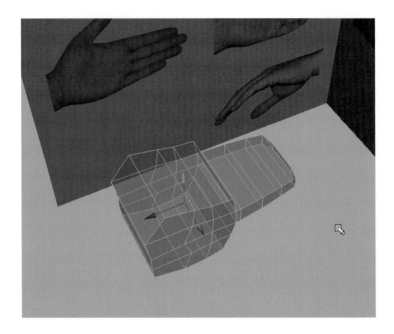

Change the view to inspect, and notice the hand is still fat in thickness.

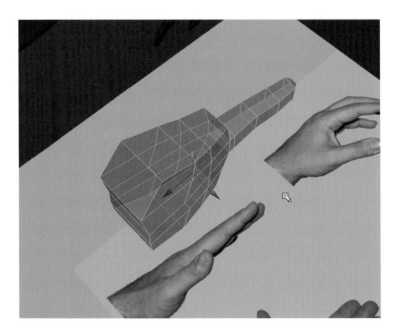

Select the vertices of each row and scale them down, making the shape match closer to the template side profile.

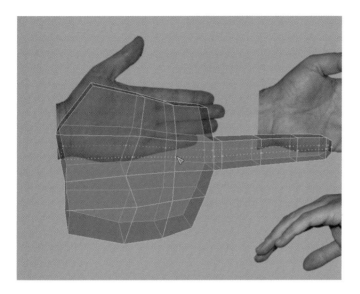

Fingers work best when modeled as a hexagon. Now that our first finger shape is roughed out, do an edge loop split through the bottom of the palm.

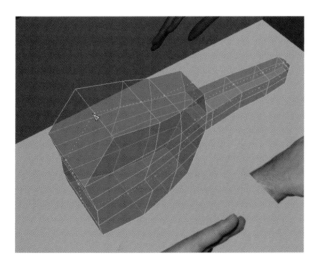

And once again through the side of the palm.

Step 3: Improving the Finger Mesh

Extracting the Finger

Now that we have the basic shape laid out, we can begin focusing our modeling effort on modifying one finger. Once completed, we will simply duplicate and scale the remaining fingers.

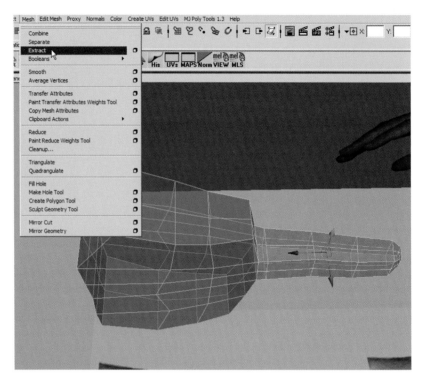

- Select the faces of the finger.
- Mesh > Extract.

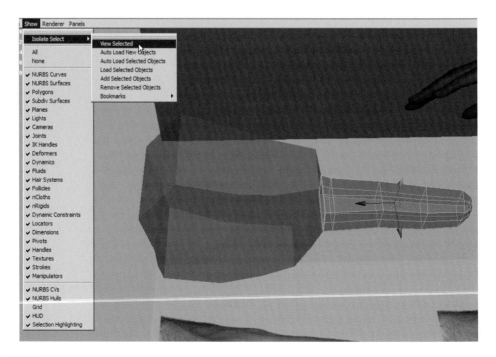

Select the finger and Isolate Select to hide everything else at this time.

Again I decided to rotate the finger at this time for two reasons. First, it became obvious to me that I began writing this lesson in the wrong axis. Maya doesn't provide a good gimbal rotation at certain angles, so rather than struggle or start over, I rotated the finger 90 degrees. The second reason is hands are best when modeled from the Top view panel as an arm is generally horizontal when modelling a character.

You can use vertices or edges when pushing/pulling mesh. Here I decided to use edges.

What makes a realistic finger is having weight at the bottom and tapering upward. Notice the thickness of the finger at its base.

Continue shaping until you are pleased with the overall shape before defining the knuckles.

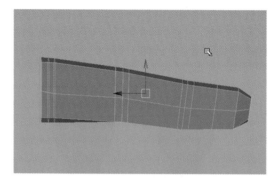

We will need three edge loops for each knuckle to model and animate correctly. Add edge loop splits to each side of the initial divisions.

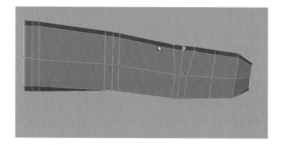

The knuckles should taper from wide on top to skinny toward the bottom for best deformation.

Adding the Fingernail

The next few steps will show you how to create a simple, yet effective fingernail.

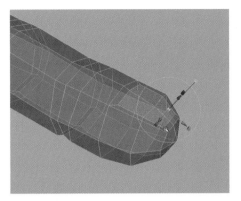

Select the top four faces of the fingertip, and extrude once scaling in and pushing downward.

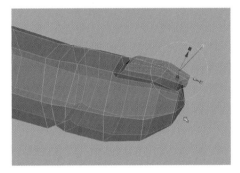

Extrude once again, this time scaling in and upward

Define the shape of the nail by moving the vertices to match the image.

MODELING TRICK: *Here is a handy trick I use quite often. Creating a quick Blendshape, I can model my low-poly mesh while watching the results of a higher, smoothed-version mesh. This process is available in Maya as a Proxy Model tool, but I have found that tool to be cumbersome at best and prefer my "old school" method.*

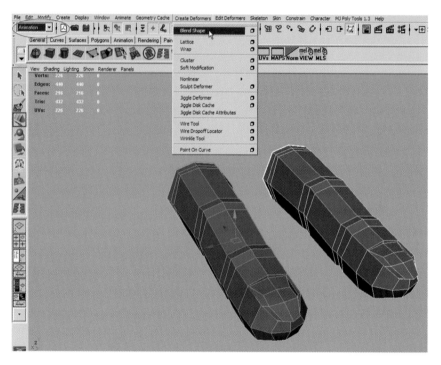

Create a duplicate finger (if Isolate Selected is enabled, your duplication won't show). You will need to turn off the Show > Isolate Selected option first.

- Switch to Animation mode.
- Select the duplicate finger, and shift + select the original finger.
- Choose Create Deformers > Blend Shape.

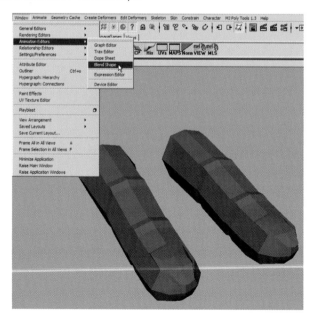

Now we need to open up the Blend Shape Editor:

- Window > Animation Editors > Blend Shape.

Turn up the value to 1.00 (100%). This will allow any changes on our low-poly mesh to influence the high-poly mesh.

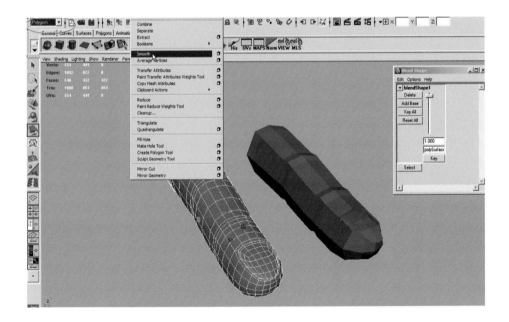

- Change back to Polygon mode.
- Select the original finger.
- Mesh > Smooth.

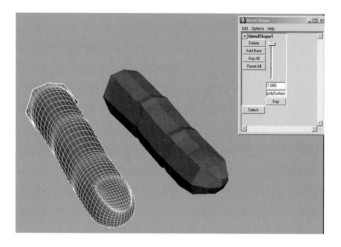

Change Divisions under the INPUTS channel to 2.

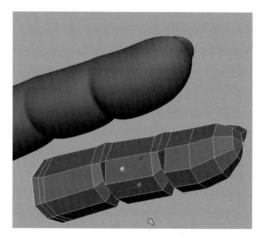

Now begin finessing the model by pushing in the creases, pulling out the knuckles, and adjusting the fingernail shape.

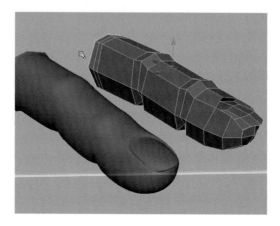

Here is another view angle.

Be sure to taper in the top faces of the fingernail and undercut the vertices for the cuticle.

When you are pleased with the model, return the smooth Division value back to 0 in the INPUTS channel, delete History to remove the Blend Shape influence, and delete the duplicate finger.

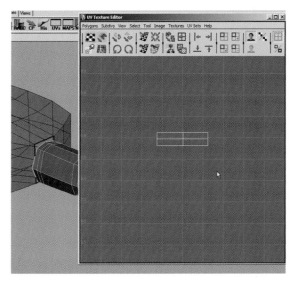

Sometimes in modeling, it's wise to lay out UVs early on in the modeling stage. Even if you need to redo the UVs later, it usually leaves you with easy shells to select. Looking at the UVs for our finger, you can see it's best to lay out the base UVs now.

SUGGESTION: *If you are a beginner to UVs and UV layout, then you may find some steps here a bit confusing. I would suggest skipping this section if you are not comfortable laying out clean UV shells.*

Step 4: UVs Now Rather Than Later

Another Reason to Do the UVs Now

If you are planning to take this model into Mudbox to digitally sculpt, it's always a good idea to have a clean UV set before adding fine details if you plan to generate a desirable normal map.

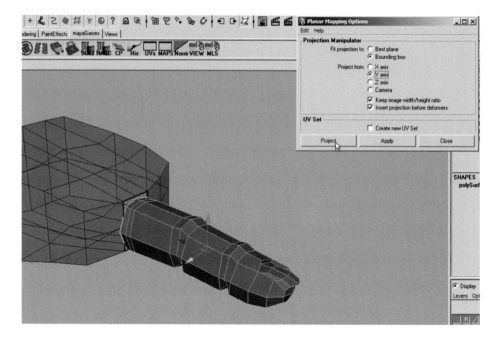

- Select the finger.
- Create UVs > Planar Map > Options.
- Change Projection to Y axis.
- Click Project.

By selecting the red "T" shape, you can initialize the rotation manipulator and rotate the planar map more in the direction of the finger.

- Open the UV editor.
- Select the lower half faces of the finger.
- Flip the UV faces, and move them to the side.
- Apply another planar projection for the nail, or use the Cut UVs option.

Step 5: Assembling the Hand

Duplicating and Attaching the Digits

With the UVs now laid out, we can begin assembling the rest of the hand.

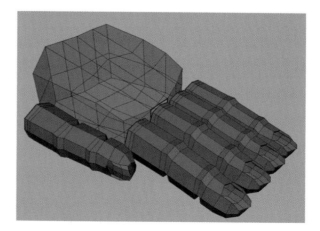

- Start by duplicating the middle finger three times, and lay them out accordingly.
- Duplicate one more, and rotate sideways for the thumb and position as shown.

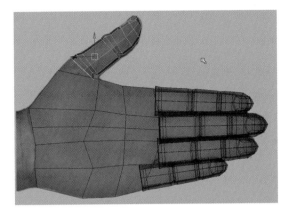

I apply the transparent shader to all the fingers and begin scaling, rotating, and positioning them to match the reference image closely.

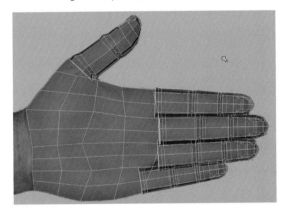

Once pleased, I make sure I have the proper number of edges for merging all of the meshes together. In this case, I noticed I needed to add a few more edge loop splits to the palm of the hand before combining the mesh into one.

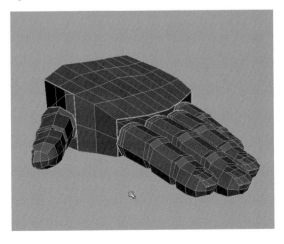

- Mesh > Combine. Combining the mesh into one object is required before merging vertices.

V-snap vertices from the finger to the palm or vice versa depending on the look. Don't be too concerned with geometry intersecting each other as these finger walls are doing. Once smoothed, they will separate realistically.

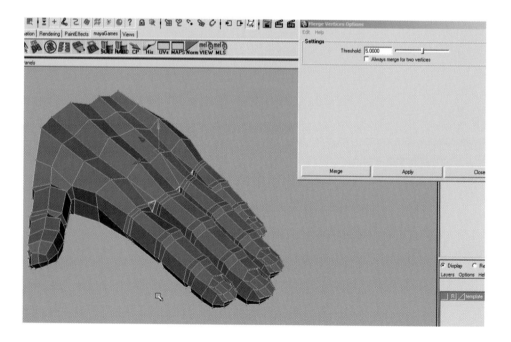

- Open the Option for the Merge tool and set to a high value like 5.0.

Then merge each pair of overlapping vertices one at a time carefully. It's important not to rush this step.

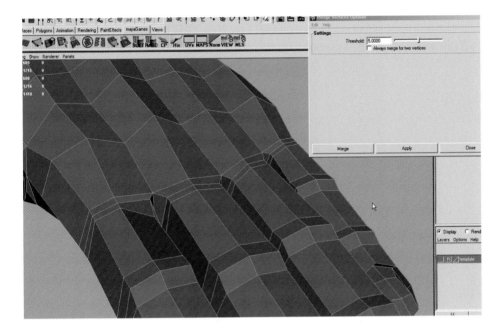

You may have to get in real close to see the open seams, but don't get nervous; if you created the proper edges earlier, then the number of open vertices should balance out.

The final step now is to select the wrist faces and do one or two more extrudes to create the forearm section.

Double-Check Facing Normals

It's always a good idea to ensure all face normals are facing in the proper direction. Just one reversed face can cause many problems, especially in a digital sculpting application like Mudbox.

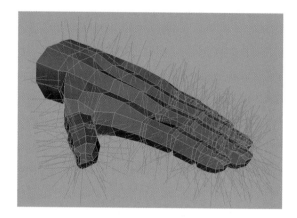

- Display > Polygons > Face Normals.
- Repeat the procedure to turn off normals. (Making a tool shelf button is a good idea!)

How Are the UVs?

Now that the hand is complete, we have some overlapping UVs to deal with.

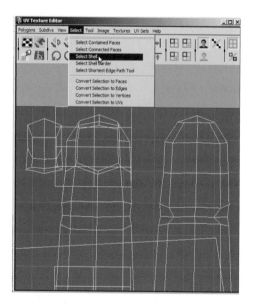

Inspecting the UV editor reveals many UVs overlapping each other. One simple solution to separate these is to select one UV then do the following:

- Select > Select Shell.

All of the vertices pertaining to that UV shell will become selected, allowing you to move it over to the side away from the others.

- Apply a "Y" planar map UV projection to the palm shape as we did with the fingers earlier.
- Flip the bottom half of the palm too.

A quick way to assemble all of the UVs into the grid in an organized pattern is to use the Layout selection.

- Polygons > Layout.

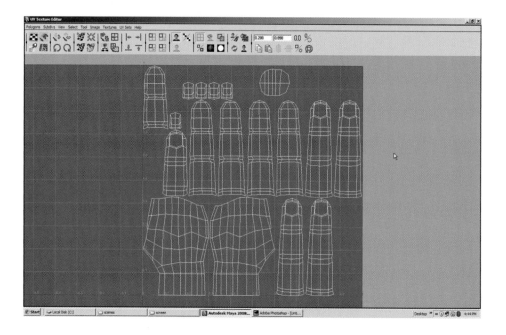

The result is a clean UV layout, ready for texturing later on.

Check Mesh for Any Seaming Issues

I always do a mesh smooth operation to ensure no open seams or bad edge loop issues are in the model. Once I inspect the model thoroughly, I revert back to the 0 to unsmooth the mesh. Always delete History after a smoothing operation has been reversed to ensure breaking the connection.

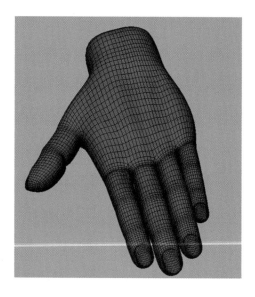

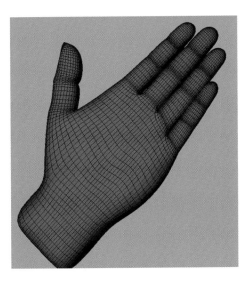

Step 6: Using Joint to Assist in Modeling

Creating a Simple Hand Rig

Bending the fingers by rotating vertices can take time and may not give the smoothest rotation to the mesh. But using a hand rig with a smooth bind is a simple setup and provides you with the opportunity to try different pose options on your mesh.

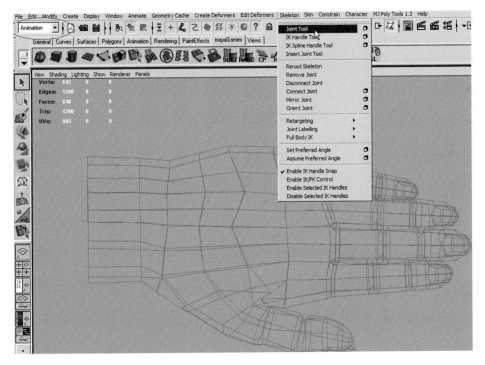

- Start by switching to the Animation mode.
- Use a top-down viewport of the fingers.
- Go to Skeleton > Joints.
- Create a joint at each knuckle by pressing the Y key after each joint to end the tool but keep it active. This will allow single joints to be created without being parented in a chain.

- Start with one finger at a time, placing one joint on each knuckle and one at each fingertip (to bind the mesh better).

- Switch to a side view, and move the joints up or down in their Y axis to the middle of the finger.

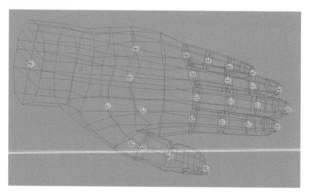

- Create the remaining joints to follow the pattern shown.

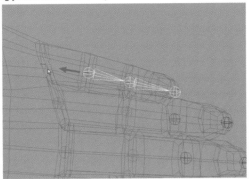

Now we'll parent the joints into a chain to create the hand rig. Select the farthest joint to the edge (fingertip); this is the "child." Shift + select the next joint down the chain (first knuckle); this is the "parent." Press the P key to connect the two joints. Continue this process until all the joints are parented.

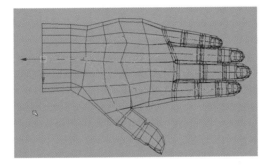

Parent the joints in formation to resemble the image shown. If you make a mistake and connect a joint incorrectly, don't worry. Pressing shift + P will disconnect the chain so you can reconnect.

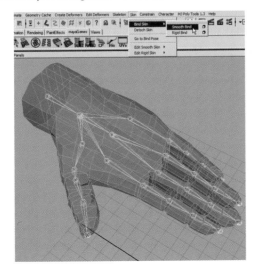

With the hand rig complete, select the root joint and shift + select the hand mesh.

- Bind > Smooth Bind. Reset the setting to the default options.
- Select Bind. The mesh will turn purple to indicate that it's influenced by the joints.

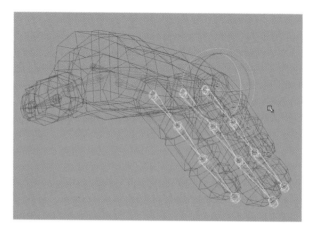

Select all of the knuckles at the base of the fingers and rotate forward.

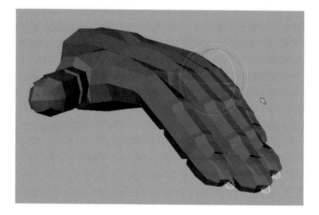

Continue with each row forward, giving the fingers a relaxed bend.

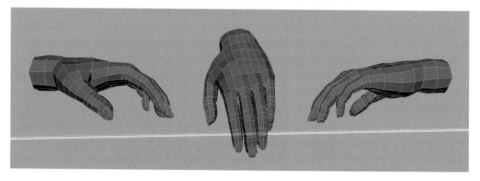

A naturally relaxed hand will tend to have more bend in the ring finger and even more in the pinkie finger, as shown. For the thumb, you may need to rotate the joints in several axes to achieve the right deformation.

Once satisfied with the pose, delete History and delete the joints, or save the file to reuse another time and Save As a new file name, then repeat the delete History steps.

At this point we are finished with the modeling stage. Digital sculpting and texturing and normal mapping will take this model to the next-generation level.

Step 7: What Time Is It? It's Mudbox Time!

NOTE: *To learn more about the tools, brushes, and processes of working in Mudbox, please review the lessons in Chapter 12, Digital Sculpting in Mudbox. The following steps are for users who are already familiar with the basics of Mudbox.*

Time to Play in the Mudbox

Here is a visual progression of the hand being sculpted with commentary on what brushes and tools I used. Most of this is basic sculpting with minimal toolsets. I also created a time-lapse video for your viewing pleasure.

- Open Mudbox.
- File > Import. Locate your exported .OBJ mesh file.

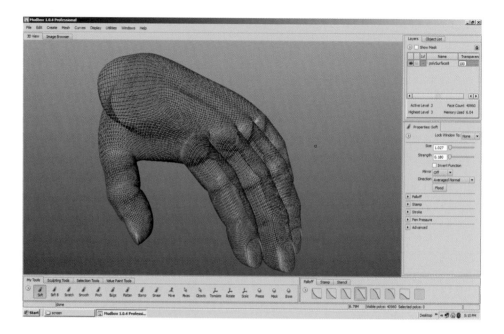

- Mesh > Subdivide Selection.
- Subdivide two or three times.
- Step back down the Mesh Density. Mesh > Step Level Down.

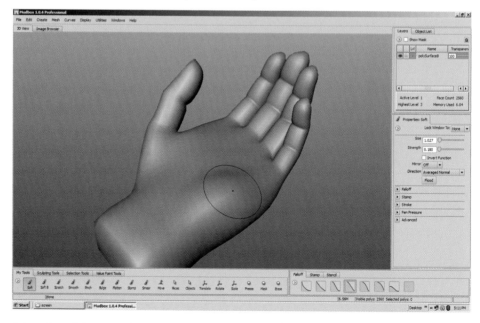

Select the soft brush and test the strength. Every mesh and density will react differently to the Strength setting. To quickly adjust the brush size, follow the same procedure that you use when you are working in Maya.

- Change the brush size. Hold the B key while left mouse sliding sideways.

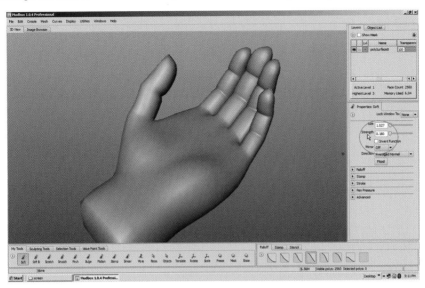

For this model, a Strength setting of .180 felt good to start with.

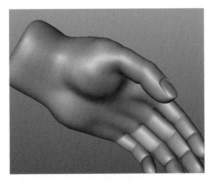

Go over all the details in the first division before increasing density. This is important!

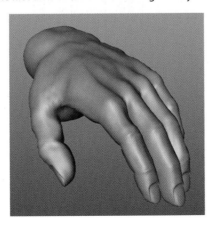

Begin to increase the mesh density, and lower the Strength settings as you proceed.

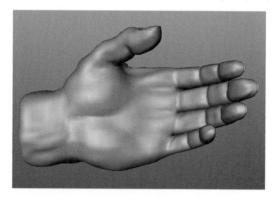

ARTISTIC ADVICE: *No book can teach you to be a good artist. It can only teach you good art technique. I highly recommend having a few good books on anatomy by your side when attempting to sculpt details like bones, muscles, and tendons under the skin.*

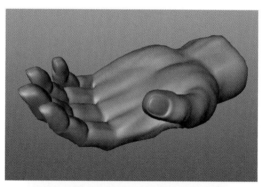

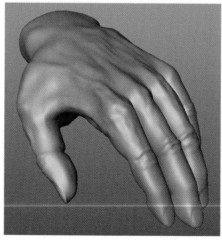

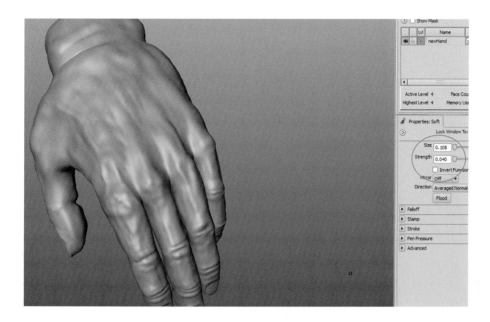

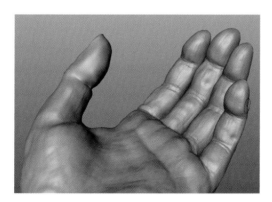

Wrapping Up

By using Mudbox, you can see we are able to push our modeling skills and model creations to the extreme of realism. Here is an example of this hand after spending less than an hour digitally sculpting details in Mudbox.

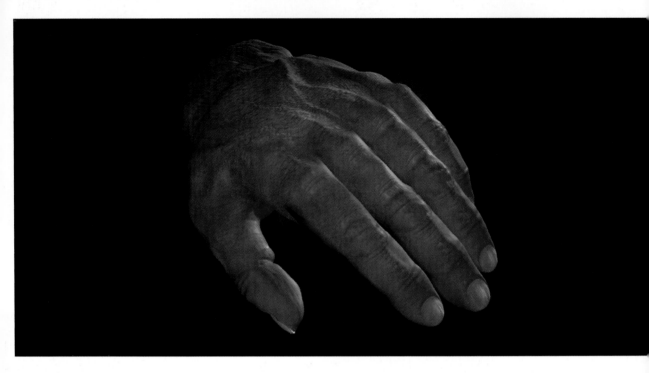

Take a look at the time-lapse video also included on the DVD showing this hand being sculpted in Mudbox.

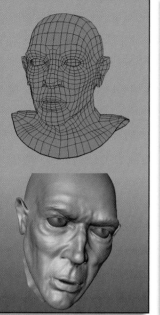

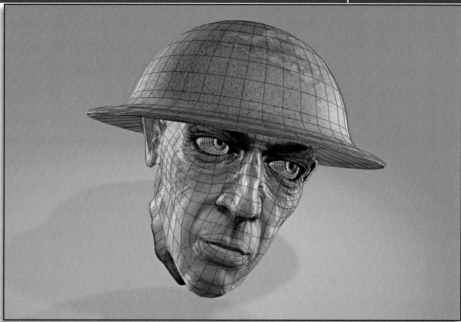

Realistic Head Modeling

The human head, a realistic one, is by far one of the hardest models to achieve. And even if you successfully tackle the modeling aspects, you have challenges with UV layout and texturing. The reasons many human faces continue to look fake are several, but it really comes down to the absence of finite details and contrast shadows. Usually the focus of the head area is around the eyes, which is by far the hardest part to model well. Don't get discouraged if your model doesn't come out favorably on your first few attempts. In time as your skills improve, so will the realism. Again, this is the hardest type of model you can attempt. This is because, as humans, we are very familiar with the subtleties of the face. A fantasy or futuristic creature can be more believable because it requires a level of imagination on the part of the viewer, but realistic human features are ingrained in everyone's memory, including children. It's one reason why feature animation studios tend to stylize their human characters rather than attempt full-on realism.

What We'll Learn

In this project, we will concentrate on the head and features to model an effective mesh that will allow further sculpting in Mudbox to flow smoothly.

 TIP: *As a beginning modeler, you have to walk before you can run. It's not realistic to think you will create a great head model your first time out. But as you do a model, then do it over, again and again, each time your process will get better and your work will become more refined. By taking the time to learn great techniques and to practice them, you will become a force to reckon with.*

Step 1: Getting Started

One Final Thought

It's important to understand that there are many ways or methods for modeling a realistic head, but in general there are a few specifics that need to be considered into the model. Proper edge looping around the eyes and mouth are of the utmost importance, especially for a character designed for lip-syncing and animated expressions.

This lesson focuses on the primary modeling requirements to achieve a realistic topology, a proper UV layout, and some detail sculpting. So let's get started.

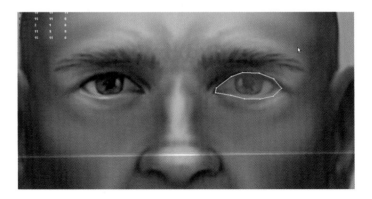

After setting up your template (facing Z axis), create a polygon shape following the inner eye; 8 to 12 vertices is best.

- Mesh > Create Polygons.

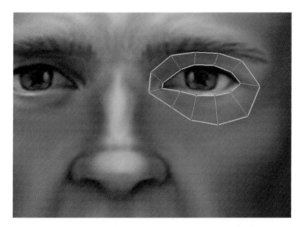

- Edit Mesh > Extrude the edges, and move them to the outer eyelid boundary.

Create a poly sphere shape, then scale and rotate it to the proper size and position.

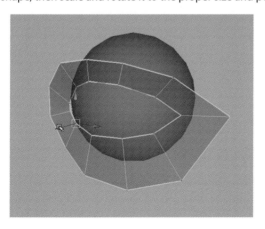

Now move the eye shape created so far up to the sphere. Work each vertice in the Z axis only so that it hugs the sphere (eyeball) shape tightly. Then move the outer vertices slightly forward to begin roughing out the natural shape of the eyelid.

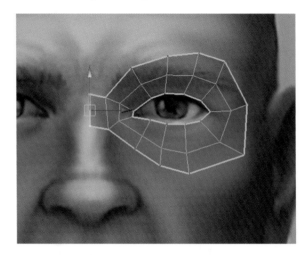

Extrude once more, continuing the same process. It's okay if you are uncertain about how far to push the edges. The head mesh will need to be worked and reworked many times over as you finesse the shape during the modeling.

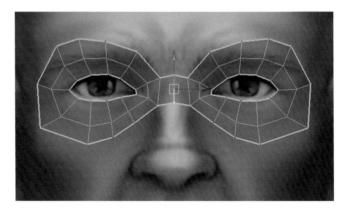

Our goal is to end up with three nice rows encircling the eyes. Use the Mirror Geometry feature to create the second side. Combine, then merge to connect the two.

Step 2: Building out the Nose

Who's the Man behind the Mask?

Sorry, I just couldn't help myself. What we are attempting to create is a nice eye mask. We will continue to build on this process pretty much throughout the entire head model.

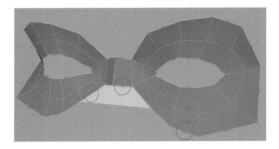

Now begin working both sides of the mesh, connecting edges using the Append Polygon tool.

- Edit Mesh > Append Polygons. Follow the purple arrow direction and select the desired edges.

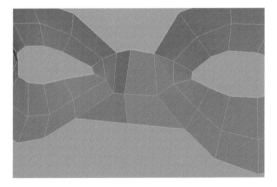

Be sure to hit enter to end the tool, or hit the Y key to end the selection but keep the tool open.

Split the faces as you work the shape of the nose bridge. Take your time and don't stress over the shape; it will all come together as you keep moving the vertices. But remember to move both sides using either the Move tool or the Scale tool.

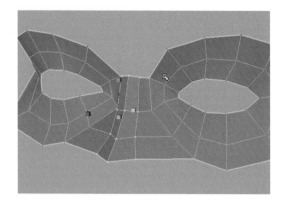

A split on both sides of the nose center will allow you to begin shaping the nose better.

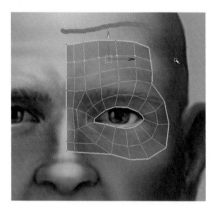

Once you are pleased with the shape, delete the other half (it's probably a good idea to work on one continuous side throughout a project). Remember to keep the edge loop flowing for proper topology. The brows should resemble a waving pattern; they should not be straight horizontally.

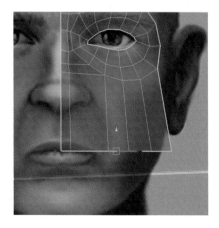

Now extrude the bottom edges to rough out the lower face. Use the Scale tool (Y axis) to even the bottom edge if you prefer.

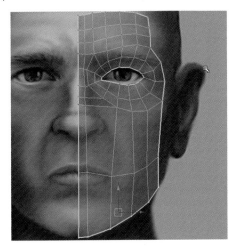

Now place the vertices to follow the basic jaw line. Also, split an edge loop through the center and define a new row from the middle of the lips and mouth.

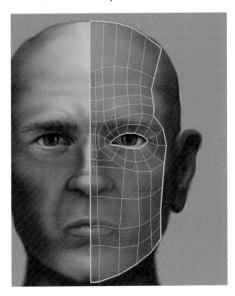

Continue to work all of the new vertice edges. Again, always keep in mind the flow of the face, such as the chin and mouth creases.

Begin Adding Details

Now we come to a tough area. Getting the nose and nostrils to look authentic can be challenging. The trick is to keep it simple for now. Don't add too much detail too soon. Modeling the face is similar to painting on canvas. Constantly work and rework all areas; don't dwell on one focal point.

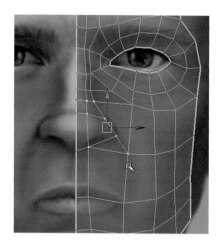

Split the outer nostril area. Do not be concerned about triangles, n-gons, and such. You can clean up all of these imperfections once the overall shape is in place.

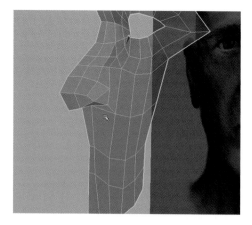

Keep switching the viewport to the side. Be sure to use the side viewport and not just rotate in Perspective because you want your vertices to move in the proper Z axis direction.

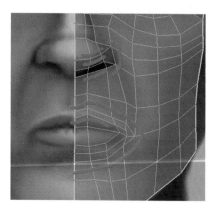

Creating the mouth requires care to get it right, but basically you're after an almond shape. Keep the flow circular as you did with the eye shape.

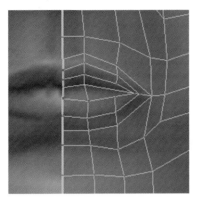

Three rows encircling the mouth is a good start to flesh out the basic shapes of the upper and lower lips. The crease from the nostril down to the outer lip area is very important for the proper facial expressions such as a smile.

Step 3: Working on the Profile

Now Comes One of the More Difficult Parts

Completing the profile curvature of the head mesh is where your skills will become tested and refined. You won't get it right the first time. If you do, then it was just pure luck. But this step is also the most rewarding part of modeling the head.

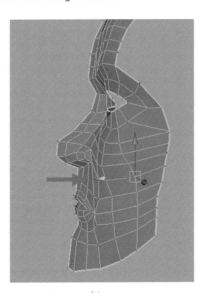

With the main front mask completed, we can now focus on pulling the vertices to the side profile to begin rounding out the spherical shape of the head.

Unlike the head we created in Chapter 7, The Pilot Bust, I am not displaying a template to show you where every vertice should be, simply because when you are creating an original, you won't have the option of a template either.

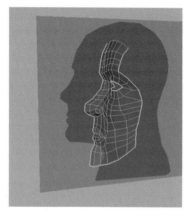

But I did provide an outline, soldierHead_profileTemplate.tif, to assist you in the general proportions of the profile. Obviously you should create a simple sketch like this too with your future projects.

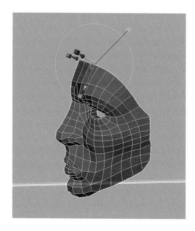

Continue to extrude the row of edges while scaling and translating them into the basic spherical shape of the head.

Notice the continuation of smooth flow lines to the face "mask."

Complete the same process for the lower jawline, working methodically to close in the face section.

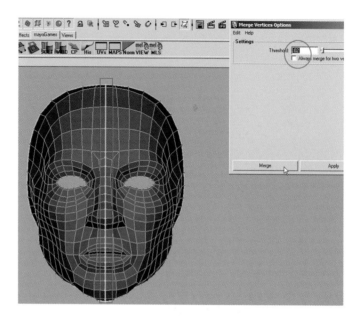

Once you have roughed out the basic head (remember to work on just modifying one side, deleting the second half, if there is one), follow these steps:

- Mirror geometry with each major change.
- Merge the vertices down the center with a low Threshold setting (.002 works well for me).
- Also remember to keep deleting All History, and saving the file in iterations.

Let me show you a trick for filling in the back of the head mesh quickly.

- Edit Mesh > Append Polygon tool.
- Select one edge at the bottom section of the head back.
- Select the opposite edge on the other side.

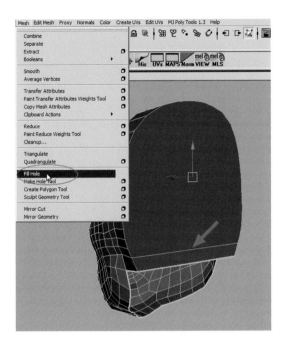

- Select the top edge of the newly formed face.
- Mesh > Fill Hole.

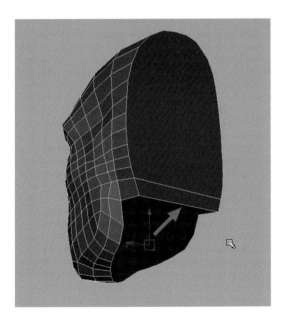

- Select the edge of the bottom of the newly formed face.
- Mesh > Fill Hole again.

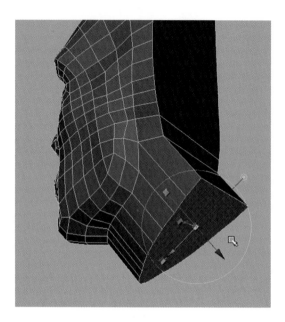

- Select the bottom face and extrude.
- Flatten the faces, if desired, using the scale box of the blue arrow.

Skip to step 4 if you do not wish to model the upper shoulders (not required).

> **NOTE:** *It is difficult and time consuming to generate the lower neck and upper shoulder region. Also, for the finished soldier these body parts won't be required because the uniform comes up to the top of the neck. I am including this section just to show you the modeling process for future projects you may encounter.*

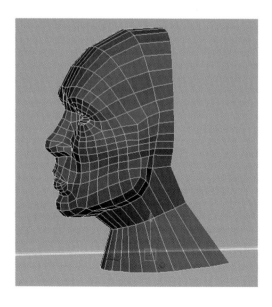

Creating the neck section is rather easy.

- Select all of the bottom faces and extrude.
- Scale all the faces horizontally, then rotate them at a slight angle as shown.
- Complete the extrude process once again, this time keeping the faces horizontal to the base.

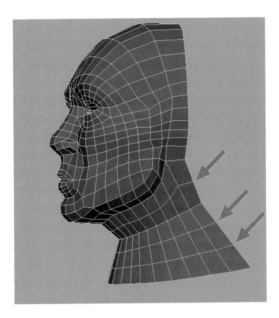

- Now add some Edge Loop tool splits to even out the mesh density and to begin modifying the neck and upper shoulder region.

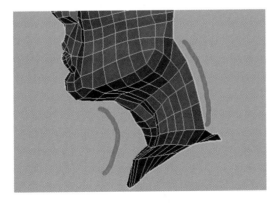

Shape the neck by pushing the vertices inward, creating a sloping "C" shape from the jaw to the shoulder.

Step 4: Modeling the Human Ear

Easier Than It Looks

One of the most unique shapes is the human ear. It can also be one of the more confusing shapes to figure out how to begin when you are creating a model. But I will show you a simple method of getting good results quickly.

 TIP: *Several great tutorials are available online that focus on modeling the human ear. Try a few to sharpen your skills and to learn other modeler's methods.*

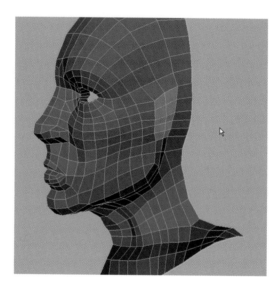

Select the 15 highlighted faces as shown in the image for the ear extrude.

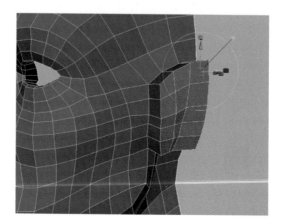

Extrude the faces outward slightly.

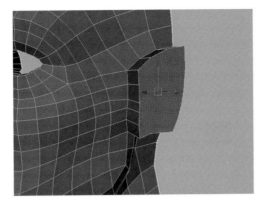

Again I prefer to delete the edges so I can work with one face rather than several aiming in various directions.

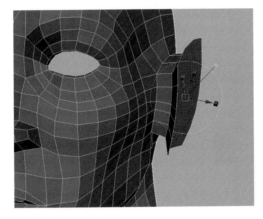

Extrude once again and scale larger now.

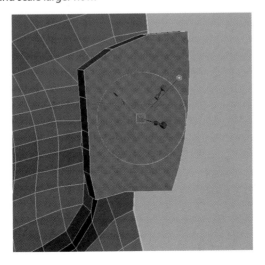

Now extrude once more to add thickness to the rim of the ear. Don't worry about proper proportions just yet.

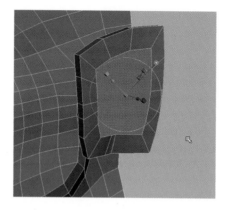

Now we'll extrude again, this time scaling inward.

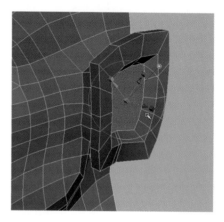

And extrude once more to add depth to the ear cavity.

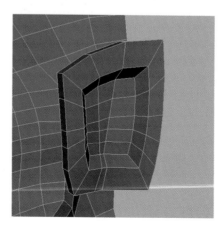

Now I will add back my edges using the Split Vertice tool.

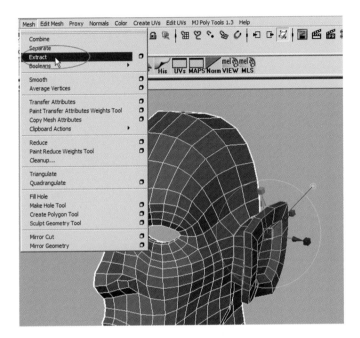

At this time I prefer to separate the ear from the rest of the head mesh so I can work on it, and from all sides, more comfortably. And because I am *not* going to alter the inside vertices at all, reconnecting the ear using the Merge tool will be a snap later on.

- Select the faces as shown.
- Mesh > Extract.

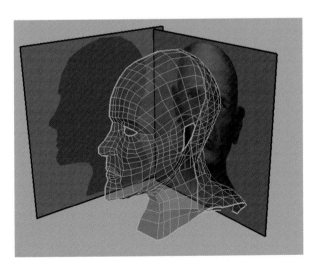

Here is the head with the ear mesh extracted from it.

- Select the ear mesh.
- Show > Isolate Selected > View Selected.

Continue reshaping the vertices, modifying the ear into the proper teardrop shape (upside down, of course).

No additional edges are required to finish modeling the ear. It's all just pushing and pulling vertices at this point to form the shape.

Because the ear is a separate object, you can make a duplicate and use the Blend Shaping process to see it in its smoothed version (refer to this method from the lesson in Chapter 8).

Once satisfied with the shape, you can reattach it to the head mesh.

- Show > Isolate Selected > View Selected to unhide the hidden head mesh.
- Select both meshes, and combine the two into one object.
- Merge the vertices where the two were joined to seam the mesh properly.

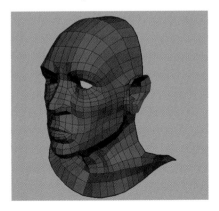

Check the final head now, and when you are ready to continue, mirror the geometry (X axis) and merge the middle row of vertices to seam together.

Step 5: Completing the Back of the Head

Many Options: Which One Is the Best?

We're now in the final stretch. This part is also a bit challenging to beginners, but there are several ways you can cheat the modeling.

Method 1

You could start with a polygon sphere mesh and change its Subdivision Axis and Subdivision Height to an approximate number of rows down the head (in this case 16 × 16 would work). Cut the mesh in half, modify the bottom section and attach.

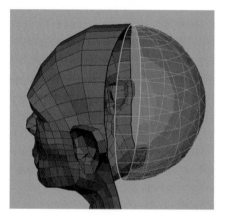

- Delete the front half of the sphere shape.
- Delete the bottom triangulated faces from the sphere.
- Append the bottom section so you can extrude the new face.

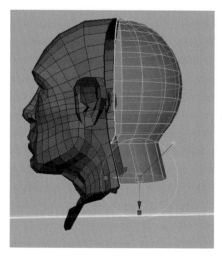

- Extrude the bottom face.
- Split new edge loops to match the front head shape.

Method 2

Fill in the back of the head with one face, and extrude the mesh in combination with the Split tool, similar to how much of the front half was created. This is the method I used for this model.

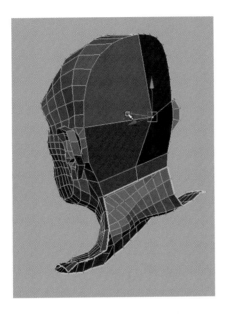

- Fill in the back of the head with the Append tool.
- Split the back of the face once horizontally and once vertically.

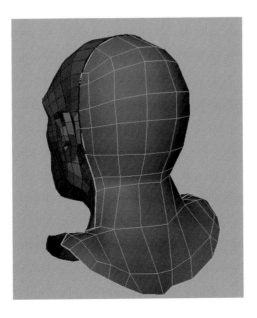

- Continue to add edge loops and rough out the dimensions.
- Add the same number of edge loops as in the front section so you can combine and merge the two halves properly.

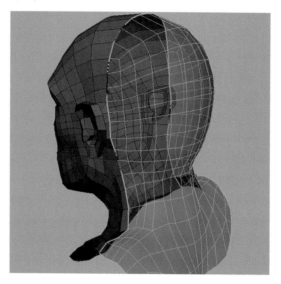

Here is how to line up the vertices:

- Select a vertice from the back section.
- Hold the V key.
- Move to the desired vertice location on the front section until the vertices snap together.

Step 6: Proper UV Layout Technique

Where to Start

I always apply a front planar UV projection and map it with the template image to see how the overall face looks. I'll even light and render to get a sense of the realism and topology flow.

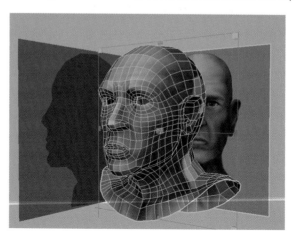

This technique is like those we completed in the first few chapters:

- Select the head mesh.
- Shift + select the template plane.
- Create UVs > Planar Mapping Options > Z axis.

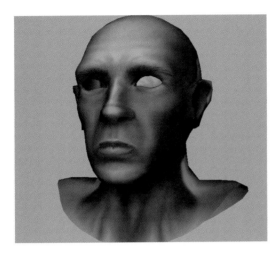

Select the head mesh, and apply the template shader material.

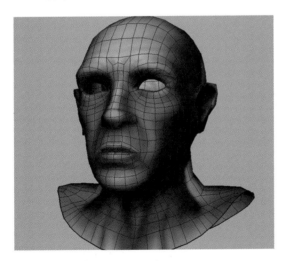

Review the look of the topology by turning on the wireframe. In the viewport menu selections:

- Shading > Wireframe on Shaded.
- Repeat the selection to turn the wireframe off again.

Unwrapping Using a Cylindrical Projection

One of the best methods of unwrapping a head shape effectively is using a cylindrical map projection. It tends to work better than a spherical map projection.

259

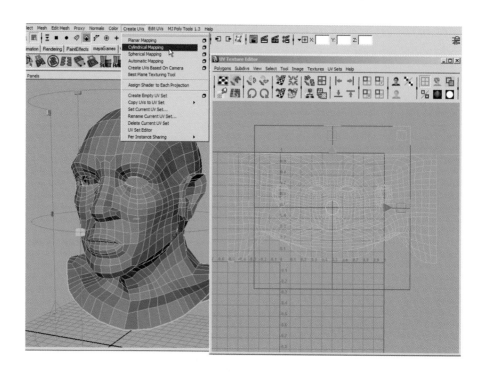

- Select the head mesh.
- Create UVs > Cylindrical Mapping.

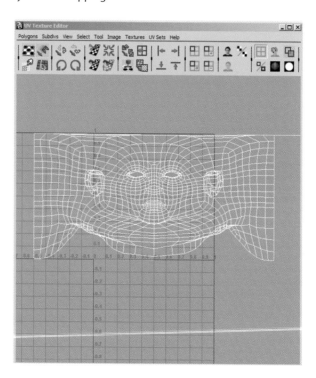

Here are the results of the mapping.

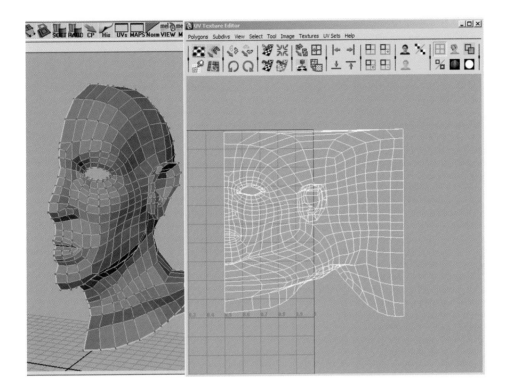

- Begin cleaning up the map by deleting half of the faces.

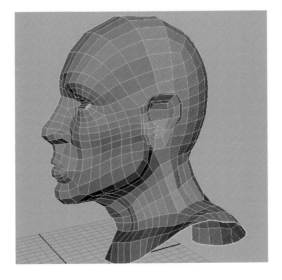

- Select the back half of the head and all of the ear faces.

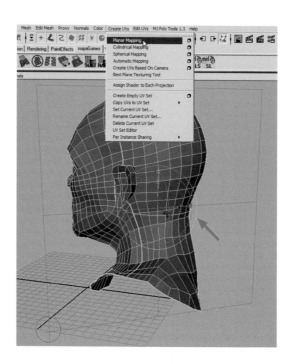

- Apply a Planar Map Projection in the X axis.
- Select the red "T" shape in the corner of the projection boundary.
- Select the light blue circle now to activate the rotation tool.
- Rotate the map direction in the Y axis (green circle).

- Select all of the ear faces, and apply a Planar map in the X axis again.

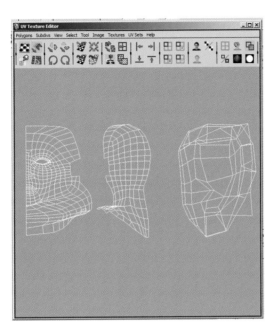

- Review the finished mapping layouts before editing.
- Be sure to move each "shell" away from the others so you can work effectively.

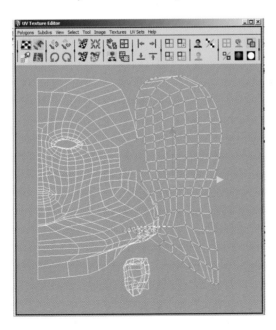

- Move the back head shell up to the front head shell to begin seaming the UV edges.

- Select one edge; the connecting edge will also highlight.
- Choose Sew Face to seam the two edges together.

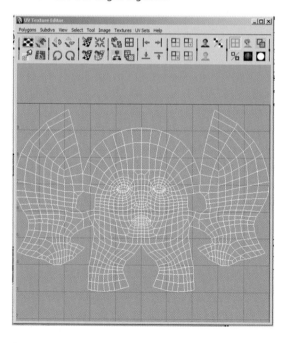

- Select the UVs on both sides and use the Scale tool in the UV editor, the same way you used it in your modeling.
- Once the basic layout is prepped, work on adjusting the UV on one side of the head.

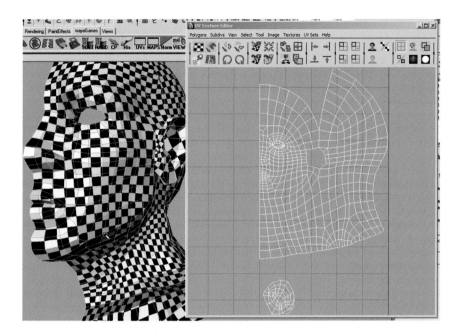

Apply the checker map shader, and review the UV textile density (notice the uniformity of the checker sizes are compared to various areas). Once pleased, select the faces on the *opposite* side of the UVs and delete; the mesh of half the head will delete also.

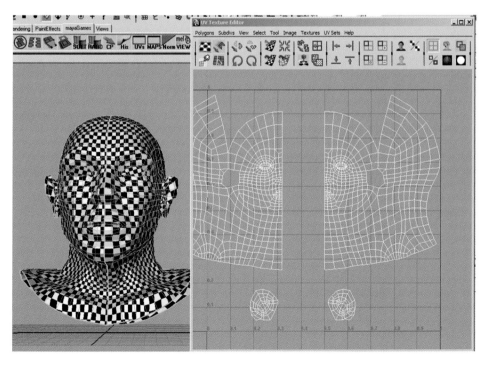

Now mirror the geometry of the head mesh, and flip the faces of the new side.

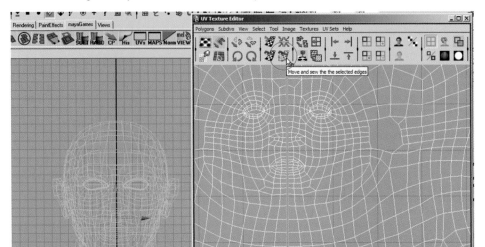

The final step for completing the UV layout is to select all of the edges down the center of the face UVs and apply the Move and Sew UVs Tool option in the upper menu icons.

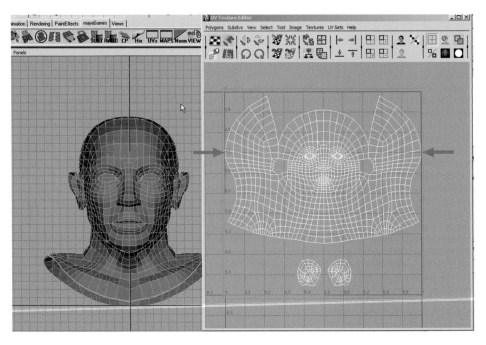

- Once pleased with the finished map layout, remember to scale it to fit within the 0/1 (upper right) UV grid.
- The completed UVs are now ready to be exported as an outUV Snapshot.
- Polygon > outUV Snapshot > Select map size. (The default location will be the sourceimages folder of the soldierHead project file.)

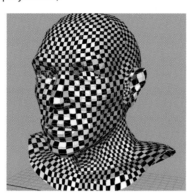

The finished head with UV map placement is now ready to be exported as an .OBJ file for Mudbox detailing.

> **NOTE:** *A slight distortion of checker size is okay, as this will be textured with a skin texture; there is room for slight imperfections.*

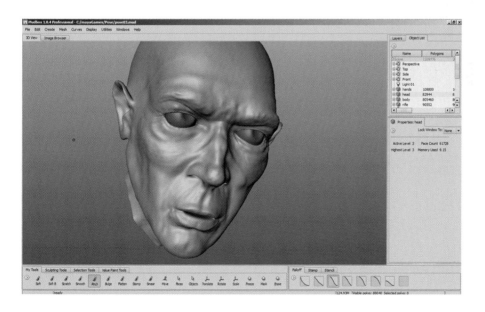

The final head is shown here in Mudbox after I added sculpting details. The Mudbox detailing went quickly and was completed within 1 hour. To learn more about the techniques used, follow along with the processes featured in Chapter 12, Digital Sculpting in Mudbox.

Wrapping Up

As with any 3D model, you can't fully appreciate your work until you texture and light a rendered image. In the case of this soldier's head model, I created a quick texture map of the face and made a few additional maps such as bump, normal, and specular. In Chapter 11, technique 5, I will demonstrate how to make these texture maps quickly and effectively for any modeling project.

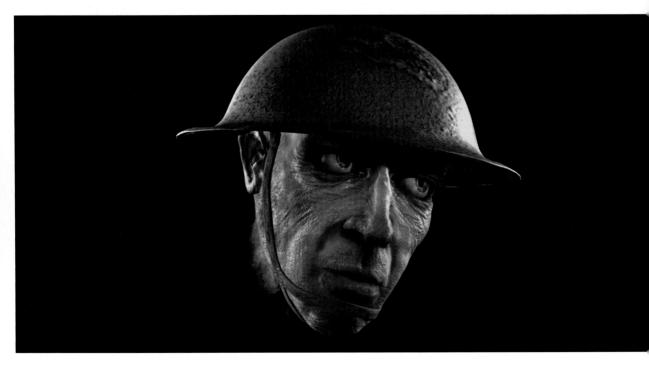

Here is the final sculpted and textured head. The test was rendered with the helmet.

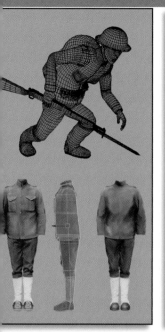

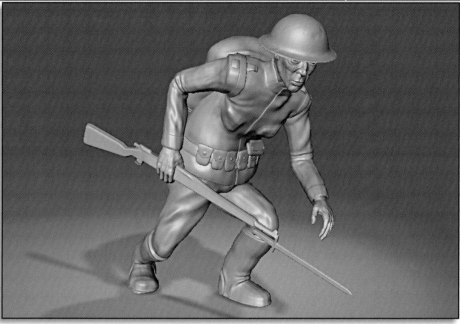

Maya to Mudbox Modeling: The Soldier

The rules of modeling have changed with the advent of digital sculpting programs like ZBrush and Mudbox. In the past it was necessary to build up your mesh, splitting polygons and adding definition in a slow and time-consuming fashion. Most of the "old school" processes are still valid and beneficial in your modeling workflow, but the benefits of achieving mind-blowing detail by using a sculpting application to get you from point A to point B quicker represents the new generation—or renaissance, if you will—of the modeler's future.

The Workflow Process

In this lesson I will demonstrate how to rough out a simple box model human form, in this case the soldier's uniform. I will then take the very low poly into Mudbox and add some details, bring the slightly higher mesh back into Maya for some touching up and changes, then go back into Mudbox for finalizing. I will also omit laying out UVs simply because I am going to use a series of UV transfer methods to still achieve a great UV layout after the high-poly mesh has been generated.

NOTE: *In this lesson, I am not going to mull over every detail step by step. Much of what there is to learn you now already understand. When it's important to do so, I will comment and demonstrate the proper tools or technique. But much of this lesson is visual, and you will find that modeling effectively is easier than you probably thought possible.*

Time Is a Virtue

"If I only had more time!" This is the veteran modeler's motto. There never seems to be enough time in production to accomplish what you really want. Even worse is handling the daily workload *and* trying to write a book at the same time! So needless to say, this lesson will be devoid of some accessories like the soldier's belts and backpack. Time permitting, however, I plan to complete this soldier with accessories in time for the book's publication. I will post the final images online and possibly even follow up with more "making of" tutorials for you to download.

Step 1: Keeping It Simple!

Letting Mudbox Do the Work

In this lesson, let's toss away everything you've heard about proper edge flow and definition. We will still take care with the model, but our goal is to produce the absolute lowest level of mesh possible in Maya and allow the modeling to take care of itself as we sculpt the details in Mudbox.

I have set up this basic template for you to begin with:

- Locate the project folder: Ch10_SoldierBody.
- Open file: soldierBody01.ma.

This model will be basic box modeling in its simplest form.

Be sure to constantly change the view from front to side as you shape each new extrude.

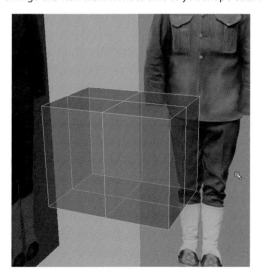

Rather than starting with a subdivided cube, just edge loop split as needed.

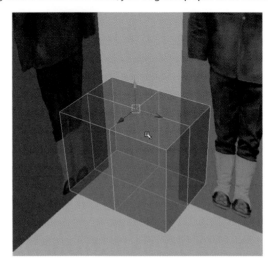

I personally prefer to remove edges so I can just extrude one face rather than having to select four in this case.

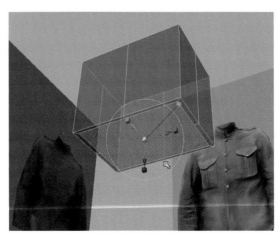

I'll start with the waist and extrude in the inner waist, defining the jacket rim first.

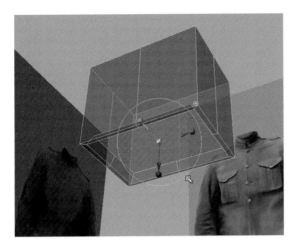

I reattached the edge split because I only wish to focus on modeling one leg.

Like the realistic hand we modeled in Chapter 8, the leg and arm require the same "knuckle" splits near the knee and elbow for proper deformation.

The shape for the boot couldn't be any easier, just a box for now.

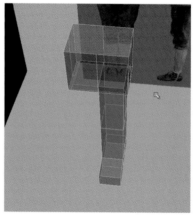

I'll focus on the upper torso now, again simple extrudes up to the neck.

I will taper in slightly for the shoulder region.

The arm may seem awkward when extruding on an angle rather than a 90-degree plane, but as you'll see shortly, we can reshape it rather quickly.

Now I'll delete one half and focus on the left side.

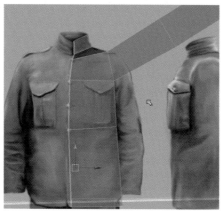

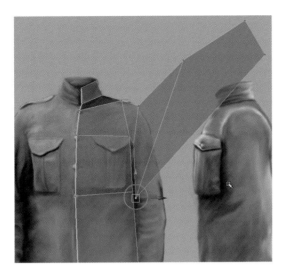

I drag-select over the vertices to ensure I am getting both the front and back sides of the mesh. Then I just pull the verts into position. If the position is awkward, it's always easy to go back and realign.

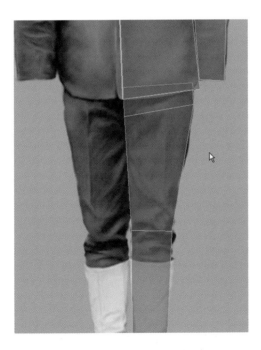

In modeling the legs, the bikini area is very important. You always want to have at least three divisions fanning out from the crotch area to allow good deformation in posing. I'll add more edge loops in a moment.

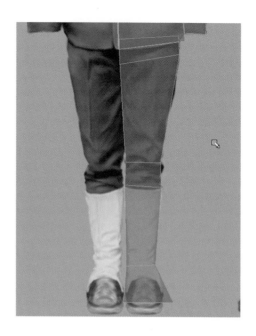

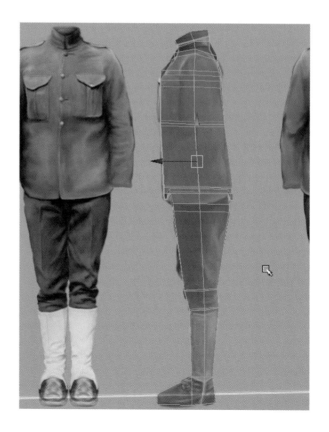

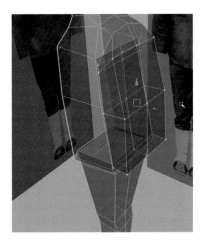

Time to focus on the side and shape the arm into a better topology.

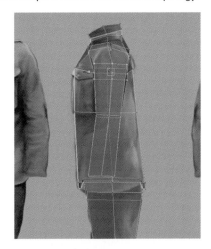

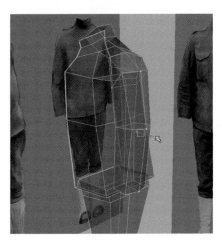

Take your time and let the center splits work for you. By pulling the vertices out gently, you can easily round out your square arms, legs, and torso.

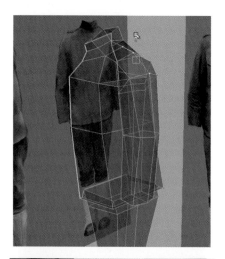

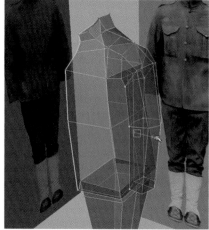

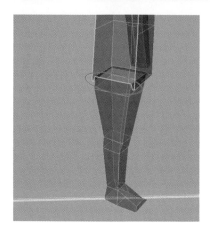

I needed to add the center split up the inner leg faces to assist in rounding them properly.

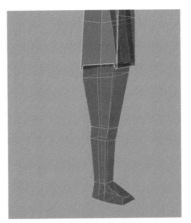

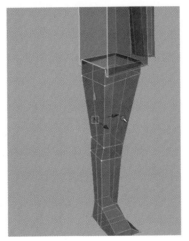

Because the center of the leg's interior is as far inward as I want it to be, this time I will move the two rows of vertices inward instead of the center row outward.

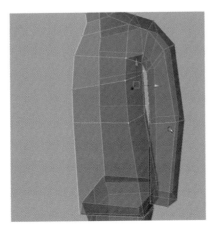

I'll keep the armpit area simple, even though it does look odd with a noodle-type bend. But I can easily work this into a nice crease later inside Mudbox.

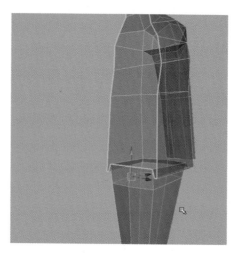

The inner crotch area is too high, and the top two faces need to be removed to allow the proper shaping for the pant's inseam.

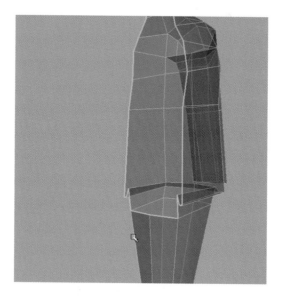

Step 2: Mirroring the Geometry

Beginning to Refine the Mesh

Now we are ready to take the model to its first stage of completion.

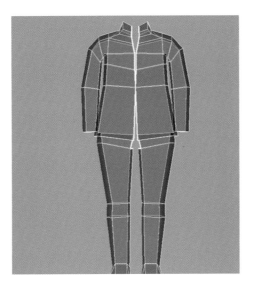

After mirroring, the curvature of the jacket pushes the dimensions outward too far. I'll show you how to easily overcome this issue when it happens to you.

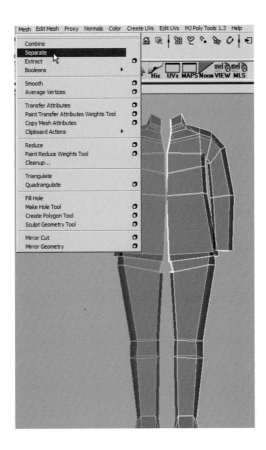

First, choose Mesh > Separate to separate the two halves into separate meshes.

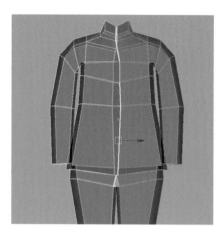

Next, pull one half into the general area you want the overall width to be; don't worry about overlapping geometry.

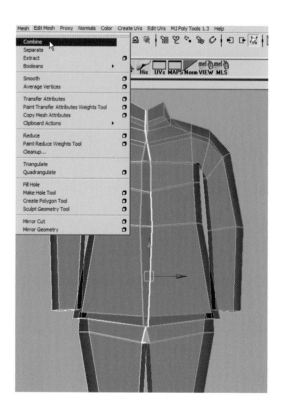

Combine the two halves again so you can merge the vertices.

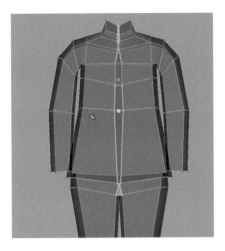

Select the middle vertices, and use the Scale manipulator for the side axis (in this case, the X axis).

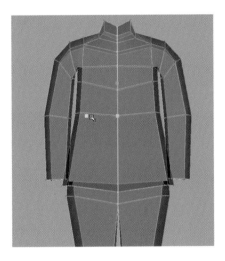

That will balance out the verts and put them into the same space as one another.

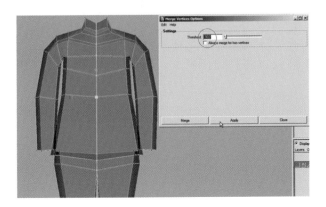

Now do a merge with a low setting such as .002.

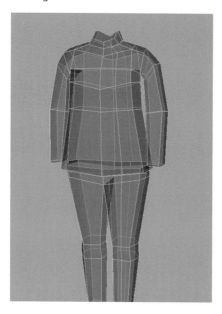

Having the general shape roughed out, I now wish to split once more through the leg and chest for a little more definition.

Like we did for the Pilot Bust lesson, do the same extrude inward for the neck cavity.

Do the same for the sleeve.

As we did for the fingers, we need to add two more edge loop splits in a fan shape for the elbows and knees.

Take time to reshape the foot. This can be challenging at times, so be patient with it.

After adding the remaining upper leg splits, we're now close to finishing for a Mudbox mesh export. Just one technical issue remains.

It's best to keep the mesh density equal throughout your model for digitally sculpting. If you don't, then the larger face areas won't sculpt as detailed as other areas with tighter density. To avoid this outcome, I simply edge loop split in the few areas shown in order to balance out the topology.

Step 3: Exporting Proper .OBJ Files

Preparing the Mesh for Proper Exporting

1. Delete History: Always Delete All History to remove any unnecessary nodes:
 - Edit > Delete All By Type > History.

2. Check for surfaces that are not quadragulated:
 - Mesh > Cleanup > Faces with more than 4 sides.
3. Did you lay out UVs, and are they overlapping?
 - Normal maps will not work correctly if you have UVs sharing the same space.

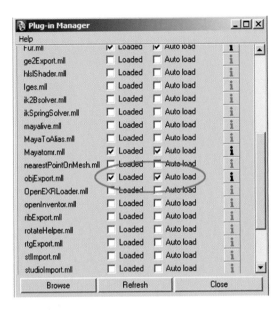

4. Is your .OBJ activated in the Plug-in Manager?
 - Window > Setting/Preferences > Plug-in Manager.

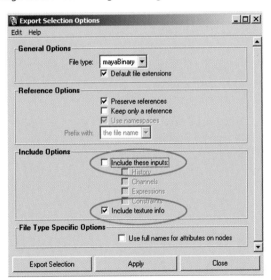

5. Are your .OBJ export settings adjusted properly?
 - Be sure Include these Inputs is unchecked, you don't want this information.
 - But make sure Include texture info is checked, this you want.

Step 4: Importing into Mudbox

Now It's Mudbox's Turn

Importing, Sculpting, and Exporting the Model

- Open Mudbox.
- File > Import. Locate your soldierBody.obj file.
- Select the mesh object in the Object List to highlight.
- Mesh > Subdivide Selection (repeat three times).

Inspect your mesh at Active Level 4 for any strange creasing, holes, and so forth.

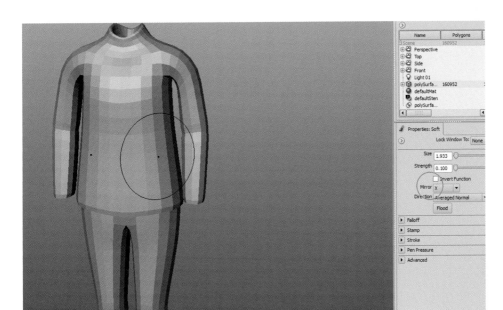

- If all looks good, then step down the subdivide level to Active Level 1.
- Select the soft brush.
- Set Strength to .100 to start.
- You can easily change the brush size by pressing the B key while dragging the mouse, just like in Maya.
- To sculpt on both sides simultaneously (recommended), check Mirror to "X."

You can begin to move vertices too if the brush isn't getting the detail or creasing you desire. For the armpit region I want a sharp, closed mesh.

- When ready, increase the mesh one level by Mesh > Step Level Up.
- Holding the ctrl key allows you to invert the tool. You can switch from pushing to pulling the mesh surface quickly.

In a short time you will notice the detail coming along. Mudbox is very easy to use and a lot of fun too. Don't add too much detail; your goal during this process is just to smooth out the geometry in some areas like the boots, chest, and jacket folds.

Take time on the boots; they won't be too cooperative because of the low poly count in the original, but get as much detail as possible for now.

Step 5: Back into Maya

Once your adjustments are complete, you are ready to take the model back into Maya. Follow these steps:

- Highlight the mesh by selecting it from the Objects list.
- Reduce the mesh density. Mesh > Step Down Level to Level 1 (approximately 2,260 faces).
- File > Export Selected.
- Save as .OBJ.
- Save a .mud file just in case too.

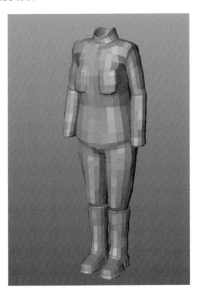

You can open a new scene in Maya and import your mesh or simply import it into the previous file. If you use the previous file, I recommend putting all of the older work into a layer and turning off the visibility.

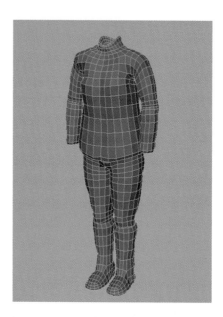

The new mesh imports back into Maya at a slightly higher poly count (1,890 verts)

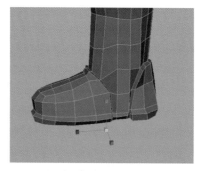

Now we have more geometry to begin working in some details like defining the boot area.

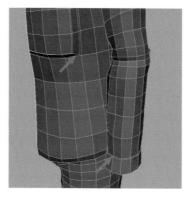

In places where you want the edges to remain crisp, add an edge loop split. I added one to the jacket cuff and two to the jacket pocket

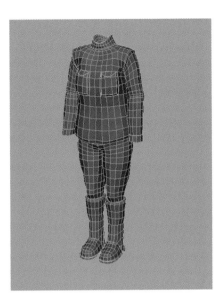

After spending a few minutes modifying the mesh, I am ready to repeat the process back into Mudbox for the final sculpting details. But I decided to pose my character as a statue for the final detailing.

Animated or Statue?

If you intend to animate your character at some point in the future, then it's necessary to keep it in a relaxed standing pose. But if you are simply creating a one-off statue for fun or for a demo reel turntable, then you could do a simple rig and bind and pose your character mesh before investing time in sculpting. This way you can add more unique nuances to your sculpt rather than the usual X-mirror detailing.

I decided to detail this character in a dynamic pose so I could add more depth to his clothing and action. I'm not concerned about UV layout or texturing because as you will see in the next chapter, I show a unique workaround that will allow you to transfer your UVs and textures from one mesh to the other.

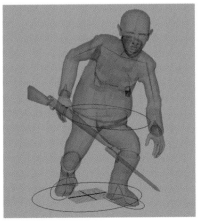

Posing the Character

I created a simple skeletal rig, smooth bound the mesh, and posed it. The scope of this book doesn't allow space for me to show the rigging process, but I used nothing more than a basic joint system.

I've included this rig in the scenes folder in case you wish to give it a try. Here are the basic steps to follow:

- Select the rig ROOT joint (the waist joint).
- Shift + select the mesh (if attaching the head and hands, select them too).

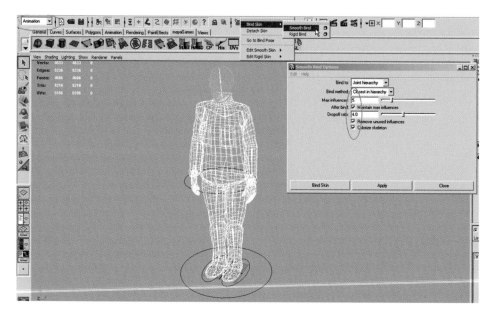

- Switch to Animation mode.
- Skin > Bind Skin > Options.

Default settings will work fine.

- Select Bind Skin.

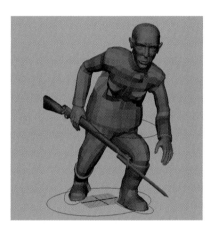

Finalizing Preparation for Export

- Delete All History.
- Select and export each mesh separately.

I included the separate posed .OBJ exports in the Ch10_SoldierBody/Pose folder for you to experiment with in Mudbox.

Wrapping Up

Mudbox is a great application. Spend time playing with the tools and settings. I would recommend not focusing on a masterpiece right off. Rather, use simple primary shapes and see how far you can push your skills within the tool itself. As you become more comfortable within Mudbox, you can explore the workflow from Maya to Mudbox and back again. This will make you a proficient modeler in no time!

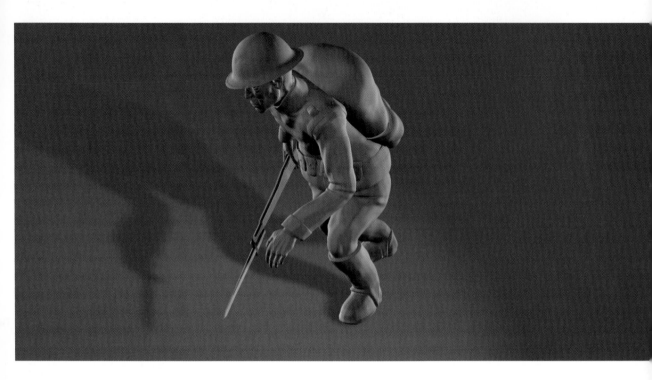

Here is the work-in-progress of the soldier statue. Only detailed sculpting and texturing remains before we can call this character "complete."

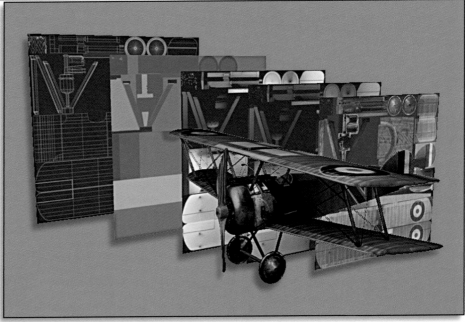

Texture Mapping Techniques

Texturing is by far one of the most critical parts of the 3D process. For this technique, it also helps if you are artistic regarding digital painting. But as you will see in this chapter, there are many processes aside from painting textures that will help you to achieve a great-looking 3D model.

To Paint or Not to Paint?

That is the question. If you are vying for a chance to break into the game or film industry and have poor texture-painting skills, then it's better to show your models in grayscale form than with poor or unrealistic texturing.

Texturing Is Much More Than Color

The color map is important obviously, but also critical for achieving great-looking 3D models in a game engine or image render is the combination of several other maps such as bumps, normals, occlusions, and speculars. I will discuss the purpose of each and how to create them in easily.

Technique 1: Proper UV Layout

Unwrapping Perfection

There are no magic button clicks that will lead you to a great UV layout. In fact, there is never a "perfect" UV layout, but you do need to be as clean and organized as possible. Without a clean UV set, you cannot expect to create the best texture. The following example should help you to understand proper UV layout.

Unwrapping the Biplane Cockpit

The biplane cockpit has an interesting shape that is worth considering. The overall shape has the same complexities you will face when unwrapping a character torso or robot, for example. Let me walk you through the process and tools for achieving a quick and effective layout.

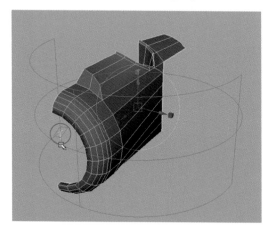

Setting up the UVs

We're going to use a cylindrical map for this part. It will yield better results than a planar map projection layout.

- Create UVs > Cylindrical Mapping.
- Select the red "T" shape on the display to initiate the light blue circle.

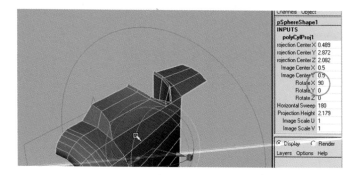

- Select the circle to initiate the rotate manipulator.
- Rotate the projection 90 degrees in the X axis.

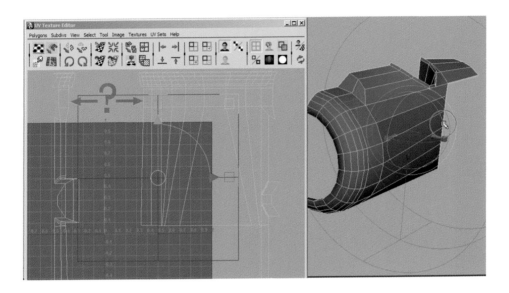

Open the UV editor and look at the mess you just made!

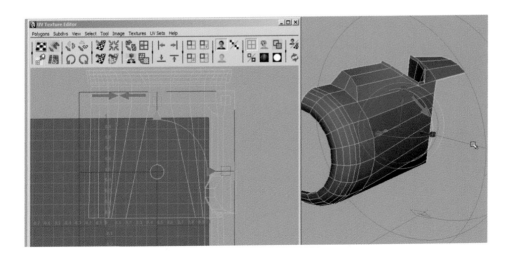

- Rotate the Z axis to the 90-degree mark. This will clean up the UVs quite a bit.

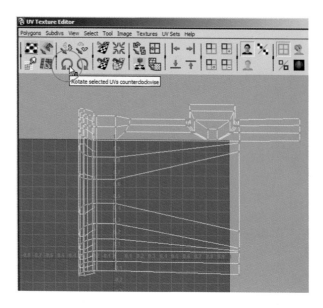

- With all of the UVs selected, rotate the shell twice in the counter-clockwise direction.

- Select the faces of the seat and the trimming, and apply an Automatic Mapping projection.
- Use the Reset function to make sure the default settings are used.

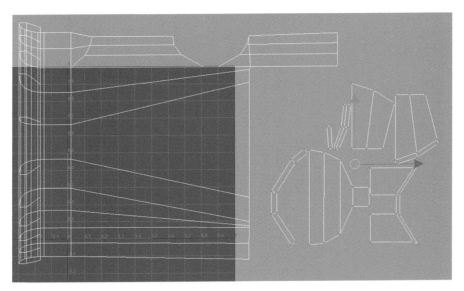

- Move the UV shells of the seat and trimming off to the side for clean up later.

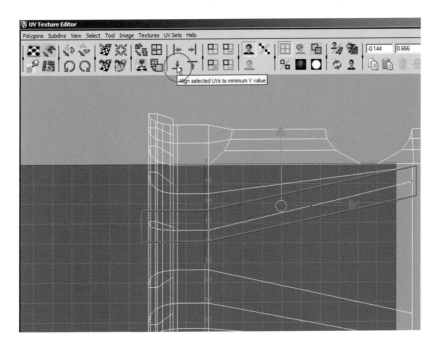

Cleaning up the Main Shell

- Select a row of UVs, and apply the Align selected tool.

- Another way to level out the UVs is to use the same scaling trick we use for modeling.

- Once the horizontal lines are straightened, we can pull out the edges from inside the casing.

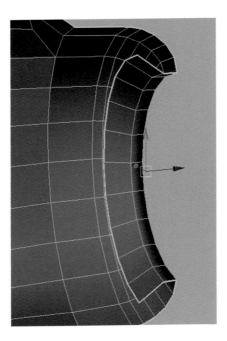

- An easy way to select these UVs is to select the inside edge loop.
- Select Edge Loop tool.
- Double-click on the edge to select the loop.

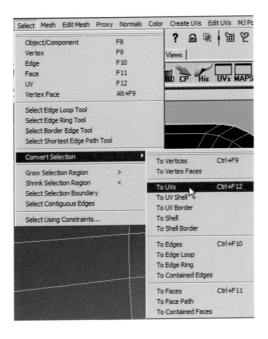

- Convert the selection to UVs.
- Select > Convert Selection > To UVs.

- In the UV editor move the selection to the left.
- Deselect the inner UV row and continue to move to the left, essentially "opening" the UV shell.

Here is the finished, clean UV shell. Now onto the cockpit seat.

- Select the seat faces, and apply the Create UVs > Automatic Mapping Projection > Default settings.

Begin sewing the cockpit seat UVs into one shell.

- Select a few edges that fit together > Move and Sew Tool.

You have two options regarding the layout of this UV shell. I decided on option 2, which was made after I did a basic clean unwrap of option 1. Because it is an inside object that will be covered mostly by the pilot, perfectly unwrapped UVs are not essential.

It's always a good idea to apply a checker map to inspect the quality of the UV layout.

Technique 2: Blockout Color Map

The Importance of the Blockout Color Map

Blocking out a base color map is important and helpful for several reasons.

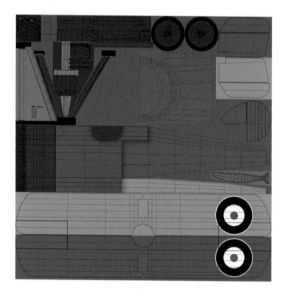

In most production pipelines you need to do two things: get the model into the game environment for testing and send it over to the texture department for final mapping. Here are two more reasons why the blockout map helps.

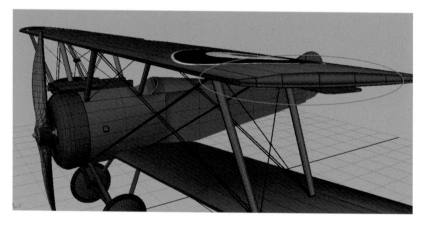

First, you can quickly spot any issues such as missed UVs, stretching, or wrong color placement.

Second, the base color will help you to address the seaming issues when edges meet. Through a variety of clever tricks, you can quickly and easily eliminate any noticeable seems without having to paint your model virtually in an application such as Deep Paint.

Technique 3: Photo and Hand Detailing Methods

Learning More about Texture Painting

Using photos and using a variety of Photoshop filters and tricks are the heart of polishing textures. An entire book can be written on the game texturing subject alone, and no one book can teach you everything, nor should it. So if you are seriously interested in learning the finer techniques of creating great-looking textures, I highly recommend *3D Game Textures* by Luke Ahearn, also published by Focal Press.

Enhancing the Color Map

Basically, a variety of photo references, metal, wood, fabric, propeller, and so on were used to overlay the base color. These overlays are also combined into a grayscale bump map and eventually a "dirt" or "grunge" overlay to bring more realism to the final texture.

The Dirt/Grunge map can also be created from a detailed bump map. This is the longest process of 3D texture map painting, but it is also the most important as a good painted map will make your modeling look many times better, especially when rendered in a game.

Technique 4: Creating a Seamless Texture Map

The Importance of Seamless Texture Maps

Seamless textures are used in many situations within gaming: walls, terrain, rooftops, and so forth. A small square map is created, for example, 512 × 512. By making the map seamless, you can repeat the texture multiple times without displaying any noticeable seams or repeating patterns.

To create a seamless map easily:

- Make sure the map is of proper size (256 × 256, 512 × 512, etc.).
- In Photoshop, go to Filter > Other > Offset.

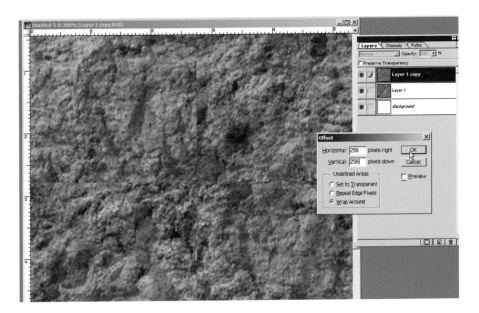

- Set the Horizontal value to {1/2} the map width, in this case 256.
- Set the Vertical value also to {1/2} the height, also 256.
- Make sure Wrap Around in selected.

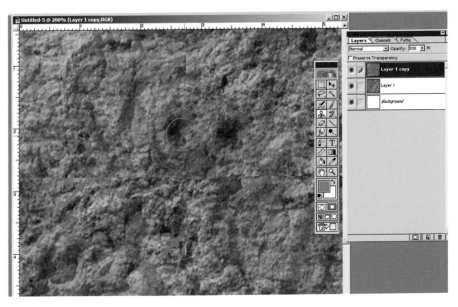

- Use the Stamp tool to copy a section away from the middle seam and begin to paint over the seam.
- Do this process to remove the entire seam edging.
- Repeat the Offset Filter once again, and save the map.

Technique 5: Creating Bumps, Normals, and Specular Maps

Building Realism Requires More Than Color

The addition of a slight bump map can make your model achieve much more realism than going without. Normal maps too can be generated rather easily from a bump map.

Here is a series of simple techniques of generating bump, normal, displacement, and specular maps using simple methods in Photoshop.

Example: Stone Wall

The Proof Is in the Render

I could go on and on about techniques and settings, but this next example is a perfect illustration of why every map is different, and only by testing different settings will you achieve optimum results.

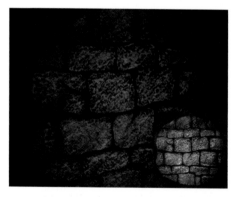

Render with Color Map only.

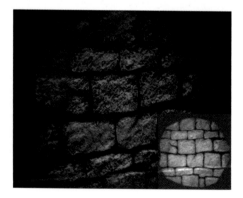

Render with Bump and Color Map.

Render with Normal and Color Map.

Render with Specular and Color Map.

Render with Normal, Displacement, Specular, and Color Map.

Starting with a Color Map

Most 3D artists will generate their maps after creating the color map first. Although I strongly recommend creating your bump map first, I wanted to show you how to achieve great results when creating additional maps from the color map.

I did an experiment in which I wanted to achieve a "claymation" style. I sculpted a brick castle wall in Sculpey clay, painted it, photographed it, and used it as a texture map. Now I'll show you a progression of tricks and technique for achieving great results. Of course, you don't need to use a sculpt; this technique will yield similar results with any photo or image.

Creating a Bump Map from a Color Map

Bump maps can be tricky. It's important to realize that you simply cannot grayscale a color map in most cases and use it as a bump map. As in this example, you want the depth and the height to be averaged. If you have a darker stone, then it will yield a lower height stone, which is not exactly the result you want.

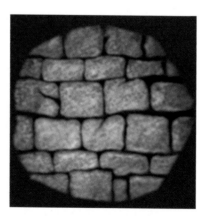

- In Photoshop, change the image from RGB color to Grayscale.
- If asked to flatten image, that's okay.
- Apply a slight Blur > Gaussian Blur to remove harsh edges.
- Brighten or darken the map depending on how much height you want.

Creating a Normal Map from a Bump Map

Normal maps can be generated several ways. One way is to render a normal map right from an application such as Mudbox. The second method is to transfer the map detail of a high-poly sculpt to a lower-poly mesh using Maya's Transfer Maps (see Technique 9).

The final technique and probably the easiest is to use the NVIDIA Normal Map Filter plug-in within Photoshop. The settings can be tricky, but you can achieve good results with a little tweaking.

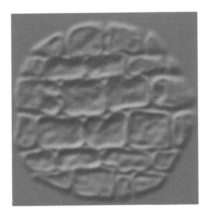

Use your newly created bump map, and convert it back to RGB. The NVIDIA filter won't work on grayscale color.

- Filter >NVIDIA Tools > NormalMapFilter.

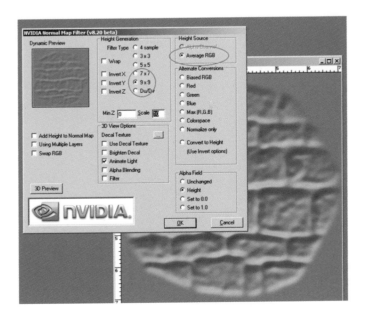

315

- Set your filter type value based on whether you want sharper or smoother details. For the rock I want softer details so a setting of 9 × 9 works well.

You also have two options, which also work well for Height Source:

- Average RGB or Biased RGB.
- Experiment with both, and see the results.

Creating a Specular Map from a Color Map

A specular map helps to control shine. Black has no shine, white is shiny. Obviously a rusted pipe would not be completely shiny. The rusted areas will read more realistically if you make them dull and make the nonrusted metal shiny.

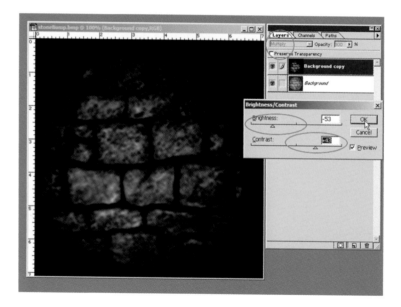

- One quick method is to grayscale the color map, then duplicate the layer in Photoshop.
- Use the Multiply filter.
- If necessary, adjust the Brightness/Contrast option to lower the shine even more.

Technique 6: Baking Occlusion Maps

Quick and Easy Shadow Detailing

A quick, light bake in Mental Ray can enhance your texture map tremendously. Shadows tend to be weak, especially in game development. Most game assets tend to still look fake because the lighting has to be generalized and not too many light sources are possible in a level, especially in FPS (First Person Shooter) games. So faking the shadows by giving the textures some contrast other than the effect that results from hand-painting can push your models into the next generation. Here is a simple and quick setup.

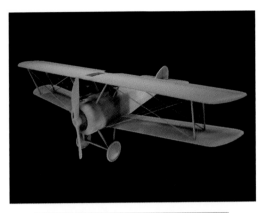

To achieve a balanced light, I import a simple Fake Global Illumination lighting setup. I have saved this lighting setup for you in the scenes folder (GI_Lighting.ma).

• Apply a base Lambert shader with Gray or White, depending on how much detail you want.

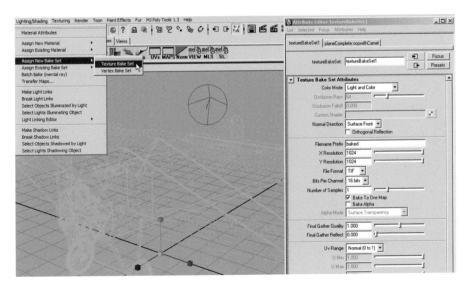

- Select your object.
- In Render mode, go to Lighting/Shading >Assign New Bake Set >Texture Bake Set.
- Set File Name.

> **NOTE:** *The render will save itself to the "project" folder, so be sure you set your project correctly to the file path you want.*

- Select Lighting/Shading > Batch Bake (mental ray)> Options.
- Objects to Bake: Selected.
- Bake to: Texture.
- Check On: Use bake set override.
- Set Color Mode to Occlusion.
- Set map size to the desired render size and format.
- Select Convert and Close.

The Maya Output window will display the render progress. Your map will end up in the renderData/lightMap folder, *not* the sourceimages folder.

The generated occlusion will have lighting and shadow baked into a grayscale map. You can then Overlay or Soft Light Filter this map over your Base Color map to begin adding depth to your model texture.

Here is the result of the two maps combined.

Technique 7: Using CrazyBump for Map Creation

CrazyBump Makes Map Creation Easy

I was so impressed with this seemingly simple application that I felt it was worth mentioning in this chapter. After tinkering around with the beta version, I contacted Ryan Clark, the creator of CrazyBump. Rather than demonstrating how to use his tool, I went straight to the source and asked him to demonstrate it for us.

ON THE DVD: *Ryan was also very generous in allowing me to offer a limited-use version of CrazyBump on the accompanying DVD. So install it and enjoy!*

Extracting Maps with CrazyBump

This is a simple demonstration of how you can quickly and easily create color, bump, specular, and, most important, normal maps. The illustrations show the resulting maps generated quickly by using CrazyBump. Several major game studios are now using this application, and I recommend learning how to use it effectively.

We'll start out with a basic photo-sourced rock texture to use for the creation of a wall.

Step 1: I clicked the "Open Photo from file" button, and opened the rock wall photo.

Step 2: CrazyBump asked me to choose between two basic 3D shapes, both generated by image-recognition. I chose the right-hand shape, because it looked better.

Step 3: I adjusted CrazyBump's normal map settings. I set "large detail" and "very large detail" to zero, because the rock wall requires sharp edges. Larger detail settings produce smooth edges. I also raised "fine detail" to 99, to capture the roughness of the surface.

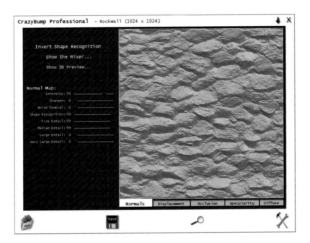

Step 4: I adjusted the specularity map. The default settings looked pretty good in this case. I only raised the contrast.

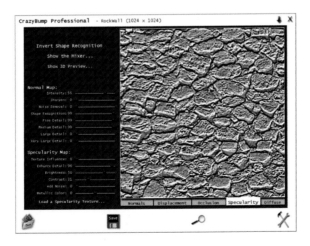

Technique 8: Transferring UV Sets

Transferring a UV Set

Okay, you got all excited and began sculpting your mesh in Mudbox before you took the time to carefully unwrap your mesh. (Don't deny it; we all do it!) But now your Mudbox sculpt came out

much better than you thought. Now what? Not to worry, I have a cool solution. It does have a few specifics, but otherwise it works flawlessly.

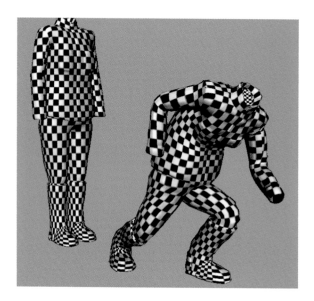

Using Maya's Transfer Attributes, we can transfer one clean UV set to an identical poly count mesh.

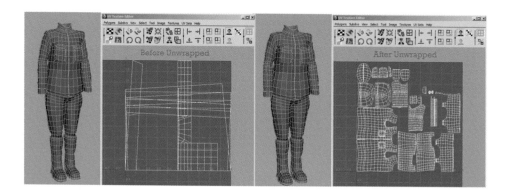

The first step is not easy.

- You will need to unwrap the mesh properly, but you can do it on the low-poly mesh object before it was deformed or sculpted.

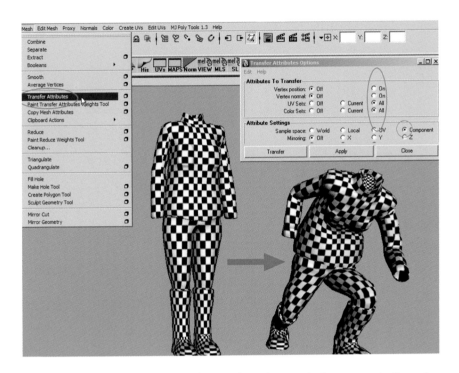

- Bring both meshes into one scene. Make sure the poly count is the same on both meshes, otherwise the technique will not work.
- Select the good UV source mesh first. Then shift + select the target mesh second.
- Mesh > Transfer Attributes > Options.
- Make sure UV Sets is checked to All.
- Color Sets can be checked to All too.
- Attribute Settings: Component.
- Select Transfer.
- Apply a checker shader map to ensure a clean UV layout.

Technique 9: Transfer Maps

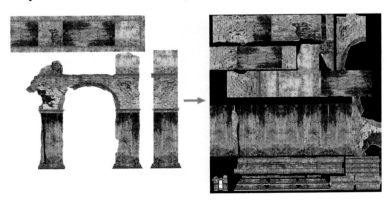

Benefits of Transferring Maps

Version 8.0 provided new toolsets for transferring maps such as color and normals very easily from one mesh to the other. This opened up many easier and interesting methods for creating texture maps.

Imagine for a moment that you have an object that has been modeled and textured, but because of time constraints it is poorly UV mapped. You quickly apply eight various color maps to different faces. It looks great and gets the art director's approval, but now it needs to be cleaned up properly for in game use. You make a duplicate of the mesh, take some time to lay out the UVs more efficiently, transfer the maps from the bad mesh to the new improved one, and viola! You now have one nice color map that can be touched up and plugged right into the game. I have used this very technique many times and am still blown away by its efficiency and ease.

We'll do it now on our wall, but first a few guidelines:

1. Our wall will only be seen from one side in the game, so we are not going to waste much texture space on the back faces.
2. We will do touchup and apply texture magic to the map after the transfer.
3. We'll generate good-quality normals maps from the color map.

Ready? Let's Do This Thing!

- Start by creating a new layer and applying the wall mesh to it.
- Then create a duplicate mesh, and make another new layer; apply the new mesh to the new layer.
- Turn off the visibility of the layer of the old mesh.
- Now we'll lay out the UVs in a more efficient manner.

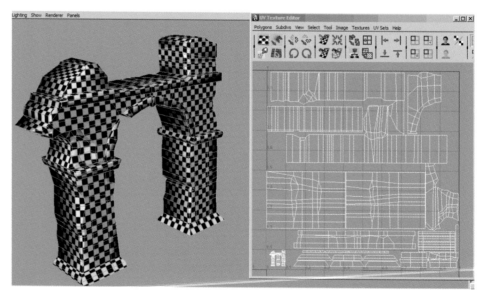

Transferring Maps Technique

- Select your new wall mesh.
- Go to the work mode drop-down menu and switch to Rendering.
- Lighting/Shading >Transfer maps editor.
- Target meshes should be the new duplicate wall with the new UV layout.
- Source meshes should be the original wall with the overlapping UVs.
- Select the Diffuse color map from the Output Maps options.
- Click on the folder, and find the path to your sourceimages directory.
- Make sure Connect Output Maps is a new shader and checked.
- Set the Maya Common Outputs to whatever your desired map size is. I strongly recommend 1024 as higher resolutions will take a long processing time. You could do a test map at a lower setting to make sure everything is working first.
- Sampling quality will also improve your map. Medium is a good starting point. Again, a higher setting will slow down Maya substantially and is very RAM intensive.
- I find a filter size of 3.000 works well for most.
- Select Bake and Close.
- Maya will not only make the new texture, but it will create a new shader and apply it to the new wall mesh automatically.
- Under the Renderer menu on the interface window; if you select High Quality Rendering, you can see your results, even with normal map effects if you have them. Not all video cards are capable of displaying this option in Maya.

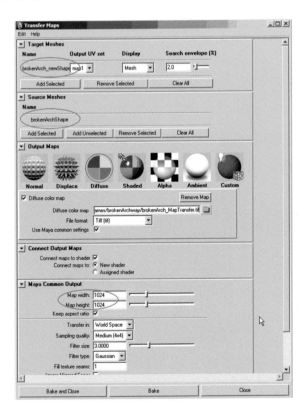

Very Important for Transferring Success

- Make sure both meshes are on top of each other. The separate layer will help you to view and select each mesh without difficulty.
- Any hard or soft edges will transfer into the new map, especially when it comes to normal maps.

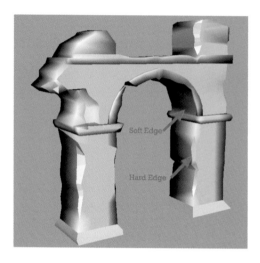

The Reasons to Use It Are Simple

Many times photos or concept art will accompany the order for an asset in game production. And the art department will spend great amounts of time to make the image look good for art director approval. It's time consuming and foolish to create a high-quality concept art only to have the texture department need to recreate it in a more 2D form. By using a little common sense, the art department can help the modeling department to get the texture map "almost there."

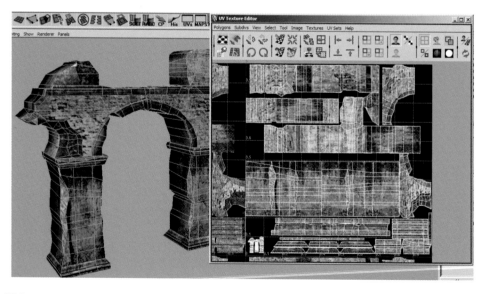

Now all that is required to make this model perfect is some detailing to the map; a few nips and tucks and we can generate a new normal map and call this model complete, or as we say in gaming, "Ship it!"

Technique 10: Using Renderings for Color Maps

Faking Photo Realism Easily

Creating convincing color maps is essential, but another way to push your models over the top is to light and render your objects, then use the render for your color map. Here's how it's done.

The Biplane Wing

In this lesson, I am going to demonstrate how to create a 3D render to be used as an overlay for a texture map of the wing. You could also detail a high-poly model with textures, then simply render a snapshot for even higher realism.

Why hand-paint the ribs of the wing when you could use real geometry to do the work for you?

- Begin by using a square mesh so rendering will be uniform to a square map.

- Pull in every other vertice edge to form three beveled ribs.

- Once pleased, you may wish to smooth the mesh to remove any chiseled edges. Remember this will only be rendered, not used as part of the model.

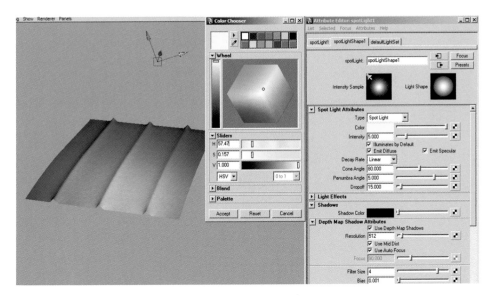

- A simple spotlight with drop shadow is necessary to add depth. You could also use three lights to avoid shadowing in any one direction.

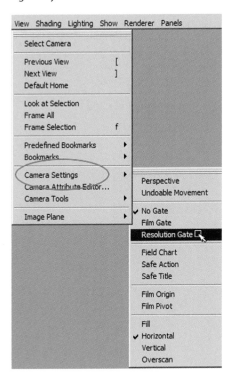

- In the Top View panel, open the Camera Settings > Resolution Gate. This will display the render boundaries.

- Zoom into the mesh until it fills the boundary line completely.

The rendered image can be taken into Photoshop and used in the bump map or detail overlay creation.

You can add much more detail such as rivets, creases, bullet holes, and so on.

Here is the rendered riveted wing panel.

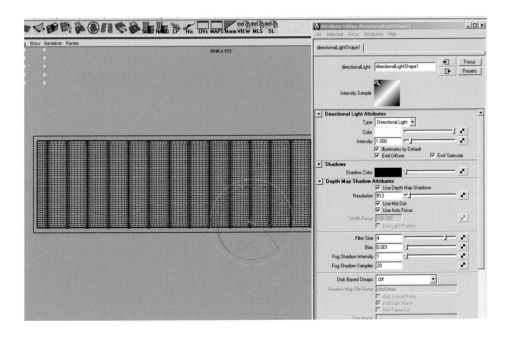

Here I duplicated the panel several times and created one long map to be used for the wing. I did have to alter the light source to a direction light because the spotlight had a noticeable falloff.

Here is new rendered wing panel ready to be used in Photoshop.

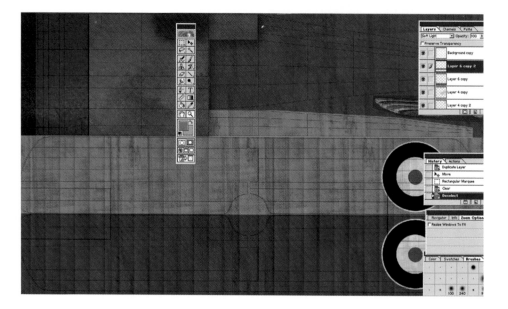

In Photoshop, I use the panel as an overlay and also in my bump/normal map creation.

Here is the final rendered image created without any hand-painting work. This is a great technique if you are not artistic or experienced with digitally painting textures.

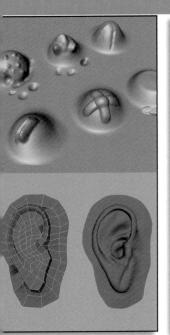

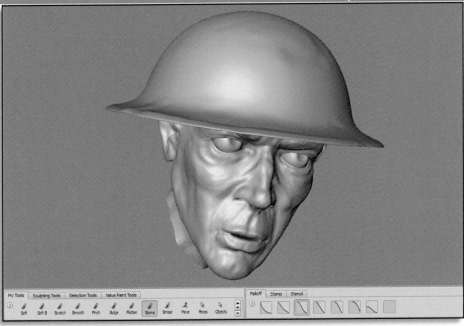

Digital Sculpting in Mudbox

As the previous chapters demonstrated, digital sculpting has become part of the modeler's toolset for the next generation. I cannot stress enough the importance of traditional art skills such as anatomy drawing, understanding light and tone, and clay sculpture. Artists who possess these skills will always run circles around artists who simply have technical 3D training. I have seen work created in Mudbox by clay sculpture artists who never even used 3D before, and their work blows the doors off of the best veterans around. It's proof positive that this tool will be around for a long time, and the sooner you learn and practice how to use it effectively, the sooner you will find yourself working at the best studios in the industry.

Why Mudbox and Not ZBrush?

Both are great applications. I have nothing bad to say about ZBrush, but personally prefer Mudbox, and here's why: Mudbox has a simple, easy-to-understand interface. Novices can be up and running in a few short minutes, and best of all the interface and keyboard shortcuts closely resemble those of Maya. In fact, you can customize the keys to your preference too. If you're saying, "ZBrush has texture painting capabilities and Mudbox doesn't," that's true, but

for only a short time longer. Mudbox 2.0 will introduce texture painting, and once it does, this application will become the new standard in the 3D sculpting and texture painting arena in my opinion.

Is Mudbox Hard to Master?

Nope. Actually it's much easier to learn than Maya is. Think of using Mudbox as working in digital clay. What makes it so much fun is its ability to work fluidly with high-density meshes of a half-million to a million polygon objects and higher! Depending on your computer's power and RAM, you can do very detailed work in Mudbox.

What We'll Learn Here

This chapter is not intended to teach you all the details of Mudbox; rather it will skim over the more important tools and processes to help you locate the "how and where" of the application. The following lesson on detailing a realistic ear will give you a good generalization of sculpting in Mudbox and workflow from importing to exporting of a mesh object.

Step 1: The Mudbox Interface

Understanding the Menus and Tools

The ease of Mudbox lies in its simple interface. It is easy to navigate the tools and functions, and many of the shortcut keys mimic those used in Maya. Here is a quick overview of the menus and tools.

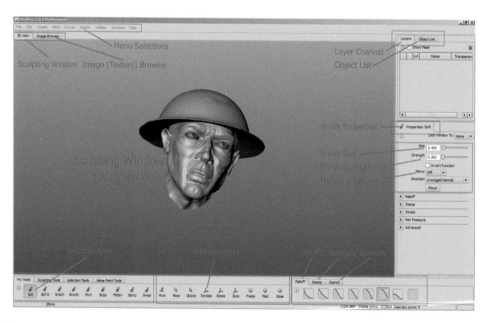

3D View

Allows you to view and sculpt your model in the Mudbox window.

Image Browser

Allow you to search for the model's texture map so you can work directly on your textured model.

Layers

Allow you to create a working layer for different mesh parts or for different sculpting changes. Just like in Photoshop, you can modify your sculpt then use a percentage scale to adjust the sculpt opacity level from 0 to 100 percent. Layers can also be locked so that they are visible but unselectable, similar to Maya's layer channel "R" render mode.

Object List

Allows you to select individual mesh parts, lights, and so forth.

Properties Channel

Displays the properties of the selected brushes in use and allows modifications in power, brush size, mirroring, falloff, and so on.

Toolbar

Located on the very bottom, My Tools displays all of the brushes, translations, and masking toolsets.

Falloff/Stamp/Stencil

A visual display of the brushes Falloff options in addition to the Stamp and Stencil map choices.

Step 2: Importing Meshes and Adjusting Density

Proper Import and Sculpt Development

It is important to ensure that your imported mesh is in .OBJ format. Of equal importance is that the mesh is in quads and a clean UV set has been applied before you start to sculpt.

Once imported, the mesh needs to be subdivided several times to increase the density for sculpting fine detail. You can increase the subdivisions as you progress in the sculpting process or at the beginning, then reduce the levels back down.

It is important to work your mesh up in detail from a low level to each higher-level progression. Starting at the very highest setting is not the correct workflow; however, you can do some quick detailing at high settings then lower the levels to begin. Sometimes this "cheating" method saves time rather than having to use the Move tool.

Step 3: Using Different Brushes and Falloffs

Which Brush for Which Use?

The falloff is simply the profile of the brush. An angled taper falloff will create a sloped edge as opposed to an outward curved edge, which will be more of a bulging outer curve. My experience shows the falloff providing little difference when working, especially when you are using low-pressure settings.

There are several specialized brushes. Here is how each one functions:

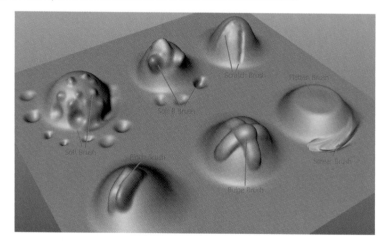

- **Soft:** A great brush to start with for adding general detail and shaping to the mesh.
- **Soft B:** Similar to the Soft brush with one major difference. Soft B does not use velocity when stroking the brush. In other words, it will provide clean lines regardless of how fast of slow you paint.

- **Scratch:** This is a great tool for for cutting creases, crow's-feet, and scars into a mesh area. Using it in combination with Bulge and Pinch brushes can make incredibly realistic skin details.
- **Smooth:** This brush will soften the mesh and reduce any sharp edges that sprout up during the sculpting process. While you are sculpting with another brush, holding the shift key will enable the Smooth brush and automatically disable the currently selected brush.
- **Pinch:** This brush will pull the vertices and faces together into a tight seam. It is very helpful when used in combination with the Scratch brush for creating creases and wrinkles in the skin and surrounding eye detail.
- **Bulge:** Swells the mesh substantially in all directions of face normals. Most effective when used next to Pinch brushes to accentuate creases, wrinkles, and folds of skin and cloth.
- **Flatten:** This brush allows you to flatten or dull the height of the mesh surface. It's a handy tool that is especially useful for rigid object sculpting such as metal objects or for stylized characters with chiseled mesh edges.
- **Stamp:** This brush allows a map to "stamp" its image onto the mesh. Meshes need to be in a higher density level for good results. The image can be scaled and dropped onto the mesh, making it easy to vary from large to small patterns.
- **Smear:** This brush will pull the vertices dramatically and needs to be used carefully. Also, your UV set will most likely require a new layout because the older UV set will become distorted.

TIP
Reversing the Brush Stroke: *You can reverse the direction of the brush stroke from "pulling" to "pushing" the geometry dynamically by holding down the ctrl key. You can smooth out rough areas dynamically by holding the shift key too. This makes Mudbox efficient and easy to use.*

Step 4: Using Stamps and Stencils

Both Powerful Texturing Tools

How Stamps Work

Stamps allow you to pull and scale a square map to various sizes. When you release the mouse button, the stamp will apply itself to the model.

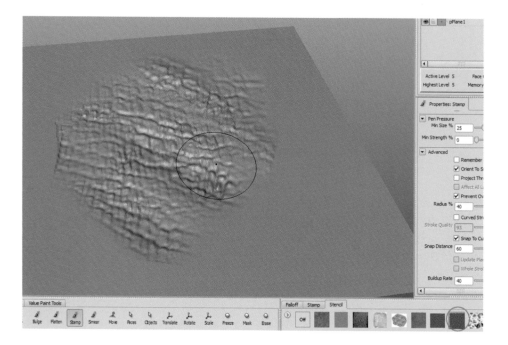

Using Stencil Maps

Stencils are alpha maps that can be used for painting with a texture. Drag setting can be enabled, allowing you to pull the texture across the model surface. The stencil maps can also be custom created in a program such as Photoshop.

Adjusting Size and Rotation of the Stencil

Middle mouse click allows Scaling the size of the map. Press S to click and drag to rotate the stencil image while working.

Tiling and Hiding the Visibility

You have the ability to tile the alpha map. It is recommended that the map is seamless first. You can hide the visibility of the stencil map in the Advanced channel.

Step 5: Utilizing Layers

Here is how you can select and work on individual meshes.

In the creation of the soldier model, I put each individual object onto its own layer, allowing me to turn on and off parts of the character as I worked. This makes it easy to sculpt the top of the soldier's head by turning off his helmet, sculpting his jacket without the tool belt interfering, and so forth.

You can also add detail to a new layer, which can be adjusted using a transparency slider that allows degrees of detail from 0 to 100 in strength.

Step 6: Exploring the Various Display Modes

Smooth Shade, Textured, Wireframe

You can display your mesh however it feels most comfortable to you. Obviously wireframe allows you to check the density, and smooth shaded removes the hard faces. I personally find it most helpful to sculpt with smoothing turned off. I prefer to see exactly where my faces and edges are and how they are deforming during the sculpting process.

Showing a Model's Texture Map

It is easy to display the texture of a model while sculpting in Mudbox.

- Select Image Browser tab.
- Locate your texture map folder.

The folder will display all maps inside the left column.

- Find your desired map. (Note that some image formats will not display in Mudbox.)
- Select the Set Color Map icon to show texture on the mesh.

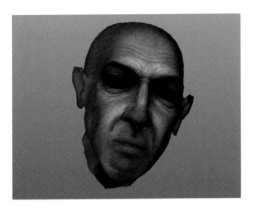

- Select the 3D View tab again to switch back into the display panel.
- Texture is now on the mesh and helps to define areas better requiring sculpt detailing.

Step 7: Baking Maps

Generate Normal and Displacement Maps

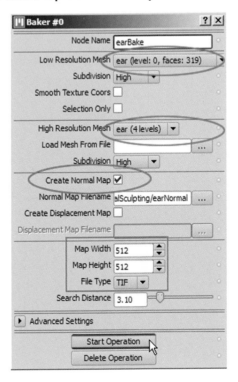

Part of Mudbox's ease is how quickly it generates highly detailed baked maps of the mesh. You can select the level you wish to capture for baking, and Mudbox will export the map easily. Sometimes it can stall on very high meshes at their highest level. So one trick is to subdivide the mesh one level higher than desired (if possible) then reduce down one level before exporting your map.

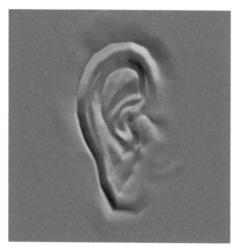

Step 8: Detailing a Realistic Ear

A Practical Test Project

- File > Import > Ch12, DigitalSculpting/realisticEar.obj.
- Choose Open.

Select the Display menu, and try checking on and off the different display options such as Smooth Shade and Wireframe.

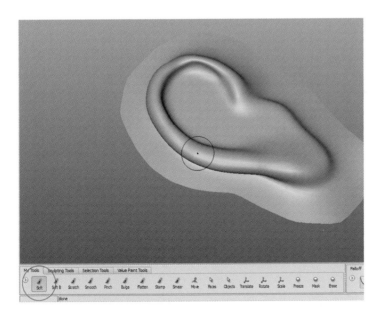

Begin by increasing the Mesh Density by Subdividing the mesh.

- Mesh > Subdivide Selection. Do this for three to four levels.

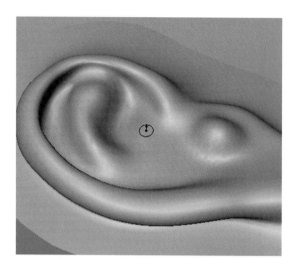

- Pressing the B key allows you to adjust the brush size.
- Holding the ctrl key allows the brush pressure to be inverted, usually pushing rather than pulling the mesh surface.

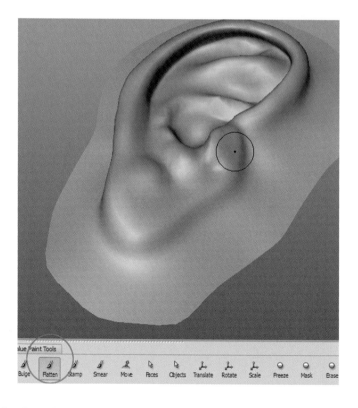

The Flatten brush can help you to define certain areas such as the outer ear.

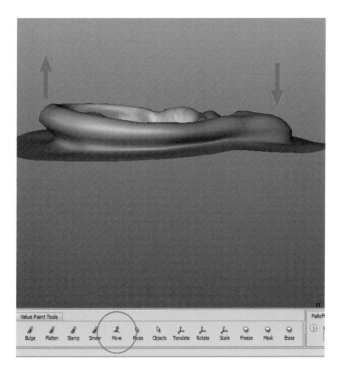

The Move tool can help you to raise or lower areas of the mesh that may not have been done adequately in the earlier modeling stage.

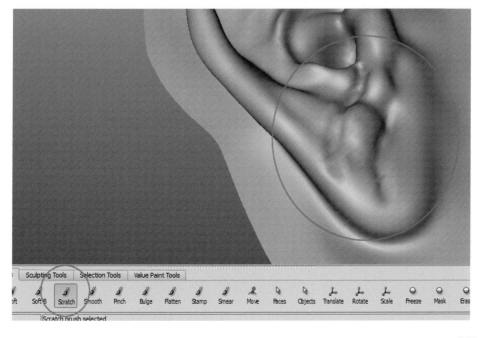

Using the Scratch brush easily cuts into the mesh surface to create creases.

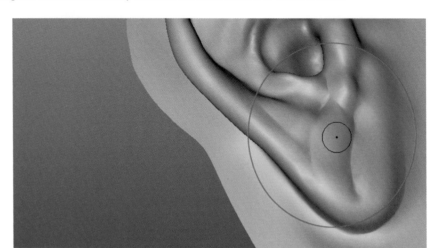

Following the Scratch brush with the Pinch brush creates soft skin folds. Using the Soft or Bulge brush to further push the fold out adds to the final effect.

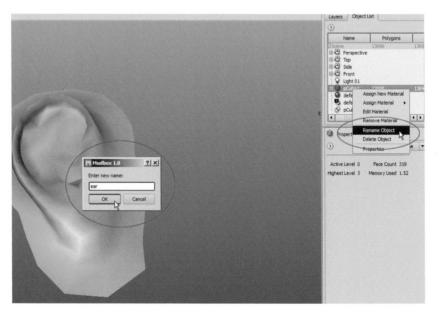

To rename the mesh, go to the Object list menu.

- Right-click on the mesh object > Rename Object.
- Enter the new name.
- Press OK.

Lower the Mesh Density to reexport out the new low-poly mesh. You can export out the high-poly mesh too for generating a Normal map in Maya using the Transfer Maps tool. (This procedure is demonstrated in Chapter 11, Technique 9: Transfer Maps.)

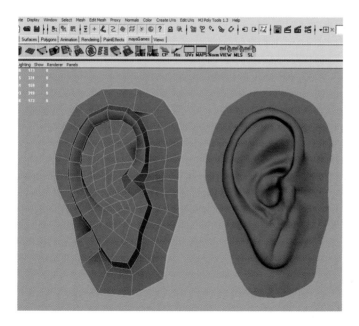

Here is the final result of this quick lesson. It shows the original low-poly mesh on the left and the resulting high-poly version that was exported from Mudbox.

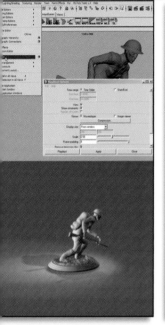

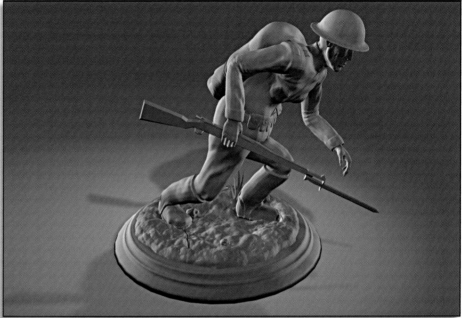

Creating a Model Turntable Animation

At the heart of any good modeler's demo reel is an impressively lit and rendered turntable animation displaying the mesh wireframe and topology. In this lesson, I will demonstrate a simple but effective turntable setup. I have also provided the lit and animated turntable scene file.

Step 1: Getting Started

Preparing the Turntable

Modeling a turntable is easy. For this lesson I used a NURBS (non-uniform rational b-splines) curve, to which I then applied a revolve. This allows a quick lathing action, and using a NURB makes the turntable smooth, as opposed to a polygon mesh, which would have to be a high poly count.

Creating the Profile Curve

- Create > CV Curve Tool > Reset Default settings.
- Start from the center, and begin to click an interesting profile.
- Don't be concerned about scale at this time.
- Select the two middle CV points, and scale them evenly in width.

 TIP: *CV curves average the points between the CV, so when creating sharp edges you need to add several CVs close to one another.*

Revolving the Turntable

- Change modes to Surfaces.
- Select Surfaces > Revolve > Options.
- Set Axis to Y (the revolve will spin from the center top).
- Make sure End Sweep is on 360 for a complete circle.
- Keep Output set to NURBS.
- Press Revolve.

 TIP: *Undesirable results? If the revolve doesn't look like it should, press the Z key to back up and check the pivot. It should be at the center (end CV points of the flat ends).*

The nice part of NURBS is you can adjust the shape by selecting your CV points on the profile curve and make changes that will automatically update on the NURB surface. Once you are pleased with the shape, delete All History.

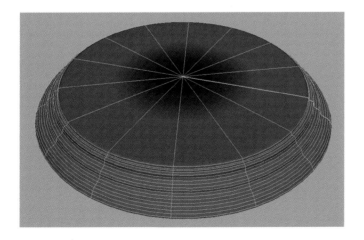

Snapping the Pivot to the Grid

Select Revolve, and X-snap the platform to the center 0/0 location on the grid.

Freezing the Transforms

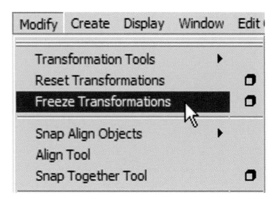

It's always a good idea to freeze the transforms (zeros out the translations) on models before animation.

Step 2: Parenting the Model

Because the turntable is zeroed on the grid and ready to animate, we will make it the parent of the model. This way, the model will do whatever the turntable is doing. But by parenting as opposed to combining the mesh, the model remains free to move, rotate, or scale on the turntable.

Importing Your Finished Model

If the model is made of multiple meshes, then select all the mesh parts and press ctrl + G to group the meshes into one node. Rename this group Model_Complete.

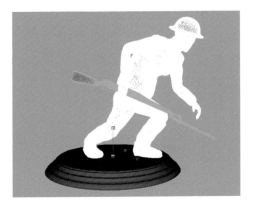

- Select the Model Complete node, and shift + select the Turntable mesh.
- Press P to Parent.
- Now select the turntable and rotate it. If the model follows along, then the two objects are connected properly. Remember to reset the turntable's Rotate Y channel back to 0.

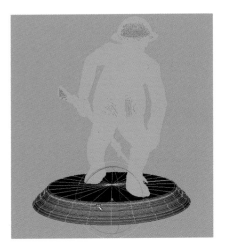

Step 3: Animating the Turntable

Setting Keyframes

We are only rotating the turntable in the Y axis.

Set the Range Slider to 1 on the left and 360 on the right. This will give us the proper number of frames. If you started with frame 0, then you would actually end up with 361 rendered images for a 360 rotation.

- Start Frame.
- Go to Frame 1 on the Animation Time Slider.
- Select the Rotate Y channel.
- Right-click drag to Key Selected.

The channel will highlight orange, indicating animation has been applied.

- End frame.
- Go to the last frame, 360, and repeat the process.
- Press the play button on the Animation Time Slider to ensure the turntable animates.
- Remember to save your scene.

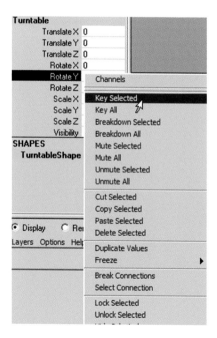

The same is true for the actual animation. Because 0 degrees and 360 degrees represent the same rotational point, we need to alter the range to avoid a two-frame overlap, which would cause a visual "popping" on the animation sequence.

Rendering a Quick Playblast

Rather than render an entire scene for testing, which may take a few hours, we can render a quick playblast both before and after we set up our lights and camera. Here's how to do it.

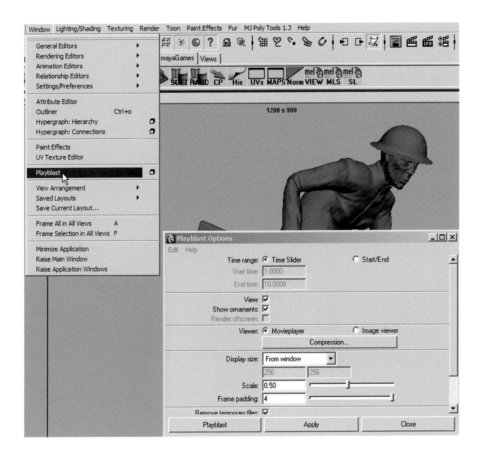

- Windows > Playblast Options.

Decide if you want the animation based on the current Time Slider or a Start/End frame.

Set all other settings as per the example image. Maya will begin recording an image sequence slide show. You can also render to a file and view through the **fcheck** editor:

- File > View Sequence.

Step 4: Setting up the Camera and Lights

Easy Three-Point Light Setup

Three-point lighting is the basis of most light setups, and this system works great for turntable animations too. Basically, here is the breakdown of the lights and their purposes:

- **Key Light:** Usually a spotlight works best with a nice drop shadow and linear decay.
- **Fill Lights:** Two directional lights fill out the scene and also add contrasting color.
- **Rim Light:** A fourth light can be added to accent the rim of the object and give a nice contrast against the background.

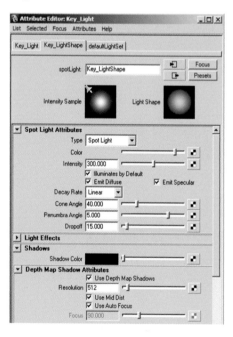

Key Light Settings

The key light is the main focal light for your model. I prefer to lower the color from pure white to something more natural and warm, so I find a slight off white or light beige color works best.

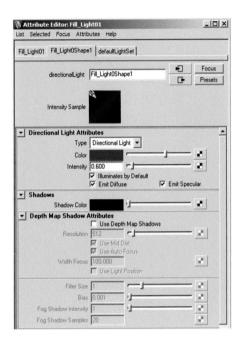

Fill Lights

The directional fill lights add warmth and atmosphere to a boring scene. I find crossing two directional lights of contrasting color at 90-degree angles from each other works well. One warm light (e.g., burnt orange) and one cool light (violet-blue) can be flattering to the model. A low setting of between .5 and 1. works best as the goal is to add a gentle wash of color, no shadows necessary.

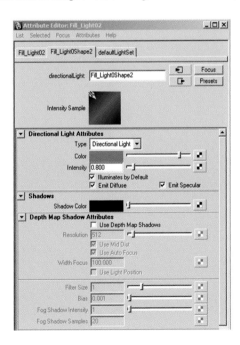

I also angle the lights in a slight upward direction, which avoids adding too much light to the base or floor plane.

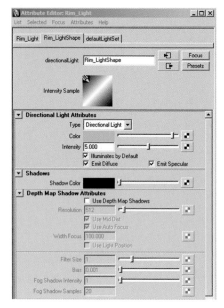

Rim Light

The rim light is optional, although it does help to define the edge of your model and push it away from the background. This light requires a much higher intensity setting; between 5 and 10 works best. Again, no shadow should be used.

Setting up the Camera

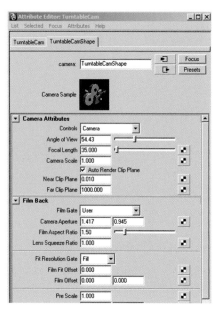

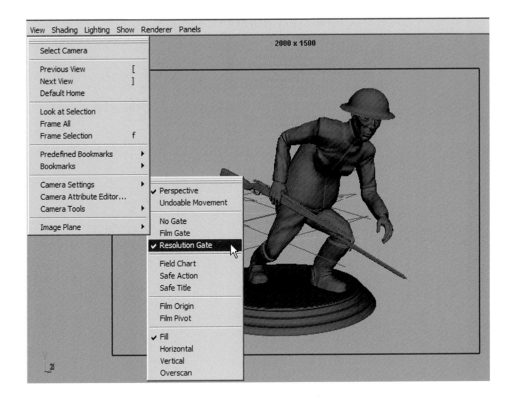

Camera Gate

The Resolution Gate will help you to see how your model will look within the rendered scene. Sometimes when No Gate is on, Maya won't display the correct proportions of the final render.

- **Safe Action:** Defines a boundary within which all animation should remain for proper broadcast display.
- **Safe Title:** Defines a boundary within which any text displayed should remain for proper broadcast display.

NOTE: *View the movie file provided on the DVD to learn how to set up the lights easily.*

Step 5: Rendering the Animation

Setting up the Render Global Correctly

Setting up the Render Global is easy, but you have to make sure certain fields are set properly, otherwise you will not get the best images or numerical sequence for importing into a video editing program such as Premiere or Final Cut.

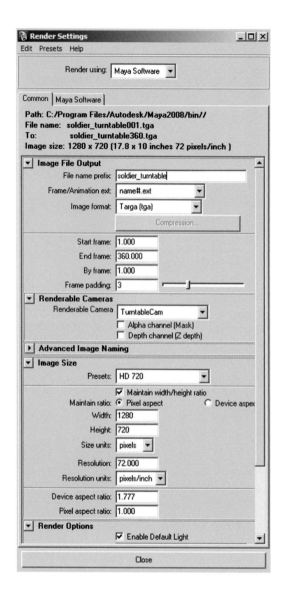

Rendering the Global Common Tab

1. Make sure you have your project set correctly so the renders end up in the proper location and are easy to find when you are editing.
2. Give your file a name.
3. Choose an extension. "Name#.ext," for example, would render as "soldier_turntable000.tga."
4. Choose your Image Format. I prefer .TGA for my work.
5. Select a Start frame. (Yes, you can begin the animation render from any frame.)
6. Select an End frame too.
7. Frame Padding will add a series of numerical spaces. Padding 3, for example, would render up to 999 frames.

8. Ensure that the correct camera has been selected to render.
9. If an Alpha or ZDepth channel is required, then select. Adding these channels will double your rendering time.
10. Set your Image Size. Although 640 × 480 is common, I prefer the 1280 × 720 HD format; or you can use 720 × 405, which is a smaller "cheat" ratio of high definition for users with less computing speed.
11. Be sure to check Maintain Ratio to see if the width/height ratio is scaling larger or smaller.
12. Leave all other settings at their defaults.

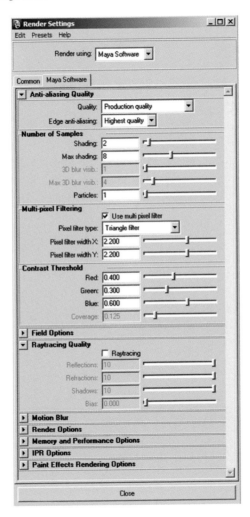

Maya Software Tab

1. Set Quality to Production quality.
2. Edge anti-aliasing will automatically set to the highest quality.
3. Set all values at their defaults.

4. Turn on Raytracing Quality if you plan to render any shiny or reflective materials.
5. Turn off Motion Blur. It's preferable to display your turntable without blur to show your modeling at its best quality.

Step 6: Batch Render

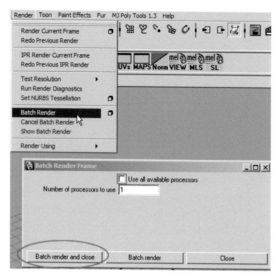

Rendering the Image Sequence

- Change to Render mode.
- Render > Batch Render > Options.
- If you have multiple processors, check ON.
- Select Batch render, and close.

Maya will display the frame render progression in the lower right Status bar.

Step 7: Video Editing

Importing the Animation Sequence

Use a video editing program like Adobe Premiere or Final Cut. The rendered image sequence is now prepared to import easily. Rather than take too much space on these pages, I created a video tutorial that will take you through a simple process of creating your very own demo reel movie with suggestions on transitioning from one scene to another.

Additional Suggestions

Consider adding some terrain, rocks, debris, and blades of grass to enhance the final model presentation. Remember, you want to impress potential employers, so adding small pluses will make your work stand out from the competition's.

Camera Tricks

You can make realistic and stunning images by adding motion blur or, even better, depth of field to your rendering camera. Be careful, however, because the postprocessing time Maya requires for depth of field and motion blur will slow down render times substantially.

Wrapping Up

By rendering several versions of your model—for example, wireframe, shaded, and textured— you can create a turntable that transitions from one display into another. Also recommended is rendering a few closeup images that show the finer details of the model and mesh.

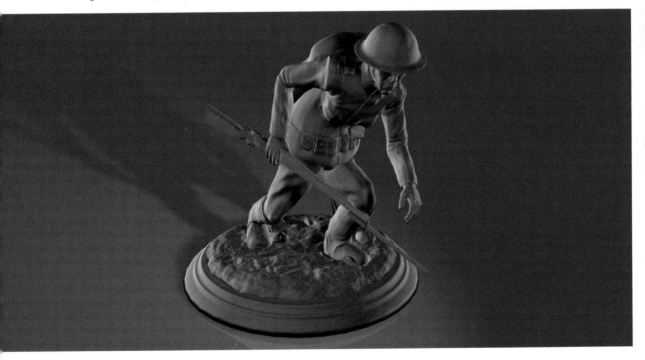

The DVD includes a movie file of the finished soldier turntable, complete with additional transitions showing a professional demo reel presentation called "Creating a Killer Reel."

Contents on the DVD

Video Tutorials

Video 01

- Setting up a Modeling template- Watch the author demonstrate how to quickly prepare an effective modeling template.

Video 02

- Using the Mirror, Merge, Soften and Snap- Speed up modeling using these special tools.

Video 03

- Using Joints in Modeling- Learn to effectively deform mesh using this powerful trick.

Video 04

- Using Blend Shapes- Finessing low poly models using this quick technique.

Video 05

- How to Transfer UV maps- Save time transferring clean UV's from one mesh to another.

Video 06

- How to use Transfer Maps- Generate new texture maps easily using this powerful tool.

Video 07

- How to Transfer Normals- Learn how to bake high poly detail onto low poly mesh.

Video 08

- Using Mudbox- A time-lapse demonstration using Mudbox to sculpt a realistic hand.

Bonus Video Tutorials

Creating a Killer Demo Reel

- Example Demo Reel- Shows an effective model rotation final movie.
- Creating a Killer Reel- 2 part videos demonstrating how to import, blend and output a professional quality DVD demo reel movie!

Chapter Scene Files

- All the necessary Maya scenes, templates and texture maps organized by each chapter.
- Each chapter contains a Start.ma scene file to begin with and Final.ma scene file to show the completed project.

Crazy Bump

- Free evaluation version of the popular application that makes excellent bump, normal, specular and displacement map creations ... effortlessly.

About the Author

Time goes by quickly. Seems just a short time ago I was picking up my first 3D book in my quest to learn as much as I could about this amazing art form. That was over a decade ago and today, I am proud to be a full time author and instructor of the 3D arts and find it completely satisfying to help nurture and inspire the "next generation" of 3D artists for gaming and film development.

My journey into 3D began back in the mid 90's when I purchase a new Mac computer. I thought it would be fun to try out a new game and as many of you older folks will remember, there wasn't much of an offering for the Mac back then. But from high up on the very narrow selection of what was available, gleamed this box that instantly caught my attention. It read MYST and the image on the cover blew my mind, once I turned the box over and saw the detail created in the bedroom image I was sold. Of course the adventure and puzzles were right up my alley too. Back home I viewed the cheesy little "making of" that was around 320 × 240 and came to discover the game was created on the Mac platform too, with a small application known as Strata 3D. Several hours later I found myself back at the store purchasing the very same software and installing it as soon as I could manage. 3D was cumbersome back then, but within a month or two playing around I managed to land a job working as a 3D artist for a local multimedia company. My demo reel? An image of a wooden door with a skull and crossbones as the door knocker ... go figure. Got me the job though, but they were using a program I had never heard of called 3D Studio. Our first upgraded version came in as 3DS Max 1.2 and I began learning on the job.

I became very comfortable working in Max, even had my profile featured in 3D World magazine. But the true turning point of my career came when I entered the game industry. I spent several months designing a demo reel and submitting it to several dozen game studios across the country. A few months later I found myself moving to Seattle to work on a game for a new console called the XBox. It was there, that I was told I would need to learn Maya on the job. There were no book at that time and even my colleagues were just getting the grasp of it, but once I understood what Maya was all about my work began to take flight.

Skip ahead a few years and several studios later I found myself going back to school on scholarship. My brief experience at the Academy of Art in San Francisco helped me to hone my skills to land a job as a Maya instructor teaching at Escape Studios in London and various other academies internationally. The experience as an educator has been priceless as I have strengthen my skills as an artist but more importantly as a communicator. It's simply not good enough to be a talented artist when teaching, you must know how to convey the processes clearly and effectively too.

So go ahead and embrace this book. Many years of my experience went into these pages and every asset you model from these chapters can be utilized within an impressive scene later on for your demo reel, or possibly even a cinematic animation (hinting on my sequel to this book!).

I hope you enjoy the lessons I have designed here and also hope you learn a great deal to improve your skills too. Feel free to stop by my personal website where you will find free lessons, video tutorials and of course, drop me a line should you have any questions or comments. I'm always here to help.

Warm Wishes,
Michael Ingrassia
www.MayaInstructor.com

Glossary

A

3D (three-dimensional) Having or appearing to have width, height, and depth.

Alpha Blending A graphics processing technique that simulates transparency or translucency for objects in a 3D scene to create visual effects like smoke, glass or water. Pixels in the frame buffer of a graphics system include three color components (red, green and blue) and sometimes an alpha channel component as well. The alpha channel data stores the degree of transparency, ranging from opaque to completely clear.

Antialiasing Any technique for reducing the visual impact of aliasing, or the "jaggies," on a computer graphics system.

Aspect Ratio The ratio of the width of the image to its height, expressed as width:height. A standard U.S. television screen or computer monitor has a 4:3 (pronounced "four by three") aspect ratio. Some high-definition television (HDTV) broadcasts are formatted in a 16:9 (1.78:1) aspect ratio. Most feature films have a 1.85:1 aspect ratio.

B

Box Modeling A modeling technique incorporating the extrusion of faces and edges from a simple box into a complex shaped model.

Bump Mapping A shading technique using multiple textures and lighting effects to simulate wrinkled or bumped surfaces. Bump mapping is useful because it gives a 3D surface the appearance of roughness and other surface detail, such as dimples on a golf ball, without increasing the geometric complexity. Some common types of bump mapping are Emboss Bump Mapping, Dot3 Bump Mapping, Environment Mapped Bump Mapping (EMBM) and True, Reflective Bump Mapping. Dot3 bump mapping is the most effective technique of the three.

D

Digital Painting Technique using a pen and tablet such as Wacom® tablets to create painted texture and artwork digitally. Most commonly used 2D program for painting is Photoshop.

DirectX® A hardware abstraction layer API from Microsoft that is integral to the Windows® operating system. The DirectX standard includes Direct3D, DirectSound, DirectDraw, DirectVideo, DirectPlay, and DirectInput. Microsoft continues to revise DirectX to make it the industry standard consumer graphics API.

Double Buffering A programming technique that uses two frame buffers so the GPU can be working on one frame while the previous frame is being sent to the computer display. This prevents conflicts between the display refresh function and the graphics rendering function. See *Frame Buffer*.

F

Fill Rate The speed at which your graphics card can render pixels–usually measured in millions of pixels per second (Megapixels/sec). GPUs with higher fill rates can display higher resolutions and more colors at higher frame rates than other chips with lower fill rates.

Frame Buffer Memory that is dedicated to the graphics processor and used to store rendered pixels before they are displayed on the monitor.

Frames Per Second (FPS) The rate at which the graphics processor renders new frames, or full screens of pixels. Benchmarks and games use this metric as a measurement of a GPU's performance. A faster GPU will render more frames per second, making the application more fluid and responsive to user input.

I

Image Based Modeling Technique which allows modeling from images and photographs to achieve exacting standards in 3D modeling.

J

Jaggies A slang term used to describe the stair-step effect you see along curves and edges in text or

bit-mapped graphics. Antialiasing can smooth out jaggies.

L

LOD (level of detail) Determines the amount of modeling complexity required for a specific game asset according to importance and distance from player interaction. LOD's are usually determined by classes, as in A, B or C class level assets. Classes are sometimes referred to as "Hero" models.

M

Mipmapping A technique to improve graphics performance by generating and storing multiple versions of the original texture image, each with different levels of detail. The graphics processor chooses a different mipmap based on how large the object is on the screen, so that low-detail textures can be used on objects that contain only a few pixels and high-detail textures can be used on larger objects where the user will actually see the difference. This technique saves memory bandwidth and enhances performance.

N

Normal Mapping Advanced texturing technique which allows better results than Bump mapping since the camera views the height in multiple axis directions.

O

OpenGL A graphics API that was originally developed by Silicon Graphics, Inc.™ (SGI) for use on professional graphics workstations. OpenGL subsequently grew to be the standard API for CAD and scientific applications and today is popular for consumer applications such as PC games as well.

P

Per-Pixel Shading The ability to calculate lighting effects at the pixel level, greatly increasing the precision and realism of the scene. With NVIDIA's GeForce3 GPU, game developers can now program custom per-pixel effects.

Photoshop The 2D digital painting program developed and published by Adobe Systems. It is currently the market's most popular graphics editing program.

Pixel Shorthand for "picture element." A pixel is the smallest element of a graphics display or the smallest element of a rendered image.

Polygon The building blocks of all 3D objects (usually triangles or rectangles) used to form the surfaces and skeletons of 3D objects.

R

Rendering The process of taking information from a 3D application and displaying it as a final image.

S

Shell A connection of UV's forming one unwrapped surface or shell.

T

Texel Density The smallest unit of a texture map, similar to pixels being the smallest unit of a rendered image.

Texture An image file (such as a bitmap or a GIF) that is used to add complex patterns to the surfaces of objects in a 3D scene.

Texture Mapping The process of applying a texture to the surface of 3D models to simulate walls, sky, etc. Texture mapping enables developers to add more realism to their models.

V

Vertex Snapping A method of snapping Vetices to the same 3D point in space or along the same axis distance.

Z

Z-Buffer The area of the graphics memory used to store the Z or depth information about rendered objects. The Z-buffer value of a pixel is used to determine if it is behind or in front of another pixel. Z calculations prevent background objects from overwriting foreground objects in the frame buffer.

Index